DESIGN AND PRINT YOUR OWN POSTERS

J. I. BIEGELEISEN

DESIGN

AND

PRINT

YOUR OWN

POSTERS

WATSON-GUPTILL PUBLICATIONS/NEW YORK

Also by J.I. Biegeleisen

Screen Printing

Copyright © 1976 by J.I. Biegeleisen

First published 1976 in the United States and Canada by Watson-Guptill Publications
a division of Billboard Publications, Inc.
1515 Broadway, New York, N.Y. 10036

Library of Congress Cataloging in Publication Data
Biegeleisen, Jacob Israel, 1910—
 Design and print you own posters.
 Bibliography: p.
 Includes index.
 1. Posters. 2. Lettering. 3. Screen process
printing. I. Title.
NC1810.B48 741.67 75-40176
ISBN 0-8230-1309-X

Manufactured in U.S.A.

First Printing, 1976
Second Printing, 1977

Affectionately dedicated to
Dr. Robert L. Leslie,
a legendary figure in the graphic arts
in his own lifetime, whose friendship
I cherish so dearly

Acknowledgments

Preparing instructional material for *Design and Print Your Own Posters* turned out to be a far greater undertaking than I had anticipated at the outset, and were it not for the encouragement and active assistance of my wife, this book, much needed as it is, would not have been completed. I therefore first and foremost want to particularly express my gratitude to her for the important role she played in the many phases involved in the evolution of this book, from concept to finished manuscript.

I also welcome this opportunity to thank the following—mentioned here alphabetically—for generously contributing illustrative material in the form of photographs, spot drawings, and samples of posters and lettering specimens: Advance Process Supply Co., American Crayon Co., American Institute of Graphic Arts, Atlas Silk Screen Supply Co., Famous Artists Schools, Inc. Graphic Products Corporation, M. Grumbacher, Inc., Hankscraft Motors, Herron School of Art, High School of Art and Design, Hunt Manufacturing Co., Jackson Lowell Studio, Keuffel & Esser Co., Langen & Wind, Al Lederman, Letraset USA, M & M Research Engineer-ing Co., Guy Maccoy, Byron J. Macdonald, Sam Marson, Maurel Studios, Vincent J. Mielcarek, Naz-Dar Company, Nu Arc Company, Pace Editions, Inc., Joe Pelkey, Pentalic Corp., Photolettering, Inc., Testrite Instrument Co., Inc., Ulano Company, Upson Company, Martin J. Weber Studios, and Yogg & Co., Inc.

My special thanks to Dick Sutphen Studio, Inc., Metro Associated Services, Inc., Trend Enterprises, Inc., and Harry Volk Art Studio collectively, for permission to reproduce a sampling of spot drawings. And special thanks, too, to my good friend and professional colleague, Ben Clements, for his counsel and practical assistance in rendering some of the line drawings in Part Two of the book. To Karl Fink, President of the American Institute of Graphic Arts, I am indebted for taking time off from his busy schedule to review the book in its manuscript form and for his many helpful comments. To my publisher, Watson-Guptill Publications, and Sarah Bodine, the editor who has worked with me on the book, I wish to acknowledge my personal thanks for the guidance and unstinting cooperation in preparing the manuscript for publication.

Contents

Part One: Poster Design

Part Two: Poster Printing

PART
ONE
POSTER
DESIGN

©VOLK

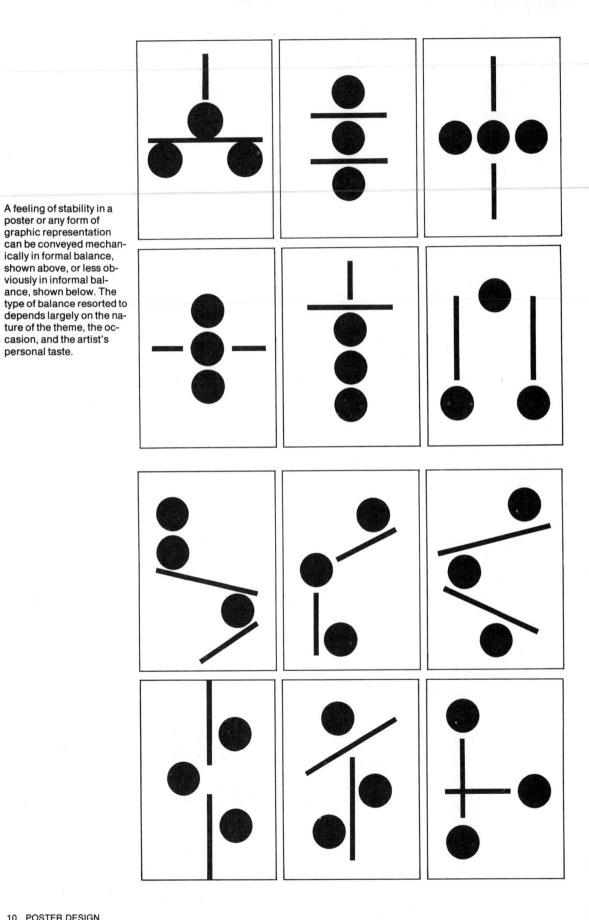

A feeling of stability in a poster or any form of graphic representation can be conveyed mechanically in formal balance, shown above, or less obviously in informal balance, shown below. The type of balance resorted to depends largely on the nature of the theme, the occasion, and the artist's personal taste.

1 What makes an effective poster

Before venturing to answer the question posed in the heading of this chapter, it will be helpful to come to an understanding as to what constitutes a poster. What's the distinction between a formal poster, a showcard, and a neatly lettered bulletin-board announcement? Broadly speaking, there is little distinction between them, except that a poster is generally made larger in size and is usually—but not always—embellished with some pictorial element to go with the lettering. Customarily, a poster designed to serve as an "original" for reproduction is rendered more carefully and with greater precision than the casual, one-of-a-kind poster. In essence, the basic principles of layout and design are the same for a poster in any form and so are (to a greater or lesser extent) the criteria for evaluating the results.

Evaluating a Poster's Effectiveness

Seasoned judgment based on a set of specific criteria will enable you to evaluate the effectiveness of any and all posters—those you've done yourself or those created by others. Let's examine these criteria of evaluation at close range.

Selling Point. The aim of a poster is to publicly announce or sell something—a product, service, or worthy cause. The message may be direct or subtle as the situation requires.

A well-planned poster should lead to action of some kind—immediate or eventual. The plan by which the artist hopes to reach this objective constitutes the central idea or selling point of the poster. The approach may be blunt, as expressed in a layout that features nothing more than an illustration or photo of a product or event, with copy which simply states, "Buy ——" or "Ask for ——" or "Attend ——." Such bluntness, however, more often than not falls short of its goal because it doesn't tell *why* the viewer should do what he is told or how he would benefit by doing so. A successful poster, once it has buttonholed the casual passerby, must compensate him in some measure for the time it has demanded of

him. This may be in the form of a pleasurable experience by depicting an amusing situation in words or picture, or it may instruct and enlighten him by presenting an interesting bit of useful information. The design may feature a slogan, rhyme, popular saying, play on words, dramatic situation, or perhaps a serious appeal to conscience or patriotism. Regardless of how this is achieved, to be effective a poster must have a selling point that is clearly understood, convincing, and impressive. Indeed, that is one of the primary functions of a poster or any other form of advertising.

Simplicity. Normally, the fewer the number of units into which a given space is divided, the easier it is to look at. When a poster design gets too involved, with diverse elements crammed into it, the message is inevitably obscured. Many a neophyte labors under the erroneous impression that if a few elements or units are good, then more of them must perforce be so much better. If one illustration or pictorial doodad seems to work out successfully, then why not try five or six, or eight? This is not unlike the reasoning of the flamboyant theatrical producer who, when viewing an early rehearsal of his forthcoming pageant based on the Last Supper, put in a request for 24 Apostles instead of the biblical 12 to make doubly sure his production would be a spectacular success!

A conglomeration of design elements— whether in the form of lettering styles, pictorial elements, painting techniques, or multiplicity of colors—invariably detracts from the appearance and the effectiveness of a poster, as it does from any other type of graphic presentation. Simplicity is assuredly one of the goals to strive for.

As one who has served on numerous judging committees in poster contests on a local and national level, I can personally attest to the fact that simplicity in layout and technique is always considered an important plus factor in the selection of the winning entry.

Unity. This is the binding power that keeps the component elements in a poster together. The

different elements that comprise the poster must be held in check by some means. There are a number of ways to bring this about.

One is by *physical contact*, that is, to have one or several elements in the layout touch or overlap the others. For example, an illustration can be so positioned on the layout that it extends partly into a featured line of lettering. Where this is not esthetically feasible, an *optical* rather than a physical impression of unity may be conveyed. This can take the form of a decorative arrowhead, a pointing finger, a series of typographic dots, etc. Sometimes a flourishing loop of an ornamental letter can be artfully extended to lasso an isolated element in the composition. We are all familiar with poster layouts where an illustration of the product advertised is made to serve as a directional pointing device leading to another unit or element. Oil, maple syrup, or a similar product is depicted flowing from a source somewhere at the top of the design, coming down in a long, unifying stream to the bottom where the company trademark is placed. Cough drops or pills are shown dropping out of a tipped container, and in their descent they lead the eye over a prescribed course to a panel of copy or other related element. By such obvious (and preferably more subtle) means, the eye of the observer can be guided from one element to another so that the design is seen as a whole rather than as disjointed parts.

A feeling of unity can also be conveyed in a poster without resorting to overlapping, touching, or directional devices, by introducing a surrounding border or by painting the background in a strong, attractive color.

Balance. A poster may achieve unity very well without having balance. This would be the case where the unified elements on one side of the poster overpower those on the other, resulting in a lopsided composition.

There are two kinds of balance: *formal* or bisymmetric and *informal* or asymmetric. An obvious example of formal balance is an offset ink blot which occurs when a sheet of paper with a splash of wet ink is folded inwardly in half. In a poster layout based on ink-blot balance, half of the layout mechanically balances the other. Unless helped by an illustration with great visual or emotional impact to serve as a strong focal point, a poster designed on strictly formal balance is apt to be static. In the trade there's a saying: "A formal layout may not be exciting, but it's always safe."

Traditionally, posters designed for financial and religious institutions are structured along formal lines. This holds good for any advertising layout where a feeling of conservative stability or refinement is sought.

Informal or asymmetric balance is *sensed* rather than measured. In planning a poster design based on such balance, the size, color, and shape of the component elements must be considered as they relate to any imaginary vertical line running through the center. The relative pull of attraction of the several elements on both sides of center is the determining factor in establishing proper balance. For example, a small area of bright red color seems "heavier" and if strategically placed close to the center will visually counterbalance a large mass of neutral gray placed distant from the center. An odd or unusual shape carries an impression of weight and attraction more than a conventional shape.

Bearing in mind these competing forces, the various components in a layout may be moved about—up or down or side to side—until a pleasing visual equilibrium is established. You can readily see that informal balance can't be arrived at through mathematical computations. It's based on esthetic judgment and offers greater opportunities for a more creative and dynamic composition.

Element of Surprise. It's sometimes said that if a poster is to serve as an effective selling agent, it must invariably deliver its message in some unusual or surprising manner. But every poster need not act the part of supersalesman. There are occasions when a polite handshake ingratiates a salesman with his prospective client far more than a forceful slap on the shoulder. A poster may show a modicum of restraint in layout, yet if it possesses other attributes, it can accomplish much in presenting its message.

If a poster is intended primarily for a "quicklook" audience, it must be designed to arrest the viewer's attention by sheer visual impact. This can be accomplished through an element of shock or surprise. An illustration (or other pictorial element) on a poster allows far greater latitude for conveying a feeling of shock or surprise than does lettering alone. The illustration may represent something bizarre, macabre—even absurd, such as a little mouse chasing a ferocious lion, or a man blithely strolling upside down on a ceiling. Naturally, for a poster to communicate an idea leading to desirable results, there must either be a direct or subliminal connection between the situation depicted and the poster's main message.

Anything seen at normal eye level isn't quite as novel as the same view seen from an unusual vantage point. The urge to see the world from a different perspective is inherent in human na-

ture. It can be observed in the antics of children who take a curious delight in bending down to look through their spread-apart legs at their surroundings, momentarily turned topsy-turvy. This impelling urge to look at things from an unusual perspective is exploited in TV and the movies by the technique of the bird's-eye view, the snail's view, the long shot, the larger-than-life closeup, the oblique view—all dramatically departing from the way we normally observe life around us. A poster where the illustration or lettering is drawn in some exaggerated and unique perspective attracts greater attention than one where everything is delineated in a normal way.

Correlated with the idea of unusual perspective is the matter of size. It's often more interesting to view things which have been reduced to Lilliputian proportions or made fantastically large. Size is entirely a matter of contrast. We measure one thing by comparing it with another. To give the impression of largeness to one particular element of an illustration, it can be shown in relation to another, made exaggeratedly diminutive. Another way to give the illusion of great size is to focus attention on the magnified detail of an object rather than showing it in its entirety. A closeup of a funnel of a ship made to occupy the major portion of the poster can be far more impressive and monumental than showing the entire ship.

Anything that suggests precarious balance is likely to engender a feeling of suspense and surprise on the part of the beholder. We watch a tightrope walker's act in the circus with rapt attention because we participate vicariously in his attempt to challenge the elemental forces of gravity. In a way we are similarly affected by a layout in a poster where some element, be it lettering or illustration, is shown at a dramatic angle. The observer is inclined to reach out mentally to something precariously tilted on edge than to the same thing shown firmly and safely planted on its base.

Workmanship. Though it's hard to say to what degree technical skill in rendering contributes to the allover effectiveness of a poster, it is an undeniable fact that everyone is favorably impressed by a well-rendered piece of work. Rendering doesn't necessarily have a bearing on the thematic concept of the poster. It refers specifically to the quality of workmanship as evidenced in the painting technique, lettering, pictorial treatment, etc.

Conceivably, even if all the individual elements in a poster are designed and rendered well, it still may not fulfill its primary objective—that is, to make a specific, effective selling point. Unless the poster fulfills its objective, it's all dressed up with no place to go. By the same token, a poster may possess all other desirable attributes—simplicity, unity, balance, etc.—but if the workmanship is shoddy, the poster is apt to be ineffectual.

Evaluating a Poster Design on a Numerical Scale

The ideal poster (and there are very few that fall into this category) possesses in full measure all the desirable attributes mentioned here. Bear these in mind in judging the poster art you see about you in store windows, theater lobbies, on the roadside, and on bulletin boards of your school or club.

For those who wish to have a more substantive basis for evaluating the effectiveness of a poster, the following percentage scale is offered for reflection and consideration.

Selling point	25%
Simplicity	15%
Unity	15%
Balance	15%
Element of Surprise	15%
Workmanship	15%
	Total 100%

Evaluated on this percentile basis, a poster with a rating between 65% and 80% would be above average; a full 100% rating, a rarity. Obviously, subjective responses in evaluating a poster, or any esthetic form of expression, will vary with the observer.

2 Basic art materials

In this chapter we'll discuss the equipment and supplies used in poster work. It's by no means to be inferred, nor is it recommended, that you acquire all these items at the outset. In general, it's best to defer making extensive purchases until the need arises and until your own firsthand practical experience makes you a competent judge of the items you buy.

The items listed here are followed by a detailed description of the range of each to guide you in your choice.

Drawing board

Drafting table

Stool or chair

Work lamp

Pencils

Pencil sharpener

Erasers

Lettering pens

Brushes

T-square

Ruler

Triangle

Drafting instruments

Cutting tools

Rubber cement

Masking tape and tacks

Cardboard and paper stock

Paints and inks
(covered in a later chapter)

Drawing Board

Almost any flat, square-edged table such as a kitchen or card table can, as a matter of temporary expediency, serve as a work surface for poster making. However, a good drawing board

or professional drafting table is recommended for any sustained practice of poster art.

Artists' drawing boards are usually made of smooth, kiln-dried, ¾″ solid white pine, carefully squared off and reinforced with hardwood strips. Standard sizes are 16″ x 21″, 18″ x 24″, and 20″ x 26″. Larger sizes go as high as **31″ x 42″**. (See the conversion chart at the back of this book for metric equivalent sizes.) Also available are hard-surfaced composition boards which you may be tempted to purchase simply because they are less expensive. Resist the temptation. Composition boards are subject to warping, they don't take pushpins or thumbtacks easily, and they aren't usually thick enough to work well with a T-square (described later).

In use, the drawing board is propped up in the back to tilt at a 30° to 35° angle, but this is a matter of personal preference. Working convenience will decide what's best for you.

Drafting Table

Drafting tables come in all styles and tabletop dimensions, ranging from 23″ x 31″ to as large as 48″ x 60″, and larger. A good medium size is 24″ x 36″. The important thing to look for when shopping for a table, regardless of size, is that it be of rigid construction and easily adjustable in height and tilt.

The budding artist whose "studio" is a corner of the living room or other confined area might consider getting a lightweight inexpensive drawing table—the kind that folds, permitting it to be stored away when not in use. When folded, the table fits into a space approximately 6″ to 7″ wide. The tabletop is adjustable to any angle as well as to a completely upright position. Hence, on occasion, it can also double as a vertical easel.

Artist's Work Stool

This is an optional piece of equipment since almost any kind of chair of the right height will do. Should you decide to buy a stool to serve as a companion piece for your drawing table, it's advisable to get one with a seat that can be ele-

vated or lowered to a changing preference in height, somewhat like a piano stool.

Work Lamp

A portable gooseneck lamp or a high-intensity table light will come in handy for close detail work, as for instance when retouching or rendering small-size lettering. The best type of lamp for professional work is a "floating-arm" lamp, one that clamps to the table edge, leaving the work surface free and unobstructed. Its main feature is that it allows the light source to be directed to any position and to any desired angle.

Pencils

The term "lead pencil" is a misnomer. The inner core—that is, the writing part of a pencil—is a graphite substance derived from carbon. Actually, there is no "lead" in a lead pencil.

The degree of softness or hardness in a drawing pencil is indicated by a marking at one end: the letter B signifies *soft*, the letter H *hard*. There are gradations from B to 6B and H to 9H. In the B series, the higher the number, the *softer* the lead. In the H series, the higher the number, the *harder* the lead. HB, in a class by itself, is a general drawing pencil of medium softness.

A limited number of drawing pencils is all you need for most work involved with poster making. These could include a medium-hard 2H pencil that you'll find especially practical for tracing purposes, an HB for routine tasks, and a medium-soft 2B for general sketching and layout work. You may also want to add to your inventory a marking pencil that takes well on acetate and glass, a white chalk pencil, and perhaps a charcoal-stick pencil.

Incidentally, when sharpening a drawing pencil, do so at the unmarked end so that you don't cut away the identification.

Pencil Sharpener

It's been said that working with a dull pencil makes you think dull. Be that as it may, for accurate measurements and all detailed pencil work, the pencil must be well sharpened at all times. This is easily accomplished with a rotary sharpener. Select one with a variable guide to accommodate pencils of different thicknesses.

You may want to get a sandpaper pad for keeping pencil points tapered to the degree required for the job on hand. Sandpaper pads have to be replaced. It's a better idea to get a metal pencil pointer that never wears out. This resembles a two-sided nailfile—one side coarse, the other fine.

Erasers

There are several types of erasers, each designed to perform a special task. *Artgum* (miscalled "soap eraser"), the one most commonly used, is meant for erasing soft pencil lines and smudges; the *hard-rubber* eraser is meant for deeper lines and more stubborn smudges. Both, however, share this common limitation: in the process of erasing, they leave residual erasure particles on the surface which must be brushed off in the final cleanup. To obviate this extra chore, a *kneaded* eraser is recommended. This is of a nonabrasive puttylike composition which erases without crumbling and works well on any surface. A *pickup* eraser (a crepe latex square that lifts up and removes dry rubber cement) is widely used in conjunction with paste-up work and the preparation of mechanicals.

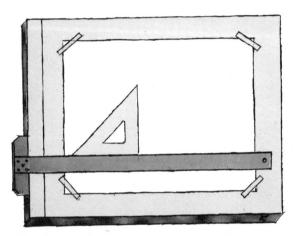

Drawing board showing position of paper, T-square, and triangle. Right-handed people generally keep the T-square to the left of the board; left-handers find it easier to keep the T-square on the right of the board.

After sharpening the pencil with a knife or sharpener, the point may be refined by rubbing it slightly over the abrasive surface of a sandpaper pad.

Lettering Pens

In the class of pens intended primarily for free-hand lettering, perhaps the most widely known are the Speedball pens made by the Hunt Manufacturing Company. Speedball pens (and others bearing different trade names) are of the "dip-in-ink" type, meant to be used with a penholder. They come in an assortment of sizes and styles for producing lines of varied thickness from thin hairlines to broad strokes ¼″ in width. In addition there are broad split-nibbed pens popularly referred to as "steel brushes." Though these are not brushes in the strict sense of the word and are not as flexible, they nonetheless simulate the action and results achievable with conventional brushes—especially for rendering fast one-stroke and thick-and-thin alphabets. Steel brushes come in stroke widths from ¹⁄₁₆″ to as much as ¾″. Beginners in the art of freehand lettering often find steel brushes easier to manipulate than the conventional-type lettering brush.

Other lettering pens are constructed as self-contained fountain pens, with built-in ink reservoirs or with replaceable ink cartridges. All have interchangeable nibs to suit different sizes and styles of lettering. There are even special left-handed pens.

You'll determine the choice of pens by your growing familiarity with them and, of course, by the nature of your work.

Brushes

The brush is the "silent working partner" of the poster artist. A well-made brush is responsive to the artist's touch; an inferior one can often be exasperating and outright rebellious. You'll do much better getting a few select brushes of superior quality than indiscriminately acquiring a large number of mediocre ones.

For general poster work, the round-ferruled showcard "chiseled-edge" lettering brush is recommended. A brush of this kind has hair of equal length cut square at the end. In a water-color brush—which in a limited way can be used for lettering—particularly fine scripts—the hair is shaped to a fine point.

Showcard brushes are classified by size from #1 (the smallest) to #20 (the largest) with #8 or #10 representing the medium and most frequently used. In any size, there are three standard lengths of hair available: short, medium, and long. The short and medium hair lengths are generally reserved for lettering with square stroke endings, as well as lettering with strong calligraphic character. For single-stroke alphabets with oval or round endings, long-hair brushes give the most satisfactory results. The best showcard brushes are made with pure red sable hair. The hair of a good red sable brush never splits or sheds and possesses a natural resiliency which makes it easier to work with. Properly cared for, a brush of this kind retains its original "springback" quality for many years and hardly ever needs to be replaced.

Showcard brushes are meant for standard water-based poster colors and aren't recommended for use with oil-based paints. There are special brushes (identified in the trade as lettering quills) made of camel's hair for working with oil-based paints. Quills are popular with sign painters for lettering on oilcloth, metal, and glass.

There is a line of flat-ferruled "fill-in" brushes made specifically for filling in large areas, but they are also good for doing rapid one-stroke lettering. Fill-in brushes are classified by width of chisel, such as ¼″, ½″, ⅜″, and so on. They are usually made with oxhair and are serviceable for both oil and water-based paints.

T-square

The all-wood type T-square—the simplest and least expensive—is the one used mostly by beginning students in art and drafting classes. The more professional type comes with plastic see-through edges. The best T-square is constructed of stainless steel or polished aluminum. It comes with a shaft that is blank or with 1/16″ calibrated markings.

In addition to standard T-squares which have a fixed head permanently attached to the blade,

STYLE 'A' SQUARE *for* SQUARE GOTHIC, BLOCK ALPHABETS, NOVELTY BORDERS, ETC. STYLE 'B' ROUND *for* ROUND GOTHIC LETTERS, UNIFORM LINE DRAWING, BORDER DESIGNS STYLE 'C' OBLONG *for* ROMAN, TEXT, ITALICS, SCRIPT ALPHABETS, ACCENTED LINE DRAWING STYLE 'D' OVAL *for* BOLD ROMAN, TEXT, ITALICS, SCRIPT ALPHABETS, BOLD SHADED LINE DRAWINGS.

A sampling of a line of Speedball lettering pens.

T-squares are also available where the head can be set to any desired angle by means of a set-screw arrangement. Though this may appear to be an attractive feature, most artists seem to show a preference for the fixed-head type. T-squares come in lengths ranging from 18″ to 60″ and longer. Match the length of the T-square to accommodate the size of your drawing board or worktable.

Ruler

Wooden rulers are the least expensive. They usually come with a brass edge which not only protects the ruler from nicks but serves as a straightedge for ruling pen-and-ink lines. The ruler most recommended for all-around use is one made of heavy-gauge tempered steel with easily discernible gradations etched on both sides. A 24″ length is a good, comfortable size to handle, although larger ones, up to 48″ and beyond, can be purchased. You can also get a thin-gauge metal ruler which is lighter in weight and less expensive. This comes with a traction strip bonded to one side to minimize the likelihood of slipping out of position when a pencil, pen, or razor blade is pressed against it.

You may want to get a roll-up tape measure or a 72″ folding ruler; both are handy for long measurements. When closed, they easily fit into pocket or drawer.

Triangle

Triangles are used not only as a straightedge for ruling in lines, but also for squaring up work. They come in plastic, wood, and metal, in sizes 4″ to 12″ and larger. Those most commonly used by artists and draftsmen are made of clear, see-through acetate. Triangles are also available in fluorescent-colored acetate to make them easier to locate when placed on the drawing surface.

In addition to the standard 30°/60° and 45° kind, you might consider getting one that adjusts to any desired angle from 0° to 90° by means of a built-in protractorlike arrangement. However, that's a luxury item that can be deferred until a later time.

Drafting Instruments

Where mechanical precision in lettering or design is called for, certain instruments usually associated with drafting techniques will come in handy. Among these are a ruling pen and a compass.

Ruling Pen. This is a precision tool for ruling mechanically perfect lines in ink or paint. It con-

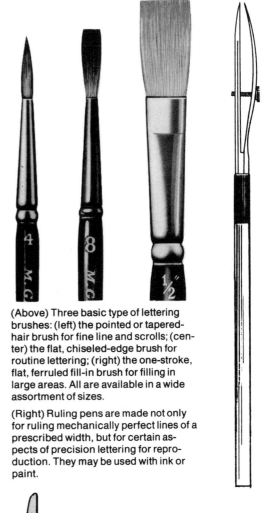

(Above) Three basic type of lettering brushes: (left) the pointed or tapered-hair brush for fine line and scrolls; (center) the flat, chiseled-edge brush for routine lettering; (right) the one-stroke, flat, ferruled fill-in brush for filling in large areas. All are available in a wide assortment of sizes.

(Right) Ruling pens are made not only for ruling mechanically perfect lines of a prescribed width, but for certain aspects of precision lettering for reproduction. They may be used with ink or paint.

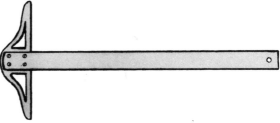

A T-square can be of wood, metal, or plastic. The most important requisite is that it be absolutely true and square and that the head be firmly fastened to the blade.

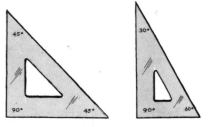

Triangles, 30°–60° and 45° are available in both opaque metal and transparent plastic.

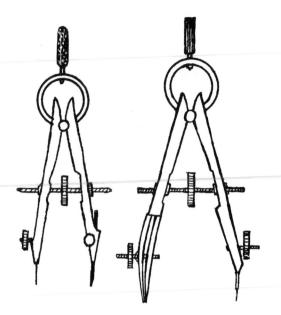

(Above left) Pencil compasses come in various types and sizes. The span of the desired radius is controlled by the little turn wheel. (Above right) Ink compasses are essentially the same as pencil compasses except they have a double-prong ink unit for ink or paint.

A mat knife is serviceable for cutting paper as well as heavy cardboard. The blade which can be sharpened when necessary is removable so that a new blade may be inserted in the grip handle.

sists of two fine-pointed steel prongs affixed to a handle. By turning a little knob attached to one of the prongs, the distance between them can be increased or decreased to give you the thickness of stroke you want. In use, the space between the prongs is filled with ink (or free-flowing paint) and the pen moved across the drawing surface, guided along a straightedge. There are fountain-type ruling pens sold under such trade names as Rapidograph and Osmiroid, that can be used for both ruling and lettering. They come with nibs of various sizes depending upon the thickness of the line desired.

Compass. All of us are familiar with the simple pencil compass commonly sold in stationery stores. There are times when such a compass can be serviceable. However, to do professional work, a draftsman's precision compass is needed. Of the many styles to choose from, you might consider getting a "combination compass" with separate attachments, making it possible to use the compass not only for drawing circles in pencil, ink, and paint, but as a pair of dividers as well.

Various other compasses with extension bars are made for drawing oversized circles.

Cutting Tools

While a pair of scissors can be used to cut some types of poster stock to the dimensions or shape required, better and faster results are achievable with a sharp razor blade, mat-knife, or paper cutter.

Razor Blade. For trimming paper, cardboard, and other lightweight stock, a single-edge razor blade does the job well, especially if it's enclosed in a blade holder for a firmer grip. The holder also helps prevent accidental finger cuts.

Mat Knife. It's possible to cut heavy cardboard stock with a razor blade by making repeated cuts to penetrate the board. A more professional way to do it is with a studio mat knife. This consists of a barrel-shaped handle holding a 4″ changeable blade that protrudes about 1½″ beyond the handle. The blade, made of high-quality carbon steel, keeps its edge for many cuts. An Arkansas stone (a small marble-surfaced honing slab) helps keep the blade sharp.

Paper Cutter. Busy commercial studios specializing in the production of posters, showcards, and displays often find a need for faster cutting facilities than are practical with razor blade or mat knife. Here, cutting is generally done with a "guillotine" type paper cutter by which any stock (thin or thick) can be cut with one down-

ward stroke of the blade. Paper cutters come in a variety of sizes, the smaller of which are portable. A good paper cutter is equipped with a built-in self-measuring ruler, a safety spring attachment to keep the blade handle raised when not in use, and a clamp-down crossbar to prevent the stock from shifting while being cut.

Rubber Cement

This is the artist's standby for general paste-up work, mounting, and laminating. Unlike water-soluble glue and paste, rubber cement doesn't curl the surface to which it is applied nor does it require weights or time to set. It's available in half-pint and pint jars and larger quantities as well. Standard rubber cement is combustible. A nonflammable type is available for school and home use.

Masking Tape and Tacks

If you want to keep your drawing board or table-top free from puncture holes—as indeed you should—provide yourself with a roll of masking tape. Should you, for whatever reason, prefer tacks, get the "pushpin" kind. They are easier to insert and pull out than ordinary thumbtacks and can be used more than once.

Cardboard and Paper Stock

Practically speaking, you won't need specific paper stock in quantity until you know what kind of poster job you'll be working on and how many posters will be required. You will, however, need paper to work with initially while composing, laying out, and pasting up your design.

Tracing Paper. Tracing paper has always been a standard item for tracing as well as for layout work. There are numerous brand names on the market, each with a wide assortment of sizes and quality of paper with differing degrees of transparency and weight. In time, you'll no doubt become partial to one brand over another, as in the case of everything else that will make up your working inventory of supplies. Experience will be the best guide.

Newsprint Paper. White newsprint paper packaged in sheets and pad form (in a variety of sizes) is perhaps the least expensive of all paper stock. Newsprint paper provides a receptive work surface for preliminary sketching, layouts, and some types of window posters.

Colored Paper. Colored paper, which comes in a variety of surfaces and an enormous assortment of colors, is an easy medium to work with while

Rubber cement has replaced "library paste" in most routine pasting jobs. It dries almost instantly and requires no weight or time to set.

composing the poster. It's readily mountable on cardboard with rubber cement, thus making it unnecessary to paint large areas by hand. In fact, an entire poster—lettering, pictorial matter, and all—can be made with colored paper exclusively. An inexpensive type of colored paper, sold as *construction paper*, is obtainable in stationery stores as well as art supply stores.

Illustration Board. Because it's rigid and not subject to warping or curling, illustration board is the best stock you can select for poster work. It provides an excellent surface for any color medium and allows for easy erasing during the initial stages of sketching in the layout. Illustration board comes in several standard thickness: *single thick* (1⁄16″); *double thick* (1⁄8″); *triple thick* (3⁄16″). There is a choice of three surfaces: *hot-pressed* (plate finish), which is very smooth; *cold-pressed*, which is vellumlike and slightly grained; *coarse*, which has a somewhat textured surface. The cold-pressed and coarse are generally recommended for brushwork, pastel, and charcoal drawing, while the hot-pressed is best suited for pen-and-ink work. Popular sizes are 15″ x 20″, 20″ x 30″, and 30″ x 40″. Colors are predominately whites, although some of the art supply dealers also carry a light gray.

Bristol Board. This type of board has the same working qualities as illustration board but is much thinner and more flexible. The thickness of bristol board is measured in ply; the ply indicates the number of sheets laminated together. Bristol board is usually white and can be used on both sides.

Poster paints, put up in jars and tubes, are available in a wide variety of colors. Most lettering and poster artists prefer jar colors.

India ink, jet black in color, is meant for pen and ink illustration as well as for ruling pen work to render lettering for reproduction.

Showcard Board. Less expensive than illustration board, showcard board comes in a number of colors including gold, silver, and fluorescent. Standard-size sheets are 28″ x 44″ and 40″ x 60″. For all practical purposes, this stock meets the requirements for general showcard work, window posters, bulletin-board announcements, price tickets, etc.

Foam-core Board. Where a combination of rigidity and structural strength is required with a minimum of weight, foam-core board is suggested. This type of board has a white, smooth working surface that takes pen and brushwork exceedingly well. Foam-core board can be purchased in sheets up to 48″ x 90″. Though 3/16″ thick, it cuts surprisingly easily with razor blade or mat knife and folds and scores without difficulty. For these and other reasons, foam-core has become a favorite with designers of large-size posters, window displays, and exhibit backgrounds.

Mat Board. Intended mainly for mounting and matting artwork, mat board possesses a soft-textured surface which sets off the artwork to good advantage when framed. It's obtainable in several thicknesses and in a good selection of interesting colors.

Corrugated Board. Rigid corrugated board has many commercial applications in the poster and display field. It's used mostly for three-dimensional counter displays, self-service floorstands, and jumbo-size die-cut posters. Because it can be made to fold easily and is lightweight, it's reserved mostly for display material that is to be packed in "knocked-down" format.

Sign Paper. Also called "banner" paper, sign paper is the preferred working surface for temporary paper signs, banners, and announcements mounted inside store windows. Lettering on sign paper is done with oil-based sign painter's colors or felt-tip markers, otherwise the paper (which is not waterproof) tends to pucker and wrinkle. Sign paper is sold in both sheets and rolls, but when large quantities are needed, it's more economical to purchase it in roll form. White in color and semitransparent, it can be used for tracing as well as for paper signs meant for indoor display.

Paints and Inks

The subject of paints and other color media is broad enough in scope to require a chapter by itself. You'll find a rather complete description of this phase of your inventory of supplies in Part Two, Chapter 8.

3 Setting up for work

The space you allot for your studio and storage of art supplies will naturally depend on available facilities and the amount of work you have lined up or anticipate in the near future. Whether you set up to do your artwork in your basement, in a corner of a room or in a "dream studio" blueprinted to your specifications, it's functionally important that your work area be kept clean and unobstructed by any encumbrances which may physically or emotionally get in your way.

Organizing Your Work Area

1. Arrange your setup so that your worktable is free from anything that's not directly related to the project on hand.

2. Keep cardboard and paper stock stored flat on a shelf, covered to keep it free from dust.

3. Arrange your inventory of paints, brushes, and auxiliary material so that you can see at a glance what you have available. Don't attempt to conserve space by stacking one thing behind another; the likelihood is that you'll forget what's hidden away and trek off to the art supply store to purchase material you may already have among your supplies.

4. Allocate a definite space for T-squares, rulers, and triangles. If possible, each should hang on its own peg or nail to be easily accessible.

5. Adjust your source of illumination or position of working (whichever is more feasible) to avoid annoying shadows. Whenever possible, plan your schedule to work under normal daylight conditions. You'll find it more pleasant and less fatiguing on the eyes.

6. The assumption is that you'll sit at your work. Adjust the height of the seat (stool or chair) to permit you to look downward at your artwork, rather than obliquely. An oblique view tends to distort normal perspective.

7. Organize your art reference files so that what you're looking for is easy to find and readily accessible. This can be done by systematically in-dexing your material according to specific subject matter and related categories. For example: in filing a picture clipping of a race horse, you may decide to put it under one of several possible categories—animals, horses, sports, or any other logical category. The original clipping may be placed in one of these; in the other files you may insert either a rough tracing or an inexpensive photocopy of it. In each of these files jot down a memo stating in what specific file the original clipping is to be found. In this way the same item can be simultaneously represented under several headings and yet the original material will always be easy to locate.

Care and Use of Art Supplies

Art supplies properly used and taken care of will last much longer than those that are abused or left dirty or without lids or covers. Here are some tips on how to prolong the life of your art supplies.

Paints. Poster color, made specifically for brush lettering and poster work, belongs in the general category of water-based paints. Exposed to air, poster color gradually thickens and loses its creamy consistency. To restore it to its original condition, add a few drops of water and mix thoroughly.

A jar of poster color left with the cover off for an extended period of time may dry up—often beyond redemption. So, to prolong its shelf life, make it a practice always to cover the jar tightly after use. To be sure the cover will fit, keep the rim of the jar clean and free from accumulation of paint.

Brushes. Good brushes are costly, but not in the long run. Properly taken care of, they can last a lifetime. To function well, a brush must be kept scrupulously clean, free from any trace of dried paint. The best brush you can buy will in time become useless if you're neglectful in this matter. Since most of the paints you'll be using for poster work will be water soluble, all that's required to keep a brush in shipshape working order is a thorough rinse with ordinary tap water

immediately after you're finished using it. There's no need to dry the brush; it will dry by itself in a short time.

At no time should you stand a lettering brush—or for that matter, any brush—with the hair side down. This is sure to irreparably ruin the hair's natural flexibility. For extended storage, keep your brush collection in a closed container of a size big enough to avoid cramming the delicate hairs. Add a few sprinkles of camphor flakes to prevent possible moth damage during the summer months.

Lettering Pens. Lettering pens are easy to maintain. With normal care and a thorough rinse with water after use, they give lasting service. Dried ink accumulated on the pen because of improper cleaning will corrode the metal due to the acidity found in most drawing inks. The nib becomes scratchy and unfit for the work for which it was intended. A steel penpoint cleaned the way it should be will glisten in its natural metallic luster. And that's the condition in which all pens should be stored when not in use.

Drafting Instruments. What has been said about the importance of keeping penpoints clean applies to ruling pens and ink compasses as well—perhaps more so. A good ruling pen or precision ink compass represents an investment of at least ten times that of a lettering pen.

A note of precaution is in order: if the finely shaped prongs of a ruling pen or an ink compass become nicked or blunted due to mishandling or accident they are almost impossible to put back into shape. What an exasperating experience it is to work with a damaged instrument!

Felt-tip Markers. If you work with felt-tip markers, you should be alerted to the fact that they dry up surprisingly fast if left uncapped even for a short period. To be sure of maximum freshness and fluidity, always replace the caps immediately after using the pens. When purchasing felt-tip markers, here's something to bear in mind: markers that have been on the display rack or in storage for a long time often dry up and are not fit for use. Don't hesitate to try out the markers in the store where you purchase them.

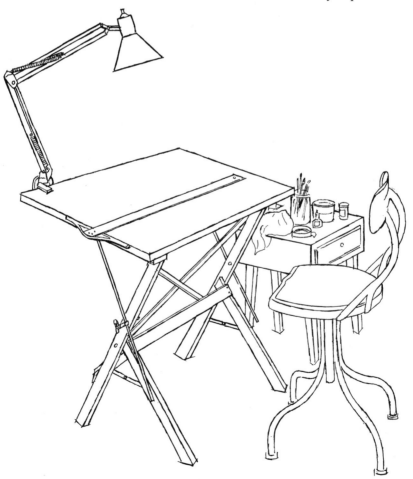

Professional studio setup with drawing table, floating arm lamp, stool, and taboret for art supplies.

4 Improving your lettering skill

"If you can write well, you can letter well" has the ring of an axiom, but it's not necessarily so. It has never been proven that there's a direct relationship between normal handwriting and potential skill in lettering. So, if you don't write beautifully, don't dispair. Proficiency in the art of lettering is developed mainly through training and disciplined practice.

Lettering is a skill that is basic for all poster work. Conceivably, an effective poster can be designed without the embellishment of any pictorial element but hardly ever without lettering. In this chapter you'll find a number of progressively arranged exercises calculated to improve your ability to handle the lettering brush—the tool most frequently used for freehand lettering. These exercises are planned to guide you in the construction of all letters of a fundamental alphabet, stroke by stroke, letter by letter. Practice these with a #8 or #10 (medium length) showcard brush and black poster color. Black is best since the results of your efforts will by contrast be more easily distinguishable against white paper. After you've become a bit more confident with the showcard brush, dexterity in handling pens and other lettering tools will be comparatively easy to acquire.

Classification of Alphabets

Before proceeding with the series of freehand lettering exercises, it will be helpful to briefly highlight some of the terminology used to classify all alphabet styles.

ROMAN

Roman. This family of alphabets is derived from the stone-chiseled inscriptions found on architectural structures of ancient Rome. The Roman alphabet, now as then, is characterized by delicately shaped upright letters made with thick-and-thin strokes and spurred endings.

EGYPTIAN

Egyptian. Originated in the early part of the 19th century, Egyptian is a modification of the Roman alphabet style—with somewhat greater uniformity in thickness of stroke—and is generally characterized by prominent squared-off serifs.

GOTHIC

Gothic. These alphabet styles are usually of uniform thickness throughout, with little or no variation in width of stroke. They are generally devoid of serifs or spurred endings. Gothic alphabets are likely to be simple and bold in structure and make up in visual impact what they may lack in esthetic refinement. Traditionally, they are the choice for posters and commercial sign work.

𝕿𝖊𝖝𝖙

Text. Stemming from German manuscripts of the Middle Ages, text alphabets are comparatively ornate, as best exemplified by the Old English and semicalligraphic styles seen so often on proclamations and diplomas. Many text alphabets combine well-modulated, massive main strokes with fine hairline embellishments. Text alphabets lend themselves best for work with a broad-nibbed pen, chisel-edged brush, or flat felt-tip marker.

ITALIC

Italic. Practically any upright alphabet style can be converted to italics if made to slant forward. The word *italic* is derived from lettering styles developed and brought to perfection in Italy by early scribes. Today, italic lettering is employed mostly to give special emphasis to a word or phrase. Used excessively, italics become tiresome to read.

SANS SERIF

Sans Serif. Sans serif literally means "without serif." The term has special reference to alphabet styles which have no serifs or spurred endings.

Script

Script. This refers to free-flowing hand-lettered or typeface styles where letters forming words are linked by connecting strokes, as in normal handwriting. Script styles usually slant forward, somewhat like italics. Used discreetly, a well-chosen script adds a personal touch to a line of copy intended to serve as a focal point.

Procedure for Brush-Lettering Practice

Place a sheet of white paper (newsprint is fine) on the drawing board and with a T-square held horizontally against the side of the board, adjust the paper so that it lines up with the blade of the T-square. Then tape the paper down to the board.

With the T-square, pencil in as many 2″ wide horizontal columns as fit on the paper, allowing a ½″ or so space between columns. These serve as guidelines for the series of brushstroke exercises to follow.

Holding the Brush. Some advice on the various ways to hold the lettering brush is in order. One way is to grip the brush lightly, holding it almost vertically between the thumb and first two fingers. This permits great flexibility in moving the brush in all directions and makes it easy to get

crisp, clean stroke endings. Another way is a two-finger hold where the brush is gripped between the tip of the thumb and the side of the middle finger, allowing for a rolling movement of the brush when going around curves. A third way is to grip the brush between the thumb and the index finger. There is no common agreement as to which finger hold is "best." In the final analysis, it will be up to you to decide which seems to work best for you and which yields the best results.

Single-Thick Strokes. Start off the exercises with *vertical* strokes. Charge the brush with paint, palette it well on a scrap card to remove the excess and at the same time to get the hairs lined up to a flat, chiseled edge. (If you want round endings, the brush must be of somewhat longer hair, fully charged, and requires less paletting.) Then, starting at the top guideline, make a straight stroke downward to the bottom guideline, moving your entire arm—not just the wrist. Do another stroke, then another, until you fill up several columns or the entire sheet. Strive for uniformity in thickness of stroke. Hopefully each exercise stroke will show a noticeable improvement over the previous ones; otherwise there's not much point in merely filling the paper. Contrary to the oft-repeated adage, practice does *not* make perfect. Perfection comes only if you analyze the results of your practice and make a conscientious effort to improve as you go along.

And now for *diagonal* strokes. Start with the slant that leans toward the right. Again, begin your stroke at the upper guideline and move your entire arm diagonally until you reach the bottom guideline. As in the previous exercise, strive for uniformity in thickness of stroke. Try to keep strokes parallel and at a consistent angle. Do as many strokes as space permits. If you're ambitious, devote an entire practice sheet to this exercise, as well as to the next, which consists of diagonals slanting in the opposite direction.

Here are a few checkpoints to help you evaluate your efforts so far:

1. Do all strokes contact top and bottom guidelines exactly, or do they start and finish haphazardly?

2. Are the vertical strokes uniformly perpendicular, or do some tend to lean over? Occasionally check with your T-square.

3. Are the stroke endings consistent?

4. Do the diagonal strokes slant the same way?

Next, practice *horizontal* strokes such as those that occur in the letters E, F, H, L, T, etc. Hori-

zontal strokes are made from left to right with the brush held in the direction of the stroke. For uniformity in stroke thickness, move your arm evenly across with unvarying pressure. It's helpful to mark off vertical pencil lines about 2" apart with ½" space between. In this way all horizontal strokes will be the same length.

Round stroke exercises come next. These are a bit more challenging. When doing round strokes, best results are achieved if the brush is held almost upright and twirled between the fingers so that the chisel part of the brush as it turns follows the constantly changing perimeter of the curve. If the brush is not twirled, the strokes will vary in thickness. Start off with a series of half-circles facing left, as in the letter C. Follow up with half-circles going the other way. Then experiment with combining both to form complete circles. Initially, you may wish to use a compassed pencil outline as a guide, but later on brush in the circles freehand. When you've completed the prescribed exercises, devise a few of your own to develop dexterity in making compound curves such as occur in the **letter S and** figure 8.

The hardest part is over when you've mastered the basic brushstrokes. The actual letters of the alphabet, formed by combining the various strokes, should be comparatively easy—and much more interesting. You're now ready to put this assertion to the test by tackling all the letters of the uppercase alphabet from A to Z, following the model shown on page 27. You'll note that the sequence and changing directions of the strokes comprising each letter are indicated by numbers and arrows to guide you along the way.

To do the lowercase letters, pencil in four parallel guidelines. The top line marks the height of the ascenders, such as in the letters b, d, f; the two center lines are for the main body of the letters; the bottom line is for the descenders, such as in the letters g, j, p. The traditional practice sentence, which includes every letter of the alphabet, is: "The quick brown fox jumps over the lazy dog."

Mention has been made here of the terms *uppercase* and *lowercase* without stopping to define them, in the belief that everyone knows what these signify and how they originated. In the event this assumption is not fully justified, the term *uppercase* has reference to the capital letters of the alphabet. This goes back to the early days of typesetting when capital letters were kept in the upper case of the printer's type cabinet. The small letters, which we refer to as *lowercase*, are so called because they were kept in the lower case of the cabinet. Although today both capital and lowercase letters are kept in

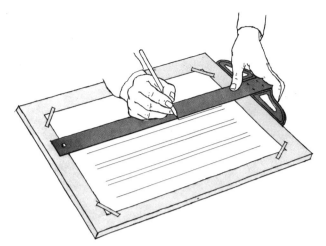

Proper way of holding T-square, butted flush against the edge of the drawing board. This illustration shows the procedure for ruling sets of parallel lines for practice work.

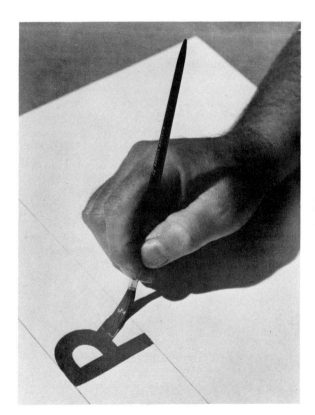

One of several methods of holding the lettering brush. In all cases, best results are achieved if the brush is kept in an almost vertical position in relation to the lettering surface.

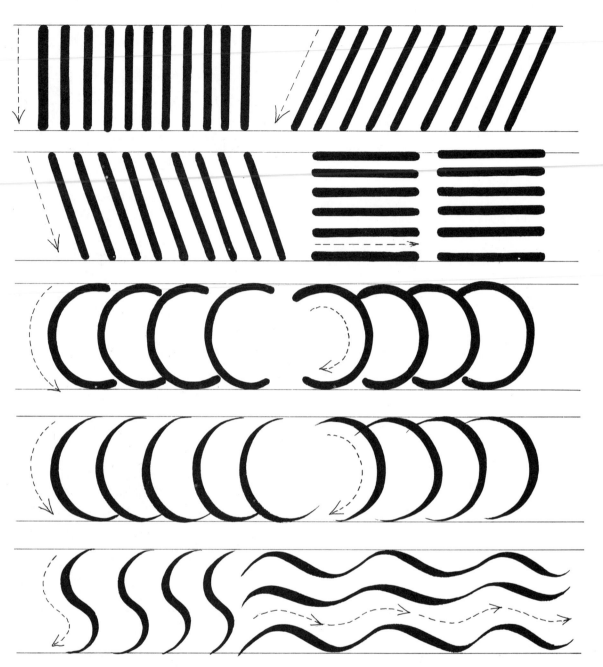

Suggested series of exercises to develop dexterity in handling the brush in freehand lettering.

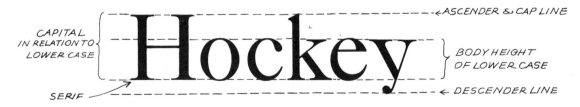

Simple terminology on the various aspects of letter construction.

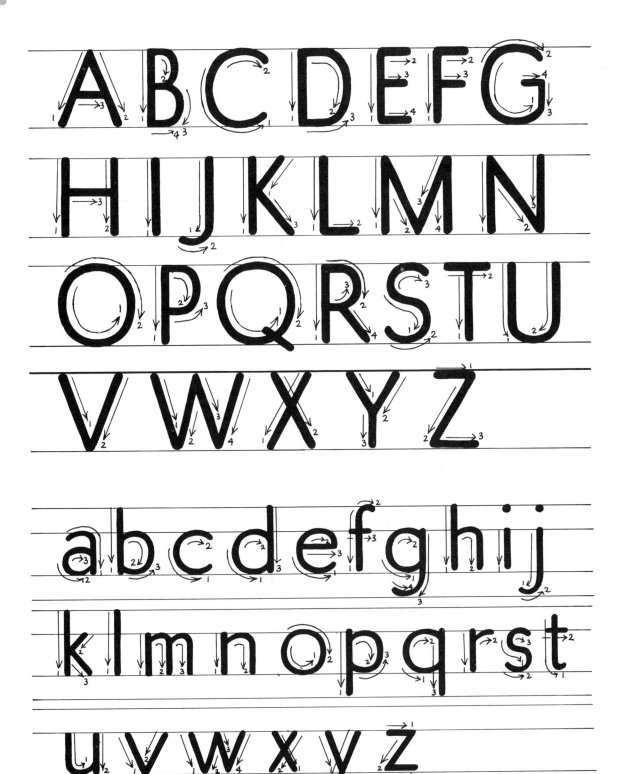

Fundamental one-stroke brush alphabet showing sequence and direction of strokes.

different compartments of the same case, the early distinction in terminology persists.

Thick-and-Thin Strokes. For doing thick-and-thin strokes (characteristic of all Roman alphabet styles), follow the same practice routine as for single-thick strokes but with some modifications. This time, *do not* twirl the brush between the fingers, but hold it rather firmly, as you would a pen. Think of the chisel-edged hair of the showcard brush as the broad nib of a pen. For thin strokes use the *side* of the chisel; for thick strokes use the *width* of the chisel. To get finely accented weights around curves, try to adjust the pressure of the brush so that you bear down more and more as you approach the center of the curve; then lighten the pressure gradually as you come nearer to completing the curve. A short-haired, well-paletted, chiseled-edge brush makes it easier to get a marked variation in control of stroke thickness.

Pen Lettering Practice

Although the brush is the basic lettering tool, there are occasions where pens serve the purpose best. Experience in pen work will stand you in good stead for work on showcards and wherever there is too much copy or the lettering is too minuscule to render with a brush.

As with brush lettering, learning how to letter with a pen requires disciplined practice. Most people, however, find the pen easier to handle because they are accustomed to using a pen in normal handwriting and also because the pen affords a more solid point of contact between the lettering instrument and the paper.

Lettering pens of the Speedball type are classified by the shape and size of the nib. For initial practice, the B-2 (round tip) Speedball pen is suggested for single-thick Gothic alphabets; the C-2 (oblong tip) for thick-and-thin Roman alphabets. The best practice surface for pen work is smooth paper or bristol board. Black India ink is the recommended medium. The position for holding the pen is a matter of personal choice; hold it any way that seems comfortable to you.

Single-Thick Strokes. Square your paper on the drawing board as usual. Then pencil in sets of guidelines. Pour a small quantity of ink into a shallow dish or coaster so that you won't have to dip the pen into the narrow-necked bottle each time you recharge it. Tape down a scrap of paper or board next to the practice sheet to serve as a scratch sheet; then proceed with the exercise strokes: vertical, slanted, horizontal, and round. Later on, do the individual letters of the alphabet followed by words, phrases, and sentences.

The "B" series pen works equally well in any direction, producing a line of uniform thickness with round stroke endings regardless of slight variations in pressure. To keep the pen in top working condition, periodically rinse it in water, then wipe it dry with a soft cloth and continue with your practice.

Thick-and-Thin Strokes. Follow the same routine outlined for practicing single-thick strokes—square the paper on the drawing board, rule in guidelines, etc.—but this time you'll be working with the "C" series pen. Held sideways, the nib produces a thin line—broadside, the line is of maximum thickness. By proper manipulation of the pen, the width of the stroke can be modulated from fine to broad to give accented weight to the letter form. In some ways, the "C" series pen works like the old-fashioned steel-point writing pen long associated with classic Spencerian penmanship.

Built-up Lettering

So far we have been dealing with the so-called one-stroke lettering technique suited for simple posters, casual showcards, and the like. In the one-stroke technique, each element of the letterform is made with one deft stroke of the lettering tool without additional strokes for accented thickness. For more finished poster work or for large-size alphabets that cannot be handled expeditiously with pen or brush in a one-stroke technique, the letters are best rendered in "built-up" style. This calls for a more careful shaping of the letters with as many strokes as are necessary to achieve the desired variations in thickness and structural refinements.

To do lettering by the built-up technique, it's helpful to first pencil in the complete structure of the letter in outline form. Next, carefully go over the pencil outline with ink or paint, as the case may be. Then fill in. Finally, touch up where necessary to achieve the degree of perfection you're aiming for.

The letters of many of the model alphabets shown in the chapter which follows are rendered in the built-up technique, as is nearly all lettering shown on the selected posters interspersed throughout the book.

A Word About Spacing

When you become proficient at forming the individual letters of the alphabet, you can turn your attention to learning how to space them correctly in words and sentences. Spacing would present no particular problem if all letters of the alphabet were exactly the same width. Spaces

between letters could then be measured off mechanically—all alike. However, as you know, there is conspicuous variance in the width of the letters. Also, some letters are structurally more closed-in than others. For example, the letter M is wide and closed on both sides, while the letter T is of medium width and open on both sides. The letter J, a comparatively narrow letter, can be said to be open on one side.

Traditionally, good spacing calls for positioning adjacent letters to equalize the open space between them. To better understand the concept of spacing, imagine the area between letters filled with free-flowing sand. In a well-spaced word, the amount of sand between letters will seem to be fairly equally distributed throughout. Don't be overly concerned about spacing at first. As you gain experience in the art of lettering, good spacing will come about naturally as in normal handwriting.

There are so many alphabet styles in use today, it would take a book of encyclopedic proportions just to list them. This would include hundreds of time-honored printers' typefaces and an ever-mounting inventory of thousands of hand-lettered alphabets designed specifically for photo-composition and transfer lettering firms serving the varied needs of the advertising industry.

When it comes to alphabet styles, poster artists tend to have their own personal favorites, limiting their choice largely to alphabets that are bold and easy to read. The choice of poster alphabets is further limited to a great extent to uppercase letters. It has been found through scientific studies that for poster work uppercase letters have greater visual impact than lower case, especially if the posters are to be viewed at a distance or at a passing glance.

The model alphabets (both hand-lettered and printers' typefaces) featured in this chapter are shown mostly in uppercase and have been selected for their particular adaptability to poster work. Use them freely. Duplicate or modify them as you wish to suit your requirements and ability. Among them you may find your own favorites, or you may be inspired to evolve alphabet styles that are entirely of your own creation.

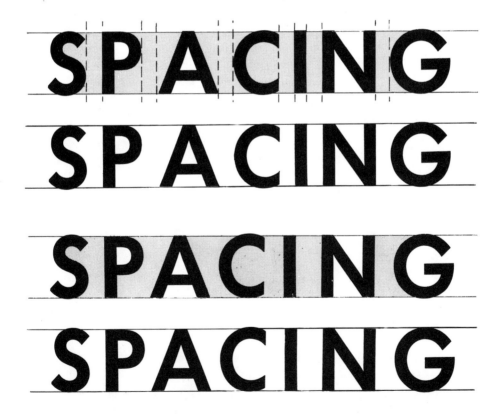

Spacing is mostly a matter of esthetic rather than mechanical determination. (Above) Poor spacing results when each letter is "boxed in" with the same space separating each letter in a word. (Below) Good spacing depends upon the construction of each letter form compared to the neighboring letters. In good spacing, the free space (shown here in gray) will appear about the same regardless of the letter construction.

ABCDEF GHIJKL MNOPQR STUVW XYZ&!

Cavanagh Balloon Italics. A practical italic alphabet for freehand lettering rendered with a brush fully charged with paint.

ABCDEFG
HIJKLMN
OPQRSTU
VWXYZ
abcdefghijklmn
opqrstuvwxyz

Brush Script. A standard typeface that lends itself admirably to brushwork, produced with a pointed or well-paletted chiseled-edge brush.

ABCDEF
GHIJKL
MNOPQ
RSTUV
WXYZ

1234567890

Newland. A lettering style that is ideally suited for poster work. Newland is a "natural" for lettering done with paper and scissors as well as with brush and paint.

ABCDEFG
HIJKLMN
OPQRSTU
VWXYZ

abcdef
ghijklmn
opqrstu
vwxyz

Folio Extra Bold. A powerful poster lettering style that may be done freehand in a built-up technique. A more careful rendering is achievable with the aid of a ruling pen and straightedge.

ABCDEFGH
IJKLMNO
PQRSTUV
WXYZ

ABCDEFGHI
JKLMNOPQRS
TUVWXYZ

(Above) **Davida.** A decorative alphabet suitable for many occasions. In spite of its apparent ornateness, it is a comparatively easy letter to render. (Below) **Futura.** A good example of a sans-serif lettering style with above-average legibility.

ABCDEFGHIJ
KLMNOPQRS
TUVWXYZ

abcdefghi
jklmnopqrs
tuvwxyz

1234567890

Lydian. An alphabet with strongly calligraphic characteristics, Lydian can be rendered with a broad-nibbed pen or flat, well-paletted brush.

ABCDE
FGHIJK
LMNOP
QRSTUV
WXYZ
1234
567890

Stencil. This alphabet is a good choice where a rough-hewn masculinity is to be conveyed. It is often seen on posters dealing with shipping or matters of urgency or danger.

ABCDEFGH
IJKLMNOPQ
RSTUVWXYZ
1234567890

ABCDEFGHIJ
KLMNOPQR
STUVWXYZ
1234567890

(Above) **Orbit Shaded.** An outline letter with a deep shadow to give it dimensionality, Orbit Shaded is especially effective when a color is applied within the outlines. (Below) **Circus.** This a casual freehand alphabet made more interesting with an inline within the letter form. The inline may be in white or any color that combines well with the body of the letter.

Sapphire. This is an alphabet that goes well where a decorative sparkle embellishment is needed.

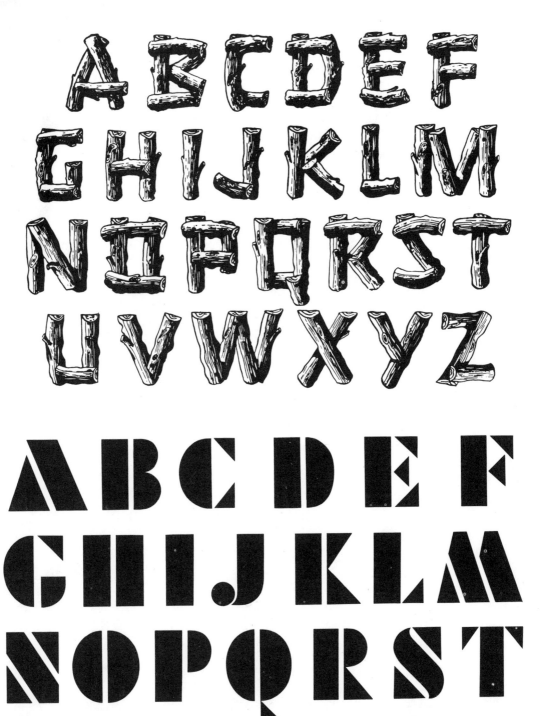

(Above) **Logwood.** A rustic lettering style that is somewhat laborious to render, but where time and occasion warrant it, you may enjoy doing this style—or a modification of it. (Below) **Futura Black.** A lettering style based largely on geometric shapes, Futura Black is devoid of connecting lines or serifs of any kind. It is best rendered with mechanical instruments.

ABCDEFGHIJ
KLMNOPQRS
TUVWXYZ

ABCDEF
GHIJKLM
NOPQRST
UVWXYZ

(Above) **Playbill.** An alphabet with an Old World flavor, Playbill is characterized by strong squared-off serifs and a condensed form, with most letters occupying the same width. (Below) **Broadway.** This is a freehand version of Broadway, a lettering style that combines power and grace with dramatic contrast between the thick and thin strokes.

It's a Majestic Fashion

Someone is Calling You

Sparkle for your Boudoir

Centuries of Hospitality

Be Elegant in Calfskin

From a snow queen for

New Symbols of Efficiency

Finest California Wines

Stewart Dry Goods Co.

Buy a Crown for Mother

Toiletries for Gentlemen

Television today and

How about Slacks?

A Christmas Holiday

The First National Hook-up

Lisbeth's holiday glamour

New Holiday Salads

Selling the ladies is not easy

Beloved by brides for

Nylon and Cordura

Birthday Specials on

Just in for Christmas

Blossom Deodorant Cream

the "Good Old Tunes"

A sampling of script styles for brush or pen.

ABCDEFGHIJK
LMNOPQRSTU
VWXYZ1234567890

abcdefghijklmnopqr
stuvwxyz ?:;""α!

The quick brown fox jumps
over the lazy dog :

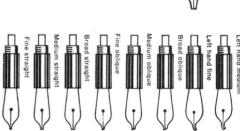

pack my box with five dozen liquor jugs

Italic calligraphic lettering that combines the natural spontaneity of handwriting and the discipline of formal lettering.

6 Special lettering styles

Designing with letter forms offers many opportunities for creative expression. The experience may also lead to a better appreciation of the art of calligraphy, an appreciation of how letters can be made to illustrate special effects, and an understanding of how personal monograms are conceived and designed.

Calligraphy

As an esthetic blend between handwriting and formal lettering, calligraphy offers tempting opportunities for creative expression and experimentation. It holds such fascination for its many enthusiasts that it has become common practice among them to correspond with each other in calligraphic style, shunning the typewriter completely—at least in the interchange of personal letters and cards. Not that calligraphy is without its more practical applications. It can be used effectively for posters dealing with religious and cultural themes, as well as for diplomas, social invitations, placecards, personalized book labels, etc. There are occasions when calligraphy serves as a good substitute for traditional Old English lettering—which incidentally is more difficult to read and more time-consuming to render.

The examples shown here are intended primarily to acquaint you with the general approach to calligraphy and not as models to slavishly trace or copy. Calligraphy thrives on variation. No two calligraphers work alike, and for that matter, no one calligrapher works the same way all the time with the same results. Calligraphy lends itself best to pen-and-ink rendering, but it can also be rendered—especially in large size—with chiseled-edge brush or felt-tip marker. Whether by pen, brush, or other tool, calligraphy permits almost unlimited flexibility and opportunity for improvisation.

No fixed rules can be laid down about practicing calligraphic lettering, but here are some helpful pointers:

1. Sit comfortably with both feet on the ground. Crossing your legs languidly tends to unbalance your working position.

2. Tilt your drawing board to a fairly steep angle, with your seat adjusted to a convenient height.

3. Hold the paper about 10″ to 12″ away from you to get the best viewpoint.

4. See to it that the paper is kept parallel to the drawing board. It may be moved up or down or side to side but it should always be in a position parallel to the board.

5. Try holding the pen lightly between the thumb and forefinger, and at a slight angle. If this doesn't work for you, experiment with other ways until you feel comfortable—and with gratifying results to prove it.

6. One more bit of advice: practice, practice, practice.

Calligraphic lettering may be done in upper case only, or upper and lower case combined; completely upright, or on a slant in the manner of italic lettering. In forming words, the letters may be joined or separated—it's all a matter of what looks best to you.

Illustrative and Special-Effect Lettering

The letters of a word can be artfully designed to suggest a given concept. Words such as *speed, fire, ice,* and *smoke* which evoke strong visual concepts are inherently adaptable to pictorial treatments. By way of example, let's see how the word *speed* might be pictorialized in graphic form.

The individual letters comprising the word are first carefully outlined in pencil, then filled in with paint or ink using the built-up technique. To carry out the illusion of speed and emphasize the forward thrust implied in the word, the letters are made to lean heavily forward as if being pushed by a strong wind. The feeling of speed can be further dramatized by a number of rapid dashlike strokes entering the letters at the left and going partly into them, as shown on page 49.

Generally, in all pictorial lettering of this sort, it's best to first draw the letters in traditional form and then modify them with appropriate embellishments or effects, whatever they may

be. The lettering may be rendered in black and white or in color and in any appropriate alphabet style.

How would you picture words such as:

Ghost	Cracked
Lightning	Shaggy
Antique	Skinny
Rain	Glitter
Air Mail	Soft

Better still, why not put down some of your concepts on paper and see how they work out in graphic form?

Illustrative and special-effect lettering has a fascination for those with a dramatic turn of mind. You will no doubt derive great personal satisfaction in creating your own lettering effects for use on posters and showcards, greeting cards, and book covers.

ABCDEFGH IJKLMNO PQRSTUV WXYZ

abcdefghijklmno pqrstuvwxyz

1234567890

A comparatively easy-to-do pen lettering alphabet with a strong calligraphic flavor. It is suitable for diplomas and proclamations, as well as general announcements.

ABCDEFGHIJ
KLMNOPQR
STUVWXYZ&

abcdefghijklmno
pqrstuvwxyz

abcdefghijklmn
opqrstuvwxyz

The fine and medium nib units can be used for

informal writing or delicate lettering

Calligraphic lettering using nibs of different sizes to match the size of the lettering.

Electrostatic Printing Corporation
cordially extends an

With pleasure we announce the continuation of our Annual Scholarship program as our gesture of Holiday Spirit·This award covers the tuition cost for one year for an art student selected by the Scholarship Committee of the Art Directors and Artists Club of San Francisco. ❋ We express our appreciation to you, our customers, who made this program possible, and extend to you our sincere Best Wishes for a Happy New Year.

to a limited showing of the
Model A
EPC process Web Printing Unit

February 15th and 16th
New York Trade Show Building
Five Hundred Eighth Avenue
New York City
from 10 a.m to 6 p.m.
RSVP

the
san francisco
story

for the convenience of the public, the banking hours of this office are 10 a.m. to 6 p.m. monday through friday.

Examples of calligraphic lettering rendered with a broad pen by Byron J. Macdonald, author of *Calligraphy*, published by the Pentalic Corporation, New York.

ABCDEFGHIJ KLMNOPQRS TUVWXYZ

abcdefghijklmnopqr stuvwx&yzz

Another example of the work by Byron J. Macdonald, suggesting a simplified version of Old English.

Love Sonnet

How do I love thee? Let me count the way.
I love thee to the depth and breadth
 and height
My soul can reach, when feeling out of sight
For the ends of Being and ideal Grace.
I love thee to the level of everyday's
Most quiet need, by sun and candle-light.
I love thee freely, as men strive for Right;
I love thee purely, as they turn from Praise.
I love thee with the passion put to use
In my old griefs, and with my childhood's faith
I love thee with a love I seemed to lose
With my lost saints, — I love thee with
breadth, smiles, tears, of all my life! — and
If God choose,
I shall but love thee better after death.

 Elizabeth B. Browning

What better way to letter a love sonnet than by calligraphy?

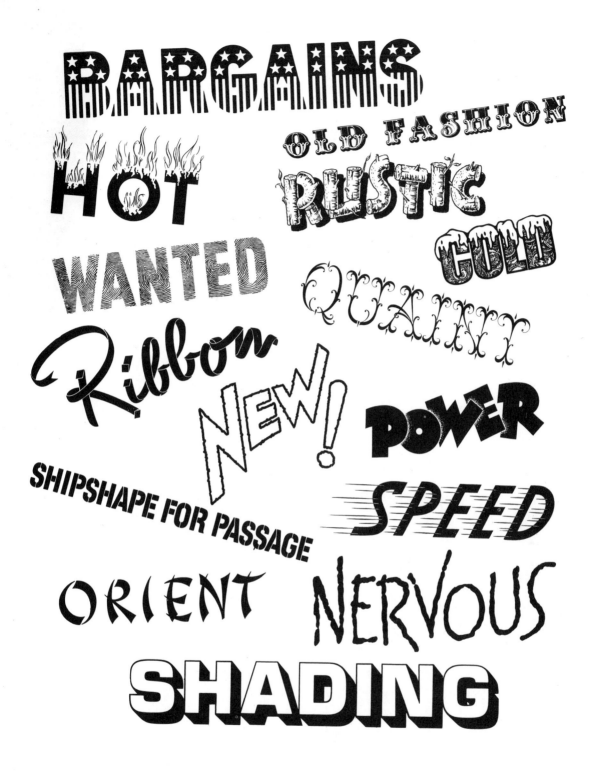

A mere sampling of what can be done with letter forms to convey a special effect.

Letter forms used as a central design motif.

7 Getting picture ideas

While it's true that not all posters require illustrative or decorative embellishment to be effective, a poster design can be appreciably enhanced with pictorial material.

Sources of Pictorial Material

The art of illustration is a distinct specialty. It calls for a thorough background in human and animal anatomy, life drawing, perspective, color, pictorial composition, and not least, a natural aptitude for drawing. If you have neither the formal training nor the inborn talent to feel sufficiently competent to create a suitable pictorial element for your poster, there is a variety of places where you can acquire resource material to help you along.

Libraries. Some of the larger libraries have extensive picture and photo collections on file, which can often be borrowed on the same basis as books. Take advantage of this service.

Magazines. Save selected picture material from magazines you personally subscribe to as well as from those your friends can contribute. In addition to the more popular newsstand magazines dealing with sports, gardening, health, fashion, motion pictures, etc., there are hundreds of trade and technical journals covering every industry and profession. Collectively, clippings from such publications can serve as a nucleus for an art reference file which reflects your current and projected needs relating to poster design.

Catalogs. Another valuable but often neglected source of reference for picture material is the voluminous and fully illustrated catalogs (old and new) distributed by Sears, Roebuck and other major direct-mail and department-store establishments.

Dictionaries. Authoritative reference material on the delineation of specific subjects, such as animals, birds, flowers, tools, flags of all nations, etc., can be found by thumbing through a copy of *Webster's Unabridged Dictionary* or a set of the *Encyclopaedia Brittanica*. Often, too, you can come across what you're looking for in the pages of children's encyclopedias, many of which are chockful of colorful and simplified drawings easily adaptable for poster work.

Travel Agencies. Visit your local travel agency for an excellent source of poster material. There are many colorful brochures and folders on the display rack free for the asking. Often, too, an obliging agent will let you have full-size travel posters he no longer needs or others he may be able to get for you. Travel posters, usually created by top artists, can serve as a source of inspiration for pictorial composition as well as for color, decorative motifs, and general design.

Clipping Services. Get to know the various professional services offered by picture archive and professional art-clipping firms. These firms carry virtually thousands of pictures, photos, and "spot" drawings covering every conceivable subject. You have the same privilege as professional artists in the field to purchase reference material to use outright or in modified form. In addition, you can avail yourself of a variety of pressure-sensitive graphic symbols available at art supply stores. Ask your art dealer for brochures showing samples.

Postcards and Color Slides. At a nominal price you can get picture postcards and color slides depicting major places of geographic interest in the United States and throughout the world. As "on-location" reference material, a collection of picture postcards and slides is the next best thing to making an actual trip.

Snapshots. Make use of the camera to record on-the-spot snapshots of places and things that can be added to your professional reference file.

Personal Sketchbook. And last, but not least, acquire the sketchbook habit. It can be enjoyable and prove to be most practical. To the best of your ability, fill the pages of your sketchbook (pocket-size is fine) with drawings of objects and scenes of particular interest to you. This will help immeasurably in upgrading your drawing ability and will add to your stock of original source material. The experience will also sharpen your

sense of perception and your visual retention—both of vital importance to any practicing artist.

With regard to reference material, it shouldn't be assumed that you're at liberty to indiscriminately make use of any and all picture material you find in publications and other sources and blatantly pass it off as your own creation. Plagiarism in the visual arts is no more conscionable than in music and literature.

The material in your clip file (except your own on-the-spot photos and sketches) is meant primarily for research, not for outright tracing or copying. However, there's no restriction on incorporating in your design a picture element on a poster if the poster is intended primarily to publicize a local bazaar, dance, or similar event sponsored by your club, school, or charity organization. Also, there's usually no legal restriction in making use of pictorial material purchased from various picture and photo archives or from books and old print collections considered in the public domain.

Thematic Design Symbols

Often the most vexing problem in planning a poster is deciding on a pictorial element that will best reflect the theme or message. If the poster is to advertise a specific commodity such as shoes, furniture, or flowers, there's no particular problem. You can merely employ an appropriate illustration or photo of the item advertised. What if the theme is to convey a concept not quite so simple to illustrate? In designing a travel poster, for example, what would symbolically best exemplify a given geographic location? To most of us geographic locations conjure up definite mental images. Thus, Holland is popularly associated with an image of windmills or wooden shoes. Interestingly enough, although there are few windmills in operation in Holland and wooden shoes are rarely worn nowadays, these have remained among the enduring symbols associated with that country. Similarly, certain fixed symbols are associated with Japan, the United States, and every major geographic location on the globe.

Abstract concepts like Brotherhood, Honesty, Power, etc., though far more challenging to symbolize pictorially, have likewise acquired popular associations with which they have become universally identified.

The following list, arranged by specific categories, is a sampling of symbolic associations to help in your search for ideas to illustrate the theme of your poster:

Abstract Concepts

Art. Artist's easel, palette, jar with art tools, Venus de Milo, tubes of paint, ornate gold frame.

Bargain. Price ticket cut in half, auction gavel.

Brotherhood. Hands clasped in friendship, interlocking links of chain.

Charity. Red Cross, heart, open hand.

Circus. Clown, drum, highwire performer, circus tent, balloon.

Clairvoyance. Crystal ball, signs of the Zodiac, turbaned fortune teller.

Cold. Ice cubes, penguin, frozen breath coming out of mouth of celestial body.

Danger. Red light, rubber stamp or stenciled lettering marked "Danger," skull and crossbones.

Direction. Compass, milestone, lighthouse, weathervane, pointing finger, arrow.

Education. Open book, Lamp of Knowledge, cap and gown, diploma, red apple, writing slate.

Endurance. Rock of Gibraltar, ancient architecture, old oak tree.

Heat. High point of thermometer, blazing sun, flame.

Honesty. Halo, angel's wings, Lamp of Diogenes, George Washington (humorously depicted chopping down cherry tree).

Hospitality. Welcome mat, open door, outstretched hand.

Justice. Gavel, Goddess of Justice, balanced scale, robed judge.

Largeness. Whale, high mountain, elephant.

Legal. Notary public seal, certificate or scroll, rubber stamp with "O.K.," "Approved."

Liberty. Statue of Liberty, Thomas Jefferson, Liberty Bell, flaming torch.

Love. Heart, Cupid, flowers, pair of doves.

Luck. Horseshoe, rabbit's foot.

Memory. String on finger, calendar with circled date, elephant.

Music. Lyre, musical note, piano keyboard, G-clef, harp.

Mystery. Black cat, gothic mansion, finger or footprint, spider, spyglass, flying bat.

Peace. Dove carrying olive branch, laurel wreath.

Performing Arts. Proscenium, spotlight, marquee lights, makeup table with light bulbs, masks of comedy and tragedy.

Power. Lion, eagle, flexed biceps, clenched fist, Atlas.

Predatory. Vulture, eagle, tiger, falcon, shark.

Privacy. Drawn window shade, "Don't Disturb" sign on doorknob, finger on lips, keyhole, label marked "Secret."

Rain. Open umbrella, falling raindrops.

Royalty. Crown and scepter, castle, throne.

Safety. Green traffic light, railroad signal.

Sea Travel. Life preserver, pilot's wheel, waves, seagull, gangplank, ship, Neptune, seahorse.

Slowness. Snail, turtle.

Space Exploration. Rocket, ring around Venus, moon and constellations.

Speed. Greyhound, bird in flight, rabbit, Mercury, Pegasus (flying horse).

Surprise. Jack-in-the-box, lighted bulb.

Thrift. Beehive, piggy bank, money bag, squirrel with nut.

Time. Hourglass, calendar, sundial, clock, Father Time.

Trouble. Black cat, eightball.

Vanity. Hand mirror, peacock, proud-necked swan.

Wealth. Treasure chest, dollar sign, stack of coins, money bag.

Wind. God of wind expelling blast of air, whirling fan.

Wisdom. Owl, graduation cap and gown.

Holidays and Special Events

Anniversary, Birthday. Cake with candles, marked calendar.

Chanukah. Menorah (8-stemmed candelabrum), stylized picture of the Maccabees.

Christmas. Santa Claus, Christmas tree, wreath and holly, toys, wrapped gift boxes, mistletoe.

Easter. Bunny, decorated egg, lily.

Fourth of July. Firecracker, flag, Liberty Bell.

Halloween. Witch on broomstick, pumpkin, skeleton, shrouded ghost.

Memorial Day. Gold star, armed services cap, flag, wreath on grave of soldier.

New Baby. Flying stork, diaper pin, milk bottle, rattle toy.

New Year's Eve. Champagne glasses, confetti, fun hat, urchin with ribbon around chest, calendar with date encircled.

St. Patrick's Day. Shamrock, green hat, clover leaf.

Thanksgiving. Turkey and hatchet, pilgrim, roasted turkey on plate.

St. Valentine's Day. Heart, flowers, giftwrapped box.

Yom Kippur. Bearded patriarch blowing ram's horn, Torah.

Seasons and Time of Day

Autumn. Falling leaves, Indian corn, pumpkin.

Winter. Falling snow, magnified view of snowflake, bare tree branches.

Spring. Daisy, fledgling bird chirping, Robin, worm coming out of ground.

Summer. Rays of sun, sunglasses, tree in full bloom.

Evening. Moon, stars.

Morning. Rays of sun, bird chirping, rooster crowing.

Miscellaneous

Announcement and Proclamation. Old-time town crier, sandwich man, megaphone, bugle, Paul Revere on horseback.

Auction. Gavel, old grandfather's clock, potbellied stove.

Business. Financial graph, stock-market report, dollar sign.

Color. Artist's palette, butterfly, rainbow, peacock, pot or tube of paint, brush with color.

Electioneering. Signs carried on sticks, flag-draped speaker's pedestal, flares, electioneering button.

Farming. Silo, red barn, pitchfork, tractor.

Fishing. Tackle, fishing rod, hooked fish, fisherman's net.

Fund Raising. Progress chart, giant thermometer, stack of coins, bar graph, clock.

Gardening. Watering can, flowers, garden tools.

Movies. Filmstrip, marquee lights, simplified movie camera, movie screen.

Parade. Large drum, majorette, balloons, confetti.

Photography. Simple camera, lens.

School. Little red schoolhouse, university building, books, diploma, cap and gown.

Toys. Building blocks, small drum, wooden soldier, hobby horse, rag doll.

Zoo. Panda, polar bear, giraffe, monkey cage, seal.

Understandably, the best specimens of art in your reference or clip file won't teach you how to draw creatively. If you've had no formal art training, you might consider subscribing to a good correspondence course to learn the rudiments of perspective, drawing from life and memory, and painting. There are a number of excellent correspondence courses to choose from, such as the one given by the Famous Artists Schools, Inc. of Westport, Connecticut. You might also give some thought to enrolling in a local evening school offering courses in commercial and fine art. As a student in a formal art class, you'll gain much from the personal guidance of the instructor, the dynamic interaction of your fellow students, and from group critiques and periodic student exhibits.

This and the following 8 pages show a sampling of pen-and-ink spots designed by illustrators for varied uses in advertising. There are a number of art clipping firms which service the advertising field with "spots" on a great variety of subjects.

SPECIAL

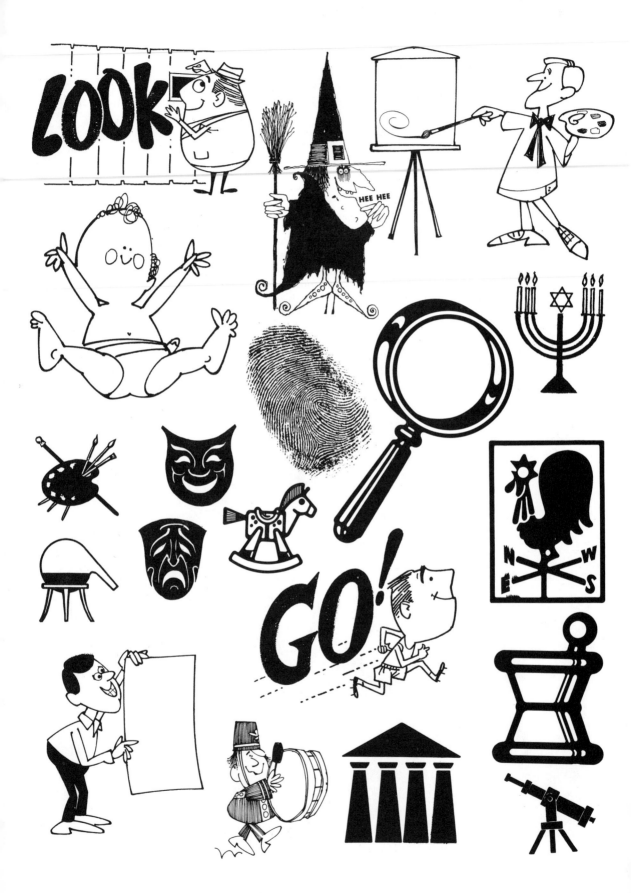

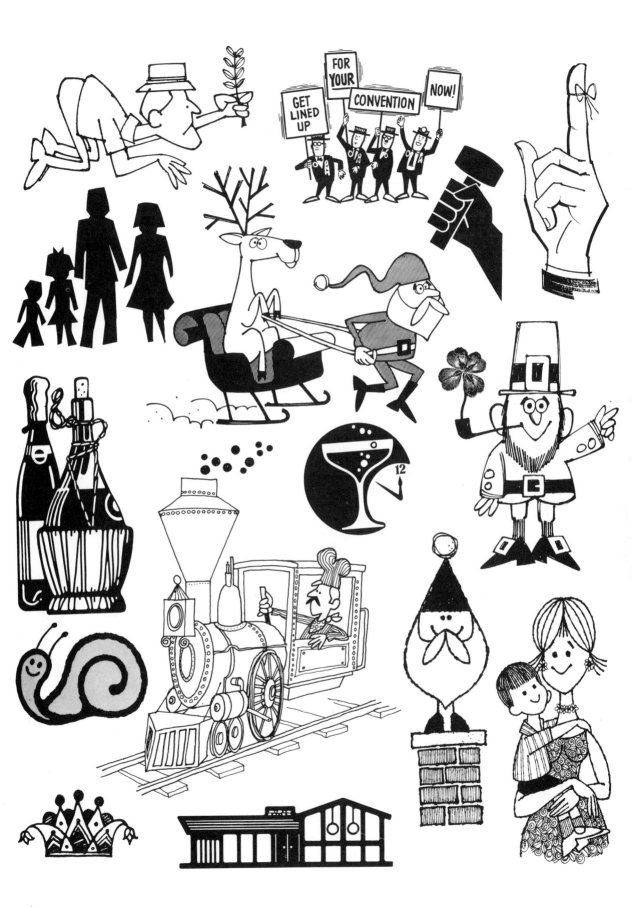

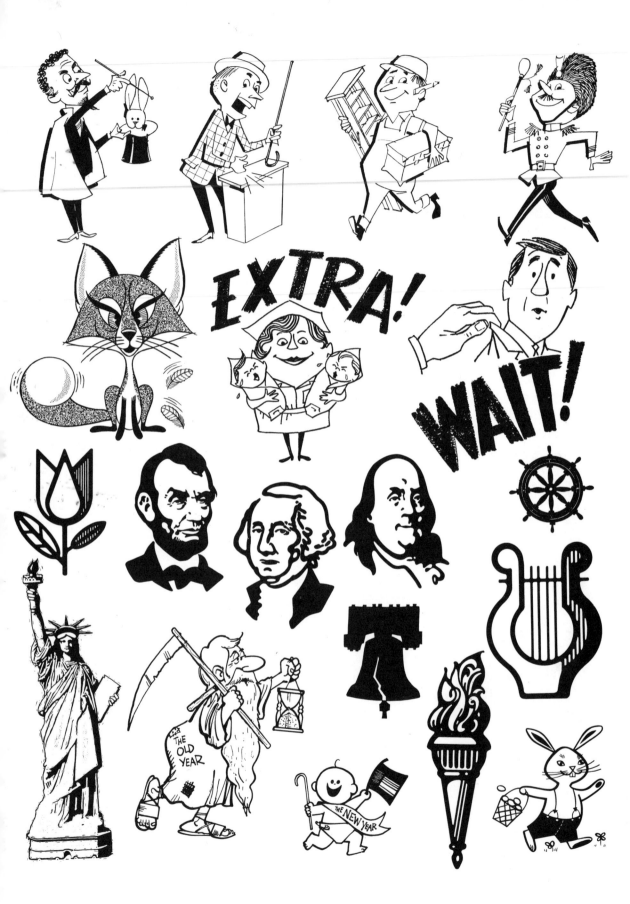

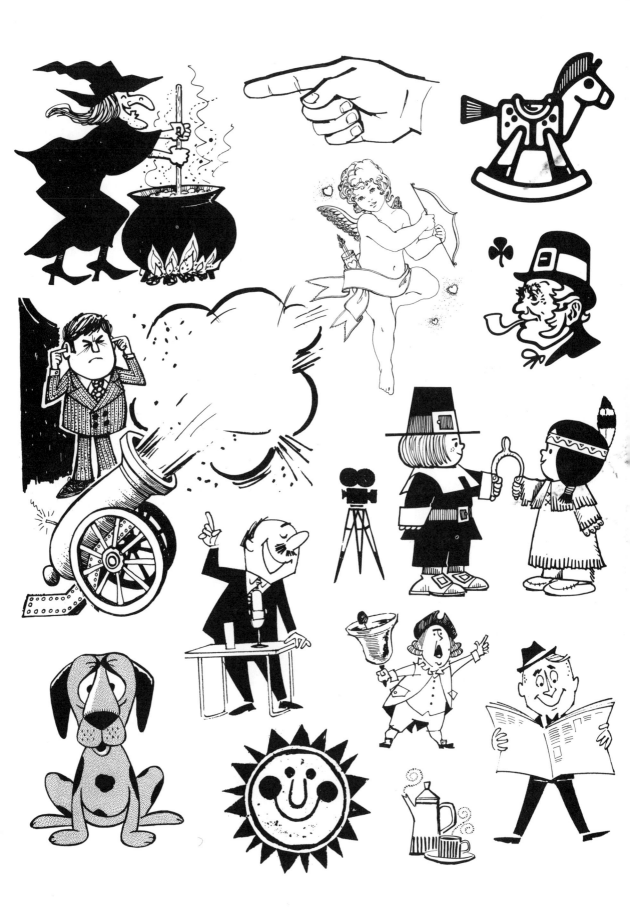

Ideas for pictorializing symbolically every month of the year.

A sampling of Symbol Signs created by some of the country's leading graphic designers for the U.S. Department of Transportations Office of Facilitation. Note the recognizable images established with a minimum of detail in the best tradition of graphic symbolism.

8 What you should know about color

Color is the lifeblood of a poster. The important thing in selecting colors for a poster is not *how many* colors are used, but rather *how well* they are combined. A poster designed in 10 colors is not necessarily more impressive than a poster designed in three or four. Quite the contrary. When too many colors are used, the overall effect can be a discordant visual hodgepodge, destroying the focal point of the poster. And if the poster is intended for reproduction, it invariably creates technical as well as financial problems—whether you do the printing yourself or have it done commercially.

To the enterprising artist, restriction of the number of colors on a poster can be regarded not as a limitation, but as a creative challenge. Each color must be put to work, and all the colors must work cohesively to bring about a harmonious composition.

The Color Wheel

To better understand colors as they have a bearing on poster design, a study of the color wheel will be helpful. Following is a list of major color classifications based on the traditional color wheel.

Primary Colors. These are red, yellow, and blue. Theoretically the entire range of colors can be produced by the selective mixing of these three primaries.

Secondary Colors. The three secondary colors are orange, violet, and green. On the color wheel, each is midway between the primaries from which it is mixed. Yellow and red produce orange, red and blue produce violet, and yellow and blue produce green.

Intermediate Colors. These are obtained by mixing adjoining primary and secondary colors. For example, mixing yellow and green will produce yellow-green, blue and green will produce blue-green.

Tertiary Colors. These represent a mixture of secondary colors. Green and orange mixed to-gether produce citron, orange and violet produce russet, violet and green produce olive.

Complementary Colors. These are colors directly opposite each other on the color wheel. Thus, green is the complement of red, violet is the complement of yellow, blue-green is the complement of red-orange, etc.

The "Dimensions" of Color

Colors can be regarded as possessing three distinct characteristics or dimensions. These are hue, value, and chroma.

Hue. This is the visual quality or identifying element of a color which distinguishes it from other colors. Thus, red is a hue, green is a hue; so is blue, and every conceivable color.

Value. This refers to the normal brightness or luminosity of a color. A color such as intense yellow is light or high in value; violet is dark or low in value. The value of a color can be changed by the addition of white or black—white will heighten the value, black will lower it.

Chroma. This refers to the intensity of a color. When a given color is at its full strength, that is, it hasn't been weakened by the admixture of other colors, it's said to be at its maximum chroma.

Color Combinations

It's comparatively easy to achieve a simple and "safe" color combination. The course of least resistance is to base the color selection on a purely monochromatic color scheme; that is, using different values of the same color, as for example, light brown, medium brown, and dark brown or other such gradations of any one color. This undoubtedly makes for a conservative color combination.

If it's a more vibrant color scheme you're after, one that's a bit more daring, you can experiment with color combinations of strong contrast such as orange and black or yellow and blue.

You may go beyond that to a resourceful combination of complementary colors—those opposite each other on the color wheel—red and green, for instance, or blue and orange.

How can a composition built on opposite or complementary colors be made to avert a clash and achieve a semblance of harmony? One way is to introduce a neutral color (or black or white) as a buffer between them. Another way is to make adjustments in value or intensity in one or more of the colors to give dominance to one at the expense of the other.

All colors are visually affected by surrounding color areas. A dark color placed next to a light color makes the dark color appear darker and the light color lighter. For example, when an area of gray is painted on a black ground, the gray will appear lighter in value and the black deeper because of the *contrast in value.*

Similarly, colors next to each other can appear to change because of *contrast in intensity.* A dull color (or one weak in chroma) placed next to a color strong in chroma will make the dull color appear duller and the strong color more intense. If a strip of neutral green is placed on a bright green background, the neutral green will, by contrast, appear duller while the background will take on greater intensity.

Colors are also affected by *opposition.* Adjacent colors appear to be tinged with their opposites on the color wheel. A strip of blue on a red background will take on a greenish cast (green being the opposite of red) and the red will take on an orange cast since orange is the opposite of blue.

Readability and Color Contrast

From time to time, attempts have been made to come up with a list of color combinations with respect to relative readability in poster and sign lettering. Such lists cannot be assumed to be unfailingly accurate. They can't encompass all the possible variations in the relative value and intensity of the various colors, nor can they include the respective areas covered by them or the type of illumination under which they are viewed.

The readability scale on page 76, based on a survey measuring the relative readability of signs and posters in terms of color contrast, is presented here with the thought that it may be of some help to you in choosing color combinations for poster work where readability is a prime objective. It's arranged in numerical order from 1 to 16 with the easiest-to-read color combination first and the least easy-to-read color combination last.

Psychological Associations of Color

Most of us react pretty much the same way to color stimuli. Our response to color is conditioned by traditional associations of colors with feelings and moods as well as our cultural heritage and environment. To most people, white suggests purity and cleanliness. Black, though generally the color of mourning, imparts a feeling of elegance and formality. Violet calls to mind tender and pious emotions. Purple is the color of royalty; when combined with blue and green, it hints at intrigue and mystery. Red is the universal symbol of revolution, excitement, fire, and fury. Blue has always been the color of sadness and night; also of coolness and tranquility, the sky and sea. Yellow is a warm color, producing a glowing atmosphere of optimism, sunshine, and light.

Similarly, color has its common associations with the seasons of the year: light green for spring; bright yellow for summer; orange or brown for autumn; white or blue for winter. Holidays, too, are universally identified with specific colors—red and green for Christmas, lavender for Easter, tangerine red and dark brown for Halloween, emerald green for St. Patrick's Day, etc. Practically any color you can name has its symbolic associations.

9 Poster colors and other media

The chemistry of paints is a highly specialized and involved science not directly relevant to the average poster artist, and certainly not to the beginner. Of greater concern to the beginning artist is what paints he needs to start out with, how to mix and match them, and how to use them to best advantage.

Poster Colors

Poster colors, often referred to as showcard colors, are formulated as water-based paints. They dry comparatively fast and with good opacity. Of the more than 30 different colors made, you need only a limited number as a basic inventory. Consider getting the following:

White	Turquoise blue
Black	Ultramarine blue
Lemon yellow	Blazing red
Yellow ochre	Magenta

To begin with, you may wish to confine yourself to just the three primaries—a red, a yellow, and a blue—plus white and black. Other colors can be added as you need them. As a starter, a 2-ounce jar of each should be sufficient; a little poster color goes a long way. All colors intermix freely. White and black serve not only as distinct working colors but also as intermixing colors for creating tints and shades.

The majority of standard poster colors are put up in glass jars, but a more intense (and more expensive) type of color known as "designer color" is available in squeeze tubes. The general preference among poster and showcard artists is for jar colors, not only because they are more economical, but also because the colors are easy to identify, the closures fit better, and the colors are of the proper brushing consistency, ready for use.

Like all paints, poster colors are made up of integrated components that include proportionate amounts of minute pigment particles, binding agents, various emulsifiers, and inert matter called "fillers"—all of which are suspended in a liquid carrier or "vehicle." Prime quality poster colors contain a greater proportion of finely ground pigments, superior binders and emulsifiers, and a minimum of fillers. Such colors are therefore brighter, easier to work with, and possess greater opacity than low-grade colors.

It's not possible to graphically illustrate, or even list, the infinite variety of colors, tints, and shades obtainable by the intermixture of two or more colors. A sampling of some of the results that can be gotten with just a few basic colors is shown on page 75.

Acrylic Paints

Similar to standard poster colors (insofar as both are water-based), acrylics are of a polymer formulation, which puts them in a class by themselves. Although thinned with water (the same as poster colors), they become waterproof upon drying. Besides this, acrylics have several other inherent advantages: they can be used not only on paper and poster board, but on any surface—rigid or flexible, they won't crack or peel even if the surface on which they are painted is bent or rolled, and they are as bright and intense after drying as when originally painted. Acrylics, however, have some limitations: they aren't consistently opaque (some of the colors are, others are not); they have a tendency to dry too fast and in so doing may dry into the brush unless the brush is frequently washed during the process of painting. Once acrylic paint dries hard into a brush, no amount of washing will restore the brush to its original condition; it's irreparably damaged. Acrylics have not proven to be as popular with poster and lettering artists as they are with fine artists and commercial illustrators.

Latex Paints

These may be considered a low-cost substitute for acrylics. They too are water-soluble while wet, waterproof when dry. However, they lack the chromatic intensity and color stability of pure acrylics. Because they have no offensive paint odor (and because they are comparatively inexpensive), latex paints are used as house

paints, both for interior and exterior purposes. They have become increasingly popular for display and exhibit work, and are, within certain limitations, serviceable for posters and signs. Latex paints are put up in quart and gallon cans in three surface finishes—flat, semigloss, and gloss.

Sign Painter's Oil-Based Colors

This special type of oil-based medium, known as "Japan color," is the traditional lettering medium in the industrial sign field.

Oil-based colors are thinned with mineral spirits, oil, or varnish, depending upon the painting surface and the intended drying time. They are 100% waterproof and have excellent holding power, making them especially serviceable for exterior signs exposed to changing weather conditions.

Many of the handpainted signs you see on storefronts and show windows are lettered with sign painter's oil-based colors, as are cloth banners, paper signs, road signs, etc. Sign painter's colors are normally not meant for poster and showcard stock because the fatty oil content in the paint causes an unsightly stain to form around the edges of the painted areas. As a rule, sign painter's colors tend to dry slowly, unless they are thinned with commercial dryers or turpentine.

Screen-Printing Inks

These, too, are largely oil-based but are processed to allow the ink to go through a fine-meshed screen without clogging. Screen printing inks, their mixing and use, are discussed in detail in Part Two, Chapter 8.

Other Color Media You Should Be Acquainted With

Besides paints and printing inks, there are other color media which can aid you in layout and visualization or in preparing one-of-a-kind posters.

Felt-tip Markers. The development of the felt-tip marker has brought about a phenomenal change in the techniques of color application. Within a comparatively short time, the felt-tip marker has evolved from a crude, black-ink shipping-case marking device to a highly sophisticated coloring medium. Today, felt-tip markers in all colors, shapes, and sizes are in wide use in the field of illustration, cartooning and animation, layout and design, and to an extent in the fine arts as well.

Many reasons account for the ever-growing popularity of felt-tip markers. Perhaps the most important is that the colors dry instantly on contact with paper. There is no chance of spilling or smudging and no time lost in wash-ups. In addition, felt-tip markers are available in a prodigious array of colors far exceeding that of paints, inks, or other comparable color mediums.

As truly remarkable as felt-tip markers are, they do have some shortcomings. They fade more readily than other color media. Also, it's difficult to color in a background or other fairly large area without showing streaks. All colors, with the exception of black and a semiopaque white, are highly transparent. This obviously limits their application to white and other light-colored stock. Then too, since colors can't be intermixed in the same way as conventional fluid paints or inks, it's necessary to have on hand a rather large assortment of different colors to allow for complete color flexibility.

To a limited degree, some color "intermixing" can be effected by superimposition, that is, by applying one color over another, or by making use of the semiopaque white to create a tint.

Pastels. A chalklike substance in stick and pencil form, pastels have for years been a favorite color medium not only for rendering realistic illustrations and portraits, but also for preparing poster visuals, magazine layouts, advertisements, etc. With the introduction of felt-tip markers, the popularity of pastels has somewhat declined.

As an art medium, pastels lend themselves ideally to subtle color blends through superimposition, finger rubbing, and other controlled-smudge techniques. Best results are achieved when the drawing surface is slightly textured to provide the proper "tooth" for the pigment particles to hold on to. Since pastels are composed almost entirely of pure pigment, they possess a richness of color and unexcelled opacity. To keep artwork done in pastels from being marred by inadvertent smudging, it must be protected by a spray fixative of clear lacquer or acrylic or by an overlay of transparent acetate. Pastels come in a wide range of colors.

Spray Colors. A practical alternative to electrically operated spray guns and artist's airbrushes, spray colors in aerosol cans provide an easy-to-use and relatively inexpensive medium for creating blended border effects as well as for allover coating of backgrounds. They may also be artfully employed within the poster in conjunction with cut-paper or liquid-type friskets for pictorial work and lettering. Spray colors in both transparent and opaque form come in a choice of finishes—matte, semigloss, and gloss. Colors include bright fluorescents.

"Look-through" color windows (easily made by cutting an opening in paper or board) provide a good aid in close color matching.

Guide to Color Mixing

There are no rigid rules or formulas in color mixing, nor can reason take the place of actual experience. There are, however, general guidelines to go by.

1. The admixture of two complementary colors such as red and green, or blue and orange, no matter how bright each color may be individually, will most likely result in a grayish, lackluster color. Avoid such intermixtures unless that's the color effect you're aiming for.

2. In mixing a tint using white as a base color, very little of the other (darker) color is generally required to produce a perceivable change in the combined color mixture. If you were to mix a tint with a dark color as a base and add white, you would most likely end up with far more color than you had anticipated. In mixing tints, it's better to start with the lighter of the two colors. When deepening a color by the addition of black, do so in small measures. It's easier to darken a color than it is to lighten it.

3. Black requires careful handling. It can sometimes mysteriously change the character of a color completely. By adding black to yellow, for example, the result won't be a darker shade of yellow (as you'd expect) but an indefinable shade of muddy green. Adding black to red won't make a deeper red, but will result in a brown—an entirely different color.

4. It's important to know the various tinting strengths of the colors you work with. Prussian blue, for example, in its pure chromatic state is a potent color, whereas ultramarine blue is comparatively weak. A color strong in tinting power when added to a color mixture will quickly upset the balance and make it difficult to get a clean color mix. Keep notes of your experiments with colors to guide you in your progress as you go along.

5. One way of assuring a harmonious relationship between several colors on a poster is to put a touch of each color into the others so that all colors take on a tinge of each other. In theoretical color terminology, this subtle tinge of colors in a composition is referred to as "saturation of colors."

6. A common problem confronting beginners is "muddy" colors. This comes about when too many colors are injudiciously intermixed. Keep color mixtures simple. If a color turns out disparingly muddy in the process of intermixing, don't think you'll restore its chromatic purity by adding more colors. The chances are you'll only

make it worse. Start fresh and learn from the experience!

7. Be mindful of the fact that poster colors look brighter in their wet state than when dry. Also, where accuracy in color match is important, it's best to try out the color first by daubing it on a piece of the same stock you'll be using in painting. (Colors dry differently on one type of surface than another.) Allow the color swatch to dry thoroughly before using it as a guide for mixing the full amount you need.

8. Knowing just how much color to prepare for a poster project comes with experience. A bit more than a teaspoonful should be enough for the lettering part of the job; proportionately more is needed for larger areas and complete backgrounds. To cover a 15″ x 20″ background area, for example, several teaspoonsful should prove ample. When using a mixed color (one produced by the intermixture of several component colors), it's always good to prepare more than you think you'll need. Trying to remix and rematch a color when you run short can be a real problem. Err on the side of too much. Leftover color, if any, can be stored in covered containers to be on hand for retouching purposes, or as components for new colors to be mixed in the future.

9. A good way to check on the accuracy of a color match is to view it through the opening of a color-match window. This is a sheet of paper or cardboard with a small rectangular center, or "window," cut out of it which when placed over the sample swatch makes it possible to see the color isolated from distracting surroundings.

PAINT SELECTOR CHART

The following chart will aid you in selecting the appropriate medium for painting on varied poster and sign surfaces.

Nature of Stock	Type of Color Medium	Solvent for Thinning and Washup
Paper and cardboard	Water-based poster colors	Water
Sign painter's banner paper	Oil-based (Japan) colors	Mineral spirits
Metal surfaces	Oil-based (Japan) colors	Mineral spirits
Composition board, plywood and other wood surfaces	Oil-based (Japan) colors	Mineral spirits
	Acrylic colors	Water
	Latex colors	Water
Glass surfaces	Oil-based (Japan) colors	Mineral spirits
Oilcloth	Oil-based (Japan) colors	Mineral spirits
Canvas and other woven cloth	Oil-based (Japan) colors	Mineral spirits
	Acrylic colors	Water
	Latex colors	Water

Note. Mineral spirits include kerosene, turpentine, naphtha, Varnolene, Varsol.

(Right) This travel poster, designed by A.M. Cassandre, dramatically depicts the colossal size of the ship S.S. Normandie by the space it occupies in relation to the total poster area. Note the suggestion of birds in the lower left-hand corner, which by contrast further emphasizes the majestic proportions of the ship.

Clay is a typical resource.

Potential is its greatest attribute.

Hire the Handicapped: A National Resource.

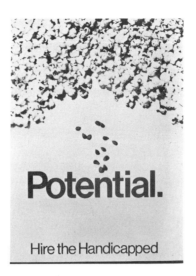

Potential.

Hire the Handicapped

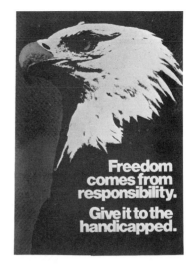

Freedom comes from responsibility.

Give it to the handicapped.

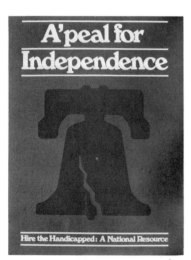

A'peal for Independence

Hire the Handicapped: A National Resource

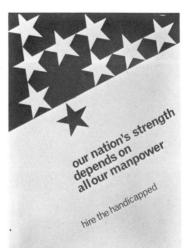

our nation's strength depends on all our manpower

hire the handicapped

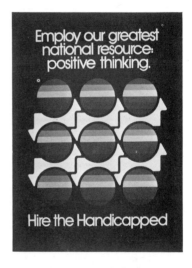

Employ our greatest national resource: positive thinking.

Hire the Handicapped

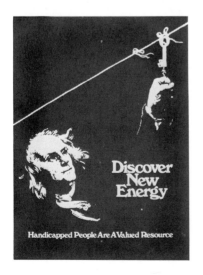

Discover New Energy

Handicapped People Are A Valued Resource

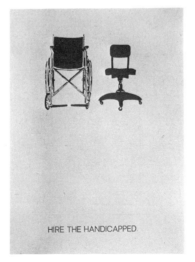

HIRE THE HANDICAPPED.

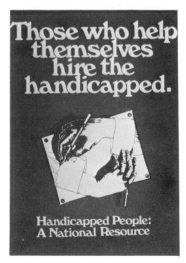

Those who help themselves hire the handicapped.

Handicapped People: A National Resource

There are many ways to symbolically portray the theme of a poster. Here are nine of more than 20 different approaches to the same theme by students of the Herron School of Art poster program.

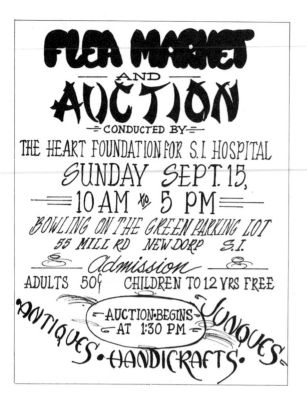

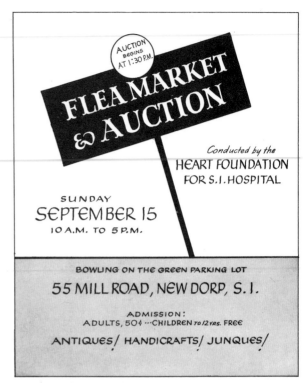

Both posters contain the same wording, yet the one on the right is easier to read, looks uncrowded, and does a better job of promoting the advertised event. Can you analyze the fundamental differences between them to explain why the one on the right is so much more effective?

An excellent poster design where the pictorial element is reduced to simple paper cutout shapes.

11 Special art techniques

Poster design is a branch of commercial art. As such, many of the professional techniques in the broad field of commercial art are also employed in the preparation of posters. Here are the more common techniques you're sure to find helpful in some phase of poster making.

Applying Background Colors

There are a number of ways to get colored backgrounds (and other large areas) on posters: by brush, by an aerosol spray device, or by making use of colored stock.

Brush. Applying an even coat of paint with a brush is a rather involved procedure, although it may not appear so to the beginner. Indeed, some more experienced artists find it a challenging task at times. Briefly, here's the way to go about it:

1. Check to see that your paint is mixed to a good brushing consistency by trying it out on a scrap card first. Then pour a quantity of the mixed paint into a shallow dish and work from that; it's easier than working from a deep container or jar.

2. Select the right brush—one that doesn't shed and is of the proper size. For covering a 15″ x 20″ background area, a ¾″ (or larger) fill-in or "one-stroke" brush is suggested. The object is to cover the area to be painted in as few strokes as possible. To get an evenly distributed coat of paint, brush with long, even strokes—each stroke slightly overlapping the preceding one without leaving a ridge of paint. First brush in one direction, then the other. Be sure to leave no "holidays" (inadvertently omitted areas), and at the same time avoid puddles. In most cases, one coat of paint properly applied is all that's needed.

Place the board in a flat position for drying, otherwise it will curl and warp—a condition that's difficult to correct later.

Aerosol Spray. To apply a coat of paint or other medium with an aerosol spray can, prop the board to be sprayed almost upright. Hold the nozzle about 10″ or 12″ away from the board and spray from side to side in one continuous movement. Avoid sudden stops and jerks. For good coverage, it's best to apply two thin coats, allowing the first to set before following up with the second. Always place the board in a flat position for drying to prevent warpage.

Colored Stock. It's sometimes advantageous to cover a background area (either totally or in part) with colored paper cut to size and mounted on the board. To do this, mark out the position where the paper is to go on the board and apply a thin coat of rubber cement. Then apply a coat of rubber cement to the back of the paper. That done, mount the paper to the board, pressing down firmly. Any excess cement around the edges comes off easily with a pick-up eraser.

Colored papers as well as self-adhesive film sheets are made in hundreds of coordinated colors printed with an easy-to-work-on surface finish that readily accepts any kind of paint medium. Papers are also available in different finishes from matte to high-gloss and in a variety of textures.

If you plan the entire background of your poster to be a solid color, consider the possibility of making use of colored posterboard or oak tag. Most art supply stores carry a good selection of standard colors and bright fluorescents as well as gold, silver, and other metallic finishes.

Making a Frisket

A frisket is a sheet of paper with openings cut through to which a paint medium can be applied by spraying or other means. In a sense, a frisket acts as a mask to cover the area not to receive the paint. The frisket technique is especially adaptable for spray painting large-size lettering and broad design areas, and allows for a degree of sharpness not easily obtainable by more conventional painting methods.

Preparing a Frisket. Mark out or trace the design image on a sheet of paper. Then coat the back with a thin solution of rubber cement and lightly adhere it to the receiving surface. With frisket knife or razor blade, cut out all parts through which paint is to pass, and peel them away. Rub

off any residual rubber cement within the open areas. After spraying, remove the frisket.

To save time, you can make use of commercially prepared frisket sheets which come with a self-adhesive back. A liquid-type frisket is also available. Liquid frisket is of synthetic latex composition and upon drying forms a temporary masking film. In use, it works something like this: With brush or other tool you apply the liquid frisket to those areas that are *not* to receive color. When the frisket sets (which is within minutes) you paint in the background area as you normally would with brush or spray, going right over the parts covered by the frisket. After the paint dries, you remove the frisket by merely peeling it away with your fingers or with a pick-up eraser.

Using Lettering Templates

You may at times find it practical to avail yourself of lettering templates. These are usually made of stiff parchmentlike paper with die-cut shapes conforming to the letters of the alphabet. Letters with isolated structural elements such as the small triangular shape in the capital A or the inside element of the O, have ties or bridges to keep them from falling out. The results achievable with such a template resemble stencil-type letter forms—the kind seen on shipping boxes and crates.

Alphabet templates come in a limited number of lettering styles and sizes. To keep centers of letters from dropping out, all require tie strips, creating a stencil effect.

To make use of a lettering template, place it on the posterboard or other surface and follow the contours with a pencil, ballpoint pen, or felt-tip marker. Then lift the template and paint within the outlined areas. If you wish, use the template like a frisket and spray or otherwise apply paint through the openings. In either case, shift the template from letter to letter in predetermined positions on the particular surface that the lettering is to appear.

Using Transfer Lettering Sheets

Transfer lettering has to a large extent replaced fine precision lettering which had to be done by hand by an expert in the field. Today, anybody can "do" precision lettering by merely following a set procedure, which mainly involves transferring printed or die-cut letter forms temporarily mounted on a backing sheet to posterboard, paper, or other receiving surface.

There are several transfer lettering systems: the dry-transfer system, the cut-out acetate lettering system, and the die-cut sign lettering system.

Dry-Transfer System. In this system, the letters of the alphabet are imprinted on the underside of a transparent carrier sheet. The ink used is of a special "dry-transfer" formulation which makes it possible for the letters to be transferred from the carrier sheet to the layout.

The procedure is as follows:

1. Draw a pencil guideline on the layout for lining up the letters. Then lightly sketch in the letters to conform to the desired spacing.

2. Put aside the protective backing sheet that comes with the carrier sheet. You'll need it later. Place your first letter in position over the layout. The penciled-in lines are clearly visible through the transparent carrier sheet.

3. Rub firmly over the letter with a ballpoint pen, blunt pencil, or special burnishing stick. This action causes the letter to leave the carrier sheet and adhere itself to the layout.

4. Lift the carrier sheet, position the next letter on the layout, and repeat the procedure, letter by letter, until all the letters of the wording are transferred.

5. For permanent adhesion, place the backing sheet over the completed wording and once again rub down the letters. Then with a kneaded eraser, remove all pencil lines on the layout.

Cut-Out Acetate System. Unlike the dry-transfer system where the carrier sheet is discarded

Dry-Transfer Lettering

1. Positioning the selected letter on the layout.

2. Rubbing the letter down lightly with the aid of a ballpoint pen.

3. Reinforcing the adhesion between the letter and the receiving surface.

4. Lifting off the carrier sheet to set the next letter into alignment.

Cutout Acetate Lettering

1. Cutting around the entire letter area (including black guidelines) with a frisket knife.

2. Sliding the blade of the knife under a corner of the cut letter preparatory to lifting it off the backing sheet.

3. Lifting the letter unit off the backing sheet, ready to mount on the "Headline Setter" aligning ruler.

4. Aligning the black guideline under the cut letter with that of the blue guideline of the Headline Setter.

Die-cut Sign Lettering

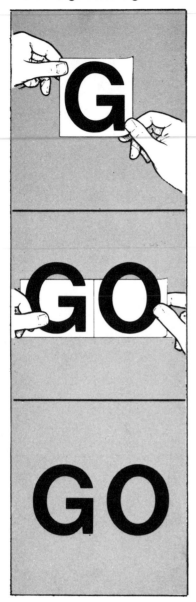

(Top) the individual letter unit; (center) butting up one letter against the other after removal of the upper section of the backing sheet; (bottom) the finished word after the lower section of the backing sheet has been removed.

after the letters are transferred, the cut-out acetate system involves cutting the carrier sheet (a thin, self-adhesive acetate film) letter by letter and adhering each section in its predetermined position on the layout.

The cut-out acetate lettering system allows for considerable flexibility in shifting the letters in the process of spacing them, even after having been adhered. The individual pieces of acetate film bearing the selected letters can be readily lifted from the layout, repositioned, and re-adhered as needed. Since the letters appear on the underside of the acetate film, and are in effect sandwiched between the surface of the layout and the acetate, they are for all practical purposes scratchproof. Because the acetate cutouts are noticeably visible on the layout, this system is practical mostly for work intended for reproduction. In reproduced form, only the letters show; the acetate itself does not.

The work procedure is quite simple. The section of the acetate film on which the selected letter appears is cut, lifted off the backing sheet, then lined up in position on the layout. When all letters are cut and properly spaced, they are rubbed down with a burnishing tool.

Die-Cut System. This letter-transfer system, while it can be used on posters, is intended primarily for sign work on glass, metal, wood, and practically any other surface, flat or round. Individual letters are available in several styles and in sizes up to 6″. The letters, die-cut out of a strong, flexible vinyl, are self-adhesive and come temporarily mounted on a protective backing sheet. This type of contact transfer lettering is simple to apply, easy to space, and when properly burnished, stays down so tenaciously that it requires a special solvent for removal.

The procedure is as follows:

1. Peel off the upper section of the protective backing sheet. Align the base of the lower section within the guideline already drawn. Press the exposed part of the letter into position.

2. Do the same with the next letter and butt the lower part against the preceding letter unit. Continue this simple process until the word is completed.

3. Now remove the lower part of the backing sheet of all the letter units, pressing down firmly as you go.

Manufacturers' brochures, usually free for the asking, show specimens of alphabets available in the various transfer-lettering systems as well as a wide assortment of pictorial symbols, border designs, typographic marks, and textural patterns.

CLARENDON BOLD
Black & White

61 6085-192C 192 Pt. Caps

61 6085-192L 192 Pt. LC, Numerals

A
61 6085-120C 120 Pt. Caps

a
61 6085-120L 120 Pt. LC, Numerals

A
61 6085-84C 84 Pt. Caps

ab
61 6085-84L 84 Pt. LC, Numerals

ABab
61 6085-72CL 72 Pt. Caps, LC, Numerals

AB
61 6085-60C 60 Pt. Caps

abc
61 6085-60L 60 Pt. LC, Numerals

61 6085-48C 48 Pt. Caps

abc
61 6085-48L 48 Pt. LC, Numerals

ABCDabcde
61 6085-36CL 36 Pt. Caps, LC, Numerals

ABCDEabcdefg
61 6085-28CL 28 Pt. Caps, LC, Numerals

ABCDEFGHI abcdefghijkl
61 6085-18CL 18 Pt. Caps, LC, Numerals

ABCDEFGHIJK abcdefghijklm
61 6085-16CL 16 Pt. Caps, LC, Numerals

ABCDEFGHIJKL abcdefghijklmnop
61 6085-14CL 14 Pt. Caps, LC, Numerals

ABCDEFGHIJKLMN abcdefghijklmnopqrst
61 6085-12CL 12 Pt. Caps, LC, Numerals

12
61 6085-192N 192 Pt. Numerals

CLARENDON LIGHT
Black & White

A
61 6025-72C 72 Pt. Caps

ab
61 6025-72L 72 Pt. LC, Numerals

AB
*61 6025-60C 60 Pt. Caps

abc
*61 6025-60L 60 Pt. LC, Numerals

AB
*61 6025-48C 48 Pt. Caps

abc
*61 6025-48L 48 Pt. LC, Numerals

ABCDabcfg
*61 6025-36CL 36 Pt. Caps, LC, Numerals

ABCDEabcdefg
*61 6025-28CL 28 Pt. Caps, LC, Numerals

ABCDEFGHabcdefghij
*61 6025-20CL 20 Pt. Caps, LC, Numerals

ABCDEFGHIabcdefghijkl
61 6025-18CL 18 Pt. Caps, LC, Numerals

The success of the various transfer lettering systems is attested to by their wide adoption by poster artists and graphic designers. There are hundreds of easy-to-apply alphabets to choose from in a great range of styles and sizes in black, red, blue, white, and other colors. Here is a page from Mecanorma—one of several leading transfer-type systems.

A page from a brochure showing a sampling of transfer-type pattern and texture sheets.

Textures and Blending Techniques

It's often said that the ideal poster is one that is rendered in solid, flat tones with a minimum of textural treatment. But to refute that assertion, it's easy to find excellent poster designs where the skillful use of spatter, stippling, cross-hatching, and similar techniques have played an important role in the total effectiveness of the composition. Some of the greatest poster artists of the 19th century, men like Toulouse-Lautrec, Jules Chéret, and Théophile Steinlen, employed such techniques with remarkably good results, combining them with the flat, bold colors which identify their distinct poster styles.

Here are some basic textural and blending techniques you may want to experiment with:

Stippling. You can get stippled textural effects by meticulously placing numerous ink or paint dots on the drawing surface to form a desired pattern. This is done with pen or finely pointed brush, employing a repeated up-and-down pecking movement. The illusion of texture and tone is created by the size of the dots and their proximity to each other. It takes considerable time and patience to cover a large area. Stippling is a technique that can't be hurried.

Crosshatching. A grouping of parallel lines made to cross in some systematic pattern will produce a crosshatched effect. Both the thickness and space between lines can be varied to create differences in tonal density. To avoid unsightly blotches, take care to keep the lines from running into each other haphazardly.

Sponging. This textural treatment deserves special attention. It's easy to achieve, is comparatively fast, and allows for many interesting color effects. All you need is a small natural sponge (not the synthetic kind) and paint. The sponge is dipped into a small quantity of paint spread on a piece of scrap cardboard; then with a deft up-and-down motion, the sponge is lightly tapped over the area to be textured. The less paint the sponge holds and the less pressure exerted on it, the more delicate the resulting texture. To add a variegated color effect, one color may be super-imposed on another.

Spatter. A spatter effect can be achieved in the following way: Place a dab of paint on a toothbrush and scrape across the bristles with a tongue depressor or knifeblade. The scraping action causes some of the paint to leave the bristles and come down as a fine spray. The spatter can be contained within a given area by shielding the rest of the art with a frisket or paper mask.

There is no one art technique that assures success in a poster design, although traditionally the preference has strongly been in favor of flat color areas combined with simple line work. This poster by the famous Beggarstaff Brothers, one of many created during the 1890s, shows how effective this can be.

Poster by Théophile Steinlen. Here's an example of flat color treatment and strong linear drawing, combined with crayon, paint spatter, and drybrush techniques.

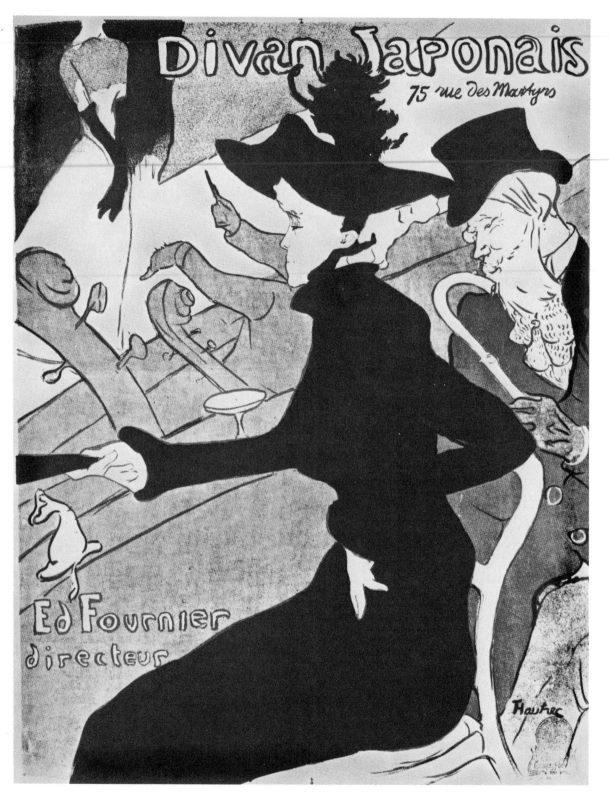

This Toulouse-Lautrec poster shows the adroit use made of flat tones, line, and texture.

Drybrush. The drybrush technique, as the term implies, is produced by painting with a brush that's partially dry. The best effect is obtained if the paint is of rather heavy consistency and the brush, after being charged, is roughened up a bit on a cardboard or blotter. Sometimes an old brush with split hairs is just right.

For large-size lettering, as for example headlines or feature copy on a poster, drybrush strokes give the general appearance of having been done with a fast, determined, almost impulsive action. In a modified form, the drybrush technique can be used to advantage to produce subtle shading effects on realistic illustrations and pictorial designs.

Rouging. It's simple to get a rouge blend effect on a poster with nothing more than a piece of colored chalk and a wad of cotton. Here's how it can be done.

Lightly rub some colored chalk over the particular area of the design you want to blend. Then with a wad of cotton (or powderpuff) rub the chalk onto the surface, following a motion similar to that of blending a touch of rouge on the cheek.

Rouging is easy to do with a little practice. The technique works equally well for the pictorial elements of a poster as for borders and other embellishments. It can prove to be effective, too, for producing interesting shadows or a "glow" around feature lettering. Rouging takes best on a vellum or slightly textured surface.

Methods of Enlarging and Reducing Artwork

Artwork can be duplicated in any given size by one of the following ways: (a) photograph; (b) the grid method; (c) opaque projector.

Photograph. Reproduction by photographic means allows for ultimate fidelity in copying a drawing or other art. For the purpose of copying, there are two photographic processes: one yields a conventional photograph where the negative image is made on film, the other, a photostat, where the negative image is on paper. A photostat (or "stat" as it's called) is less expensive and can be processed quickly—quite often while you wait. Although a stat doesn't have the sharp resolution of a photograph, if the artwork to be copied is in straight black and white, you'll find the stat more than adequate.

There are certain things that you should do when ordering a stat from a photocopying house:

1. Clearly indicate the size of the required reproduction on a tissue overlay or within the margin of the art. Give *one* dimension only. Since the camera lens sees the art as a total unit, the other dimension will automatically be proportionate.

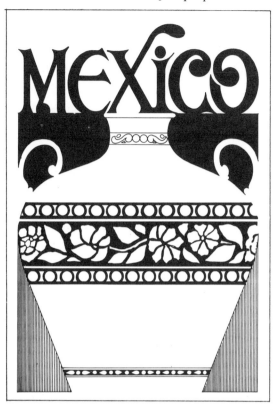

Negative. Positive.

2. Specify whether you want a *negative* or a *positive*. In a negative, what is white on the art reverses itself and comes out black on the stat. In a positive (which requires an additional step) the black and white relationship of the art is restored. A positive, therefore, generally costs twice as much as a negative.

3. Specify whether the stat is to have a glossy or a matte finish. You can have it either way. The glossy finish is somewhat sharper. However, if you expect to do some retouching on the stat, a matte finish is easier to work on.

Art Grid

Copy Grid (enlarged)

Grid. This basically involves working with two grids, an *art* grid and a *copy* grid, and duplicating the contour lines of one onto the other. Here's how the grid method works in actual practice:

1. Within a rectangular area encompassing the art, measure off (on the art itself or on a sheet of transparent tracing paper taped over it) a series of equidistant horizontal and vertical lines crossing each other at right angles to form a graph or grid of squares. The lines can be spaced ½″ or 1″ apart, or any other convenient unit of measure. Label one set of lines alphabetically, the other numerically.

2. Draw a similar grid on a posterboard (or other drawing surface), making the squares proportionally larger or smaller depending upon whether you want to increase or decrease the size of the art. For example, to double the size of the art, double the size of the squares on the posterboard. Again label all vertical and horizontal lines.

3. Copy the contour lines in each square of the original art onto the corresponding squares of the posterboard.

This grid method is used by many outdoor billboard artists to sketch in key drawings before painting.

Opaque Projector. For true-to-life enlargements, commercial studios employ projection devices of various kinds, one of the most popular being the opaque projector. You can purchase a smaller unit for poster-size reproduction at most art supply stores. With this device, which somewhat resembles a slide projector, it's possible to enlarge drawings, prints, maps, photos, and other flat surfaces—and with some limitations, three-dimensional objects such as an open book, a watch, a flower, etc.

The subject to be projected is placed on a copy board which forms part of the projection unit. Upon adjusting the lens to sharp focus, the image is projected onto an upright drawing surface. As in a slide projector or any other projection apparatus, the farther the unit is stepped back, the larger the projected image.

How to Transfer Artwork by Tracing

To transfer a drawing or lettering from one surface to another:

1. Tape a sheet of tracing paper over the art. To increase the transparency of the paper, if need be, wipe it once or twice with a wad of cotton dampened in mineral spirits (turpentine, kerosene, etc.).

2. With a well-sharpened pencil, carefully go over all lines of the art as you see them through the tracing paper.

3. After checking that the tracing is complete in every detail, remove the tracing paper and turn it face down. Then blacken the back with a soft, broad carbon pencil. You can, if you wish, use graphite paper specially made for tracing artwork. Many professionals prefer graphite paper because it doesn't smudge the surface below and the traced lines erase easily.

4. Place the tracing in position and tape it (blackened side down) to the posterboard. With a ballpoint pen (preferably in color) go over all traced lines. Apply just enough pressure on the pen to transfer the lines without digging into the surface of the board. You can use a pencil for tracing if you like, but a pen makes it easier to keep track of the lines that have been traced as you go along.

5. Remove the tracing sheet and make whatever refinements are necessary on the traced art.

Note. If you are tracing onto a dark-colored stock, you may whiten the back of the tracing paper with chalk or you may make use of carbon transfer paper which comes in white and other colors.

How to Convert a Photograph into a Posterized Painting

It's a simple matter to convert any dramatically lighted, sharp-contrast photograph into a flat poster-style painting without possessing the skill of a professional illustrator. All that it requires is to reduce the tonal qualities of the photograph into a limited number of clearly defined planes or areas. When marked out, the planes can be painted in any number of monochromatic color values or in any combina' on of true-to-life colors. Here's the procedure:

1. At the outset, determine the precise number of colors you plan to use. Surprisingly good results can be achieved with just a few well-chosen colors.

2. Tape a sheet of tracing paper over the photograph. The more transparent the paper, the easier it will be to select and separate tonal areas.

3. With a well-sharpened pencil, make a key tracing of all elements of the photograph, deciding as you go along where one sharply defined color boundary is to end and the other to begin. The decision of course is at best an arbitrary one; it will depend largely on close observation and good judgment.

Tracing procedure

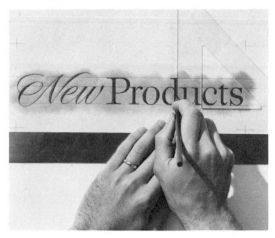

The work is carefully traced on paper, the back of which has been smudged with a soft pencil to create a carbon-like surface.

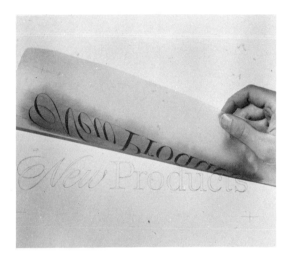

The finished tracing is transferred.

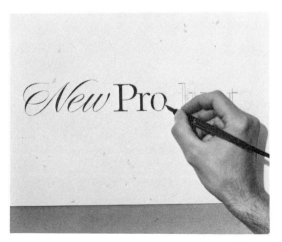

The transferred image in clear outline form is filled in.

Posterizing a Photograph

Original photograph.

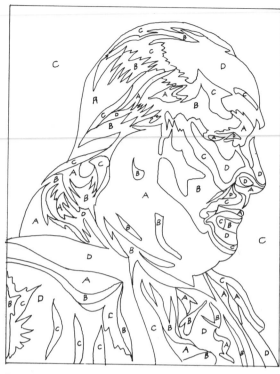

Outline tracing showing the division of tonal areas.

Posterization of the photograph in completed form. Color swatches A, B, C, D, are the predetermined set of colors employed.

4. With the key tracing complete, identify each color area by writing in the name of the color or by a coding system whereby each color is given a letter or number.

5. Transfer the tracing to the posterboard in the usual manner. Be sure to include all color identifications.

6. Mix and match each of the colors and try them on a scrap board to see how well they harmonize to give you the effect you want.

7. Paint in the various areas in their corresponding colors.

8. Compare the original photograph with your rendition and make whatever minor refinements may be necessary.

Cropping a Picture Image

By a simple, homemade device consisting of two L-shaped paper or cardboard cutouts you can select and visually "frame" any portion of a picture image you'd like to feature. With these cutouts you can also adjust proportions to conform to those on your poster layout. This selecting and proportioning procedure, known as "cropping," is used extensively in the field of photography as well as in commercial art. Here's how to go about it.

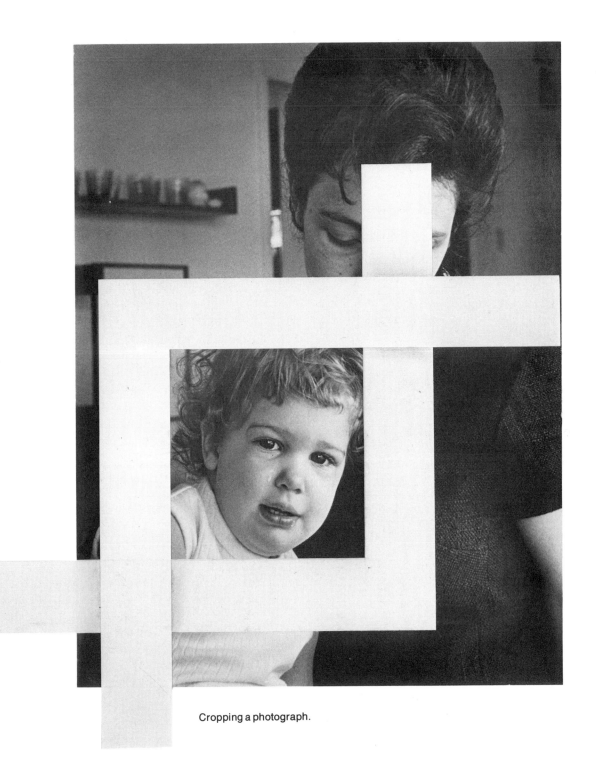

Cropping a photograph.

Place the two L-shaped cutouts over the picture image in overlapping fashion, forming a frame. Move them about freely until the selected image is located within the framed area and in the desired proportion. With that established, place corner marks within the framed area to indicate the exact perimeter of the selected image. You are now ready to trace, copy, or otherwise duplicate the image that is to become an integral part of the poster layout.

Dimensional Scaling

Here is a nonmathematical way by which it's possible to proportionally change the dimensions of a given rectangular area. To use a specific example: You have a picture image which fits into a rectangular area measuring 10″ high and 7½″ wide. You wish to enlarge it to a height of 12½″. How do you determine the new width without changing the original proportions?

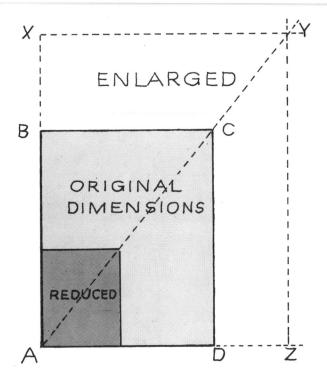

1. On a sheet of paper draw the rectangle in actual size (10″ x 7½″) labeled ABCD as shown at left.

2. Extend vertical line AB at point B; similarly extend base line AD at point D.

3. Draw a diagonal line from point A to point C, extending it beyond point C.

4. On the extended vertical line, measure off the height (12½″) of the desired rectangle, and at that point, X, draw a horizontal line parallel to the base and crossing the extended diagonal.

5. Where this horizontal line intersects the extended diagonal, point Y, drop a vertical line to the base, creating point Z.

6. Line AZ represents the new width of the rectangle and will be in exact proportion to the new height AX (12½″).

This same scaling system is as applicable for proportionally reducing as it is for enlarging a rectangular area.

Striping

In the process of doing a poster, occasions often arise for painting long, straight lines or borders quickly and accurately, without resorting to ruling pen or other mechanical instrument.

This technique, known as striping, may seem a bit tricky when you first try it, but it won't take long before you acquire the knack for it. Here's the procedure:

1. Pencil in the line (or lines) to be striped. Then place a ruler or other straightedge a little below the line but parallel to it.

2. Charge the brush with paint thinned to a rather fluid consistency. Be sure you carry enough paint on the brush to last for the entire stroke without having to recharge midway.

3. Holding the brush lightly between the thumb and index finger and sliding the tip of the middle finger along the edge of the ruler, paint the line in one even stroke. The brush should always be angled in the direction of the stroke and the entire arm moved, not just the wrist. The width of the painted stripe is largely determined by the size of the brush and the pressure exerted on it.

If it's more convenient for you, you can slide the ferrule (the metal part of the brush) against the edge of the ruler as you move the brush along. In this case, the ruler must be lifted slightly to create an off-surface working edge, otherwise the paint tends to seep under the ruler and blot. This can be done by taping a small piece of cardboard to the underside of the ruler.

Using a Transparent Overlay to Determine Lettering Position

In the initial stage of designing a poster, it's helpful to have some maneuverability in determining the best position of the lettering in relation to the total composition. One way to accomplish this is to roughly indicate the lettering on a strip of clear acetate or other transparent surface and then move the strip over the poster area until a pleasing arrangement is arrived at. This method permits you to see how the lettering will appear in a variety of positions.

When a satisfactory relationship is established, the exact position of the lettering can be marked on the layout, later to be rendered on the poster in the usual manner.

The transparent overlay method can also be adopted for the pictorial or other elements of a poster.

How to Find the Center of a Rectangle Without Using a Ruler

The fastest way to find the exact center of any given rectangle is to pencil in two diagonal lines, from one side of the rectangle to the other, forming an X. The point at which the two diagonals intersect represents the exact center, horizontally as well as vertically.

How to Draw Mechanically Accurate Stars

Procedure for drawing a six-pointed star:

1. With a pencil compass, draw a circle.

2. Without changing the radius of the circle, strike six short arcs around the circumference.

Ruling a line with paint (the professional term is "striping") with the aid of T-square or other straightedge is not difficult but calls for a little practice.

Edge striping (as in painting borders) requires no T-square, ruler, or other straightedge guide. The middle finger is run against the edge of the card, thus guiding the brush along the entire line.

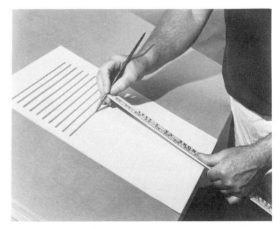

Here striping is done by holding a yardstick with the forefinger of the left hand against the front edge of the table. The brush, as usual, is held with the right hand, and as the yardstick is made to slide along the edge of the table, the brush simultaneously follows the stroke to create a perfectly straight line.

Finding the center of a rectangle.

Six-pointed star.

Five-pointed star.

Do this by placing the compass tip at any point along the circumference, then draw a short arc. Use this arc as a point from which to draw the next one, and so on until six arcs are completed.

3. Draw light pencil lines connecting every other arc (at the point where each crosses the circumference) to form an equilateral triangle. Connect the remaining three arcs in the same manner, forming another equilateral triangle. The perimeter of the overlapping triangles forms the outline of a six-pointed star.

Procedure for drawing a five-pointed star:

1. With a pencil compass, draw a circle.

2. Using a T-square, rule in diameter AB going through center C, and line CD at right angles to it.

3. Bisect line CB, creating point E.

4. With point E as a center and ED as a radius, draw a short arc crossing line AC at point F.

5. With DF as a radius, strike five short arcs along the circumference of the circle. Use D as the first point from which to draw an arc, then place the compass tip at the point where the first arc crosses the circumference to create the second arc, and so on. This will give you five equal parts.

6. Draw light pencil lines connecting every other arc at the point where each crosses the circumference, thus completing the structure of a five-pointed star.

In both the five-pointed and the six-pointed star, the size of the star is determined by the size of the circle.

Drawing Diagonal Lines With a T-square

The standard T-square is serviceable for ruling in not only vertical and horizontal lines, but slanted lines of any required angle as well. To draw a series of diagonal lines parallel to each other with the use of the T-square, try the following method: On the paper (or whatever drawing surface you're working on) pencil in one diagonal line to serve as a guide for the others in the series. With the T-square set in position on the drawing board, shift the paper so that the diagonal line is parallel with the T-square. Then tape down the paper. In this way all lines now drawn with the T-square will automatically slant at the same angle parallel to each other.

You'll find this method especially useful for ruling in pencil guidelines when doing italic and calligraphic lettering.

Dividing a Line into Equal Segments

The following method will enable you to divide any given line into a specific number of equal segments without resorting to mathematical computations. By way of example, let's say you wish to divide a line measuring 10 ⅝″ into six equal segments:

1. Draw a line AB measured off to the given length of 10 ⅝″.

2. At point A draw line AC forming an acute angle, and at a length about equal to line AB.

3. Place a ruler along line AC, and starting at point A mark off six arbitrary equal units—these can be ½″, 1″ or any convenient dimension, as long as the sum total of these does not exceed the length of the line.

4. Draw a line connecting the last marking on line AC with point B.

5. With the T-square set in position on the drawing board, adjust your work so that connecting line CB is parallel to the blade of the T-square.

6. Draw parallel lines from each marked-off point on line AC to line AB. The six points of contact on line AB automatically divide the line into six equal segments.

7. Erase all construction lines, except the marked-off points on line AB.

How to Draw a Circle Without a Compass

If the circle you want to draw is larger than the maximum span of your compass or if you don't have a compass, your problem may be solved in the following manner.

1. Cut a thin strip of cardboard about ½″ in width, making it a little longer than the radius of the circle to be drawn.

2. Puncture two pinholes in the strip, the distance between them measuring the length of the desired radius.

3. Place the strip in position on the drawing surface. In one pinhole insert a pushpin to act as a pivotal center; in the other, insert the point of a well-sharpened pencil.

4. In drawing the circle, move the strip around like the hand on a clock, pressing down on the pencil as you go along.

This method works very well for concentric circles too. All that's required is to put the pencil holes in measured-off positions on the strip.

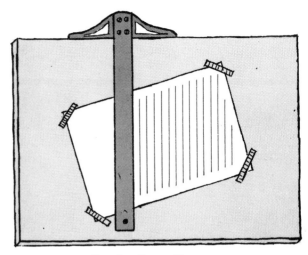

Drawing diagonal lines.

Dividing a line into equal segments.

Drawing a circle without a compass.

String method.

Quadrant method.

ELLIPSE GUIDE

Template method.

Drawing Ellipses

An ellipse (often erroneously referred to as an oval) is a circle seen in projected perspective. An ellipse is symmetrical in shape, while an oval (a term derived from the word ovum) is egg-shaped—wider at one end than at the other. You have to be an expert in freehand drawing to be able to sketch an elliptical shape with any degree of perfection. Here are several methods by which an ellipse can be drawn easily and with mechanical accuracy.

The String Method.

1. On a sheet of paper, draw horizontal line AB (representing the length of the required ellipse) and vertical line CD (representing the width of the required ellipse) at right angles to it, going through the center. The horizontal line represents the *major* axis of the ellipse, the vertical line represents the *minor* axis. The lengths of the major and minor axes determine the dimensions of the ellipse.

2. With a compass set to length CD, using C as the center, strike short arcs cutting the major axis (AB) at points F_1 and F_2. These serve as the focal points of the ellipse.

3. Insert two pushpins at point F_1 and point F_2. Insert a third pushpin at point C.

4. Tie a thin string to fit snugly around the three pushpins, forming a triangular loop.

5. Remove the pushpin at point C. Then with a pencil substituted in its place, slowly move it around within the maximum span of the loop, keeping the string taut at all times as the pencil follows the path of the elliptical shape. The string method works well for drawing large ellipses.

The Quadrant Method. In very light pencil lines, rough in freehand the approximate shape of the ellipse as well as you can and enclose it in a rectangle. Then draw vertical and horizontal lines crossing each other at right angles in the center, dividing the rectangle into four equal quadrants. Carefully redraw and refine the curved segment of the ellipse in one quadrant and erase the remaining segments. With tracing paper, transfer the master segment to the other quadrants, using the horizontal and vertical lines as register guides. When finished, smooth out any slight discrepancies at the joinings of the four segments of the completed ellipse.

The Template Method. The fastest way to draw precision ellipses is to work with a master template available at most art supply stores in a wide assortment of sizes and degree of projection.

12 Creating 3-d displays

A conventional poster can magically turn into an eye-catching display piece or even take on the three-dimensional character of a miniature stage set by the simple expediency of scoring, folding, cutting, and gluing. The effect can further be enhanced by making use of cut-out lettering and such textural treatments as flocking and tinseling. In addition, if you're at all mechanically inclined you can create a motion display where selected cut-out elements are made to move around in circles, swing back and forth like a pendulum, or perform other gymnastic animations. Motion displays of this kind are powered by a standard 1½-volt flashlight battery operating an inexpensive oscillating motor device.

Before venturing too far afield, it would be helpful to make brief reference to the composition of cardboard and how it relates to all poster and display work.

The Nature of Cardboard

All cardboard consists of a number of thin layers of paper laminated under high pressure to a "ply" of a prescribed thickness. The paper itself is produced by an involved manufacturing process by which a mixture of cellulose vegetable fibers (essentially those obtained from wood and rags) together with resins, clays, and synthetics, are cooked and "digested" to form a free-flowing pulp. The strength, density, and flexibility are determined by the ingredients that go into making the basic pulp. In the manufacturing process, the pulp (in its wet state) is made to flow over a continuously moving wire-ribbed screen. The screen vibrates as it moves along, causing the pulp fibers to mat and interlace. The structure of the wire ribs and the direction in which the pulp flows give the paper its "grain" in the finished state.

The grain is an important factor in determining which way the cardboard stock is to be cut. If the stock is cut with the grain running the wrong way, it may droop or it may not score or fold as it should. In most cases it's better if the grain runs vertically, For example, in a 20″ x 30″ vertically

held poster, the grain should run up and down, that is along the 30″ way. If the grain were to run along the 20″ way, the poster would tend to warp and droop after a short time. The thinner and less rigid the stock, the more important it is that the grain run the right way.

A good way to determine which way the grain runs is to tear a piece of the stock at both dimensions. It will tear easier and with less resistance *with* the grain than *against* the grain.

Suggested Projects and Special Effects

It's surprising what can be done with a mat knife, a pot of glue, and a little ingenuity to convert a flat posterboard into a novel three-dimensional display piece.

Three-Wing Display. Any cardboard stock can be structurally designed to take on the appearance of a one-piece "three-wing" display, consisting of a main center section and two side sections. All it requires is two vertical score-cuts. To make the two side wings face inward, score the *back* of the board; to make them face outward, score the *front*.

In scoring, first pencil in the line (or lines) where the score is to go. Then with a mat knife or razor blade held against a metal ruler, cut along the line with just enough pressure so that the blade goes no more than halfway through the stock. A score done correctly will allow the stock to fold readily—the score acting as a hinge. Scores may be cut with or against the grain, as circumstances require.

A poster designed as a three-wing display is self-supporting, that is, it can stand upright without an easel. It provides three distinct panels for lettering and for illustration, and it folds easily to smaller dimensions for storing and shipping.

Decorative Canopy. To create a three-dimensional effect simulating an overhanging canopy on a poster or display, all it takes is two parallel scores across the top. The scores are cut on the *back* of the stock so that the two planes comprising the overhang fold over toward the front. Cutting the front part of the overhang to form a

Two vertical scores create a three-wing effect.

Canopy effect achieved with two horizontal scores on top.

Simple platform effect achieved with one horizontal score on the back of the card.

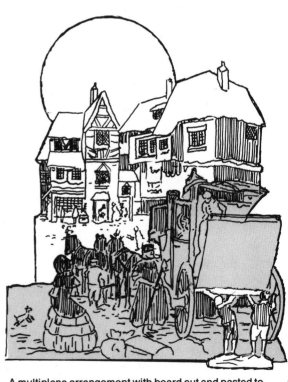

A multiplane arrangement with board cut and pasted to create a display with a stage-design effect.

scalloped edge and adding brightly colored stripes further help to create the illusion of a decorative canopy.

Platform Display. Any cardboard display piece can be made not merely to convey an advertising message in words or pictures but also to serve a more direct utilitarian purpose by providing a platform on which the advertised merchandise can be placed. A platform display may be designed to rest on the floor or counter. The simplest type of "platform" display is one where the lower part is scored to fold forward, creating a display shelf. It's possible to design platform displays with one or more steps of different heights by a series of scores and folds. Platform displays usually require an easel or other support arrangement.

Multiplane "Stage-Set" Display. You can create interesting three-dimensional display units to give the visual impression of a stage set by the manner in which two or more display boards are cut, arranged, and glued together. In a simple two-plane display, the larger plane usually serves as a backdrop to support the front element by means of a concealed, foldover, box-type easel. The easel not only holds the two planes in position creating a one-piece unit, but fixes the distance between one plane and the other.

"Take-One" Box Pocket. It's a simple matter to attach a "take-one" box pocket to any poster or display piece for holding self-distributing promotional items. Besides its obvious utilitarian value, a box pocket can add another dimension to what might ordinarily be a flat plane.

The pocket can be positioned on the poster panel flush with the bottom, in which case it needs no supporting bottom of its own, or it can be positioned anywhere on the panel if a bottom section is provided for.

To construct a box pocket *without a bottom*, measure off five sections on a sheet of cardboard of suitable thickness. These represent the front of the box, the two sides, and the glue flaps. Measurements will vary with the required dimensions of the pocket. Normally, the center section (front) is widest. With the sections marked out, score the front of the board and fold. Then glue the flaps and place in position. This type of "take-one" box pocket folds flat for packing.

To construct a box pocket *with a self-supporting bottom*, measure off five sections as before. This time include an additional section and a glue flap on the center section to form the bottom of the pocket. All scores are front scores.

Once the sides and the bottom flap are glued in place, this type of pocket won't fold flat for packing. If you want the pocket to fold flat, instead of a bottom glue flap add a tongue extension shaped to fit snugly into a slot on the display panel. When engaged in the slot, the tongue locks the bottom to the display panel; to make the pocket fold flat, the tongue is merely slipped out of the slot.

The folding box principle, with modifications in construction, can be applied to designing a variety of cardboard pedestals which may be used with (or independent of) the display panel. Such pedestals can be constructed as one-piece units, easy to assemble and easy to fold.

Cardboard Easel Construction. As an occasional user of easels, you can get them in any specified size from your local art supply store, but it's easy enough to cut your own from scrap stock you may have on hand. Two types of cardboard easels most frequently used in the poster and display field are the *single* wing and the *double* wing. Easels can be attached to the back of the board with quick-drying glue or rubber cement. They fold flat for packing and storing.

Cutout Letters. Letters adding a three-dimensional character to a poster or display panel can be cut with a mat knife, and in some cases with a jigsaw. However, for standard typeface alphabets, it's more practical to make use of precut letters readily available in paper, cardboard, felt, plastic, and wood—all beautifully machine-shaped, colored, and ready for mounting. Many don't require any gluing or nailing; they come with self-adhesive backs. Precut letters are packaged individually or in complete fonts—A to Z and numbers—in practically any size you need.

Flock and Tinsel Appliqués. Another way of achieving a three-dimensional effect of a sort is with the use of flock, tinsel, or similar appliqué material. Flock is the most widely used for simulated velour or suede finish. Flock dust consists of finely cut strands of various types of cloth (rayon, wool, cotton, etc.) and comes in a wide range of colors and lengths.

Flock is applied in this manner: Brush in the area you want flocked—it can be lettering, selected parts of the display, or entire backgrounds—with a thinned-down glue solution to serve as an adhesive. While the glue is wet, scatter the flock over the adhesive area either by hand or more expeditiously by shaking it on with a wide-meshed sieve. When the glue dries, the flock remains permanently anchored to the surface. Tinsel, glitter particles, and colored sand are applied the same way as flock.

Cardboard Easels and Displays

The cardboard displays on this page and the next can be purchased or easily constructed from waste board. The dotted line represents scores, the solid line, cuts.

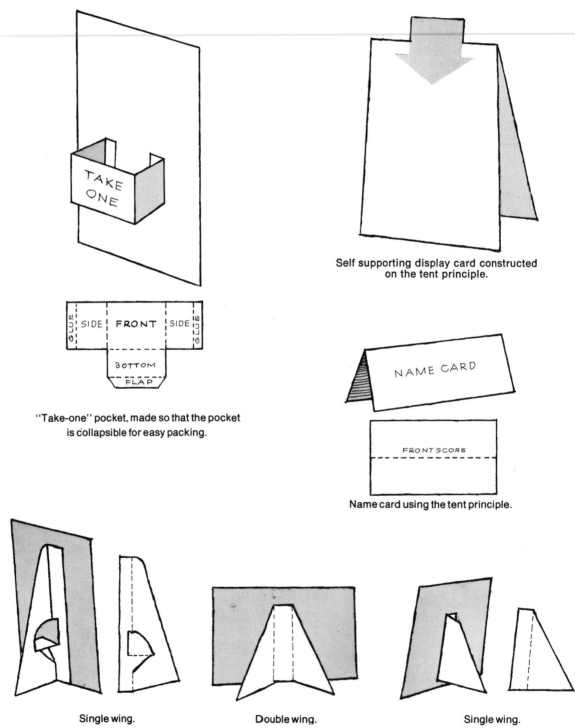

Self supporting display card constructed on the tent principle.

"Take-one" pocket, made so that the pocket is collapsible for easy packing.

Name card using the tent principle.

Single wing.

Double wing.

Single wing.

Cardboard easels can be purchased or easily constructed from waste board.

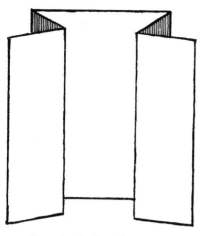

Five-wing display effect pro-
duced by a series of front-and-
back scores.

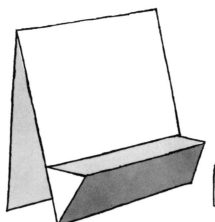

Self-supprting display incorpo-
rating a platform.

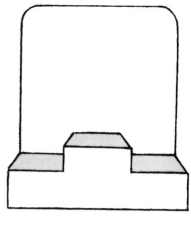

Two-level display card with three
platforms constructed to fold flat
for packing and shipping.

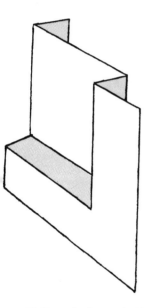

Platform display card with sev-
eral planes for art and copy.

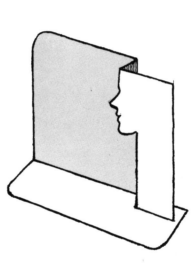

Display card combining base
platform for merchandise and
cutaway plane constructed to
fold flat.

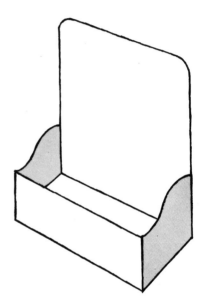

Folding box that can serve as a
merchandise platform when
combined with a display card.

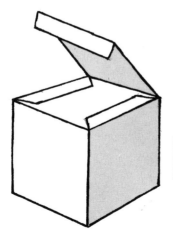

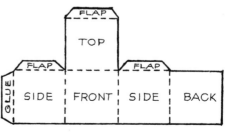

Bin-type construction for counter card display.

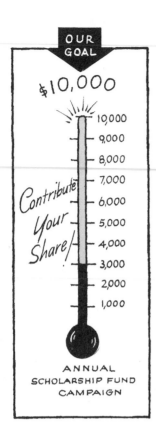

Thermometer-type chart used as a promotional piece for a fund-raising campaign.

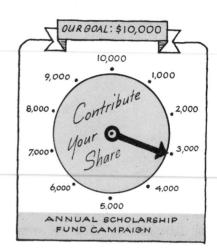

Clock-type fund-raising chart with movable hand is simple to construct and makes an effective visual aid.

Lettering cut out of stiff cardboard and mounted to a baseboard by means of small folding tabs.

Flock, tinsel, or similar appliqué material can be applied through a sieve to lettering or other design image painted with liquid glue or other adhesive compound.

Activated by a little battery-operated oscillator attached to the back of the display, the hand holding the lantern is made to swing side to side in pendulum fashion.

PART
TWO
POSTER
PRINTING

©VOLK

Relief Printing

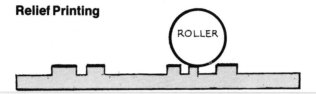

Ink rests on the raised surface of the plate, as in letterpress and woodblock.

Intaglio Printing

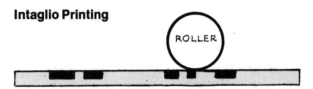

Ink is lodged within the sunken areas of the plate, as in engraving and etching.

Planographic Printing

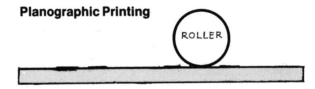

Ink rests on the surface of the plate, as in lithography and photogelatin.

Stencil Printing

Ink goes through the openings of the plate, as in silkscreen and pouchoir.

1 Introduction to printing methods

Now that you've gained a practical insight as to how to design your own posters you're ready to go ahead with learning how they're printed—better still, how you can print them yourself.

Usually, when one thinks of a printing press capable of running off large-size posters in quantity editions and in full color, one envisions a heavy piece of precision-engineered machinery, anchored to the floor and costing hundreds, if not thousands, of dollars to purchase and install. This is undeniably the case with all commercial printing methods, with the singular exception of silkscreen. While it's true that modern silkscreen printing on a commercial scale also makes use of sophisticated presses for high-speed production, the fact is that in terms of versatility and quality of reproduction, the same results are readily achievable with a hand-operated printing unit. Indeed, a good portion of all screen printing—even on a commercial basis—is done with simple equipment, much of it put together by the printers themselves.

The unexcelled adaptability of silkscreen, both as a fine and applied art, becomes all the more apparent when compared to other graphic-art processes. Generally speaking, these can be grouped into three major classifications: relief printing, planographic printing, and intaglio printing. The main distinction between the three is based on whether the printing image is *above, level with,* or *below* the surface of the plate. Silkscreen is in a class by itself. It's basically a stencil process and as such does not employ a printing plate in the ordinary sense of the term.

Relief Printing

Relief printing (printing from a plate where the design image appears as a raised surface) is one of the oldest modes of printing known to man. Historically, it's credited to Chinese artists and craftsmen who perfected the technique of printing from a raised surface cut from wood blocks more than a thousand years ago—a technique that has virtually remained unchanged to the present.

Making a woodcut involves incising and routing out parts of a flat block of wood (or heavy linoleum, in which case it's called a linocut) so that the design image stands out in relief and the surrounding area is depressed. As in all relief printing, the design is made to face backward like the letters on a rubber stamp or printer's metal type. Ink rolled over the block covers the high or relief parts only, and an impression of the design results when the block is pressed against a sheet of paper. It takes diligence, consummate skill, and many hours of cutting to create a woodcut. Today, this form of relief printing is for the most part relegated to the fine arts, although to a limited extent simple posters can be reproduced by this means.

Planographic Printing

Planographic printing generically refers to printing from a flat-surfaced plate on which the design image is neither raised nor sunken. Lithography (derived from *lithos* meaning stone and *graphos* meaning write) is the best known example of planographic printing, and while the term originally applied to printing from a stone plate, its meaning has been broadened to include printing from any flat-surfaced plate.

The principle of lithography is based on the natural antipathy between grease and water. In stone lithography, the design image is drawn with a greasy, waxlike substance (in liquid, crayon, or pencil form) on a grained limestone slab. After a chemical treatment with a solution of gum arabic and nitric acid, fatty printing ink is rolled over the wet limestone. The ink takes to the grease-drawn image but is rejected by the rest of the stone slab. An impression of the design results when a sheet of dampened paper is placed over the inked stone and pressure applied to it.

There are two distinct types of lithography: direct and offset. In *direct* lithography the print is made by direct contact between plate and paper. The design image is applied to the plate in reverse, as seen in a mirror. Lettering, for ex-

ample, is made to read backward but reverses itself in the finished print so that it comes out facing the right way. *Offset* lithography is a more technically involved process. Here, the design image is first printed on a thin rubber sheet (called a blanket) wrapped around a rotating cylinder. The wet-ink impression on the blanket is in turn offset on the paper that comes in contact with it. Thus a lithographic offset print can be said to be a "print of a print." The design image on the plate is made facing the right way, reverses itself on the blanket, and rights itself again in the finished print.

Intaglio Printing

Intaglio (pronounced *in-tal'-yo*) refers to printing from a plate that has been either hand-incised or chemically etched so that the design image appears below the surface. When printer's ink is applied to an intaglio plate and then wiped with a cloth or by other means, the ink on the surface of the plate is removed, leaving the ink below lodged in the grooves. A print is made when the plate and a sheet of dampened paper are passed through a heavy roller of a cylinder-type press. The force of the pressure and the resulting suction created cause the ink in the grooves to transfer to the paper, producing a facsimile of the design. Here again, the design image on the plate must be made to face backward, so that it will right itself in the print.

The intaglio principle of printing is the basis for hand-produced engravings, drypoints, etchings, and for certain types of wood and linocuts, as well as for gravure, a commercial process entirely produced by photochemical means.

While posters may be reproduced by hand-made intaglio plates, other methods—principally silkscreen—yield faster and more successful printing results.

Silkscreen Printing

As mentioned before, in terms of the three major categories of printing, silkscreen is in a class by itself. With other processes—relief, planographic, and intaglio—the printing is done *with* a plate; in silkscreen, which is a stencil process, the printing is done *through* a plate. It's in a class by itself for other reasons also.

Unlike comparable printing methods employed commercially or as a limited-edition graphic-art medium, surprisingly little equipment is needed to set up for silkscreen printing. The "printing press" in silkscreen is structurally nothing more than a rectangular wood frame upon which silk or other fine-meshed fabric is

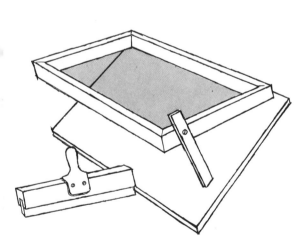

A simple screen printing unit consisting of baseboard, screen, and rubber squeegee.

stretched, a baseboard to which it's hinged, and a rubber squeegee. The unit is lightweight and completely portable. It can be purchased from most art supply dealers completely set up, or it can easily be constructed by anyone who can handle a hammer and saw.

It's the only process that prints equally well on all types of stock regardless of the nature and thickness of the printing surface: paper, cardboard, wood, metal, cloth, plastic, glass. It's even possible, with a little modification in the setup, to print directly on three-dimensional objects.

There are practically no limitations in size of printing area—anything from a bookmark or greeting card to a poster of mural proportions can be printed. Since silkscreen uses no standard presses such as are employed in lithography, etching, and other traditional printing processes, the printing unit can be "custom made" to fit the dimensions of the printing area, whatever they may be.

Silkscreen is the only printing method whereby you can successfully print with opaque as well as transparent colors. Silkscreen inks can be formulated to be 100% opaque or as transparent as you want them to be. You can print a light color over a dark background, depending upon the requirements of the job on hand. By using transparent inks, it's possible to get a multiplicity of colors through superimposition. The choice of printing inks is extensive; it includes oil-based as well as water-based inks, enamels, textile dyes, lacquers, fluorescents, and lustrous metallics.

Stencils for silkscreen printing are comparatively simple to prepare and take considerably less time to get ready for printing than hand-produced plates needed for other reproduction methods.

When the stencil is set up, the actual printing is decidedly faster and yields more uniform results than are possible with any other manually operated printing process.

Operational Principle of Silkscreen. In analyzing silkscreen operation, it's easy to see what makes this an all-purpose printing medium; why it's the ideal home and studio craft as well as why it ranks among the major commercial printing processes in use today.

The silkscreen process, often referred to as serigraphy when employed as a fine-art medium,

is based on the principle of the stencil. Everyone is familiar with the common paper or metal stencil—the kind employed for decorating walls or identifying shipping crates. Such stencil sheets require connecting ties or links to keep the inside elements of the design image from dropping out. In silkscreen printing, the design image is carried on a screen consisting of tautly stretched fine-mesh fabric tacked to a frame. The strands of the fabric hold the integral parts of the design image together, thus obviating the need for links of any kind.

Paint poured into a fabric screen will seep through the mesh, more or less as through a fine sieve. Any part of the screen blocked out by some means will act as a partial barrier in the penetration of the paint. For example, if you were to pour a quantity of red paint into a screen, place a white sheet of cardboard underneath it, squeegee the paint across, and then lift the screen, you would find that the cardboard is now coated with red paint. Proceeding one step further, if you were to mask or block out part of the screen by gluing a postage stamp to the underside, and again place a white sheet of cardboard under the screen and squeegee red paint across it, you would now have a small white unpainted rectangle (conforming to the dimensions of the stamp) on a red background.

Obviously, you're not restricted to postage stamps as a block-out medium. Any thin paper will do—cut to take on the shape of a design image. Other (and more flexible) ways of blocking out are by painting out the design on the screen with lacquer, glue, or other fluid compound which when dry forms a hard impervious mask; adhering a hand-cut film stencil to the screen; or using photographic means. Each stencil-making method has its own distinct uses and its own characteristic printing results. In all instances, the elements of the design can be made to appear in positive or negative form in the print, depending upon which part of the screen area is blocked out and which part is left open. Once the stencil is made, it can be used for printing on any stock and with any printing compound that can be made to penetrate the open areas of the screen.

In this section of the book, you'll learn how to use the silkscreen printing process with equipment you can construct yourself or buy ready made at modest cost.

2 Basic silkscreen printing materials

One of the inherent advantages of silkscreen, in addition to its unmatched versatility, is that it takes surprisingly little equipment to get professional results.

The basic screen-printing unit consists of a silk-covered frame (the screen), a baseboard or flat tabletop to which it's hinged so that it can be raised and lowered, and a rubber squeegee. Three cardboard tabs on the baseboard serve as register guides, making it possible to print the stock in a fixed, predetermined position. Much of the equipment can be homemade, stored on a shelf or in a closet when not in use, and can be put to work on short notice, as in a situation such as the following:

Bob Miller, a young public-relations executive, and his wife, Diane, have been assigned the job of producing posters for a forthcoming charity bazaar. Fifty identical posters (25 on paper and 25 on cardboard) are needed for posting at local stores and the shopping-center mall, and for fastening (with the permission of the authorities) to street poles in the immediate neighborhood. Fifty posters are far too many to attempt to do by hand—certainly not within the short span of 10 days when the bazaar is scheduled to open. What's more, Bob, who wants to help out, has no special art training—the closest he comes to art is photography, which is his hobby. Diane is the artist in the family.

Both have come to the decision that the most expeditious way to tackle this production feat is for Diane to make up a sample poster (a two-color design on white stock), submit it to the bazaar committee for approval, and then proceed to turn out the edition by silkscreen. They had solved a similar printing problem not too long ago for another fund-raising drive and now have at their disposal a temporary "production department" set up in the unused part of a two-car garage. They plan to avail themselves of the same equipment for this project as well.

Their silkscreen equipment includes a flat board on which the screen frame is hinged, a rubber squeegee to fit, and several additional screens to be on hand when needed. For drying prints on paper, Bob has strung up a taut nylon cord (with clothespins attached) across two walls; for cardboard prints too heavy for hanging, he has rigged up a long piece of firring strip with nails protruding and spaced 1″ apart. This he fastened to a wall parallel to the floor and about 10″ above floor level. By this means, rigid stock can be stood up on end between the nails like a stack of upright dominoes. The first stencil is all set for ink and squeegee; the two colors are mixed and the register guides placed in position.

Bob is now busily at work squeegeeing bright red fluorescent paint (color #1) across the screen. Each sweep of the squeegee results in a colorful design image on the white stock. In this endeavor he has the enthusiastic assistance of the junior member of the team, their young son. His task is to hang the paper posters on the cord and stand the cardboard posters upright on the floor, each in its own space between the nails.

While father and son are thus engaged printing the first color, Diane is preparing the stencil for color #2 (blue) which will "go to press" as soon as color #1 is run off and dry. In this fashion and with the use of this simple homemade equipment, the entire lot of 50 posters in two colors is silkscreened in far less time than it would normally take to do a half-a-dozen by hand—and with much better and more uniform results.

The Screen Frame

The frame serves two purposes. It keeps the screen fabric taut and also acts as a shallow bank so that the paint doesn't spill over the sides.

Dimensions. Let's assume you're planning to construct a screen unit to accommodate a *printing area* of 11″ x 14″. The specifications that follow are based on these dimensions. (A larger printing area will require a proportionally larger unit.) In all cases, the screen frame is made appreciably larger than the intended printing area—especially side to side. For our arbitrary 11″ x 14″ printing area, an ideal work size for the frame's inside dimensions would be 13″ x 24″. This allows for a 1″ clearance at the top and bot-

tom of the 11″ dimension, and a 5″ clearance on each side of the 14″ dimension, with the image area horizontally centered on the screen. As you can see, considerably more space is provided at the wider (side-to-side) dimension. This is to make room for an ample supply of ink as it's squeegeed across the screen from one side to the other during the printing operation.

Construction. Though material other than wood can be used for the screen frame, wood is by far the easiest to work with and the least expensive. For the 13″ x 24″ frame, standard firring strips or 1¼″ x 1¼″ kiln-dried, finished white pine or spruce is suggested. (Larger frames require proportionally heavier wood.) A 7- or 8-foot strip should be more than enough for the four sides of the frame. Make sure the wood is straight and free of knots.

There are a number of ways to join the corners of the frame. The butt joint is the simplest to put together; the only tools you need are a saw, hammer, and screwdriver. If you consider yourself something of a carpenter, try the half-lap joint or other joinings for extra rigidity. Whichever way you decide to construct the frame, see to it that it's perfectly flat, rigid, and resists twisting, even if forced. Gluing the joints before putting them together with finishing nails or screws helps. An L-shaped angle iron screwed to the top of the frame at each corner is an additional safeguard.

The Baseboard

The baseboard or "bed" as it's sometimes called, is the surface to which the frame is hinged and on which the stock to be printed is placed in register (correct alignment). One baseboard can be made to serve as a "master" for a number of interchangeable screen frames of the same (or approximately the same) size, if the hinges on the frame are spaced to fit those on the baseboard.

Type of Wood and Dimensions. A 20″ x 30″ sheet of ¾″ white pine or plywood obtainable at any lumberyard would make a good baseboard for the 13″ x 24″ screen frame. A discarded tabletop or a drawing board of the right size will do as well. Here again, check to see that the wood is flat and free of splits or knots. The baseboard is always made larger than the dimensions of the screen frame; the extra space allows room for a set of hinges and a side stick or other contrivance to prop up the frame.

The Hinges

Get two sets of 2″ or 3″ loose-pin hinges. These are the same type that go on doors. A hinge set

Relation between the optimum printing area and the inside dimensions of the screen. Note that more space is allowed at each end to provide ample depository for ink supply.

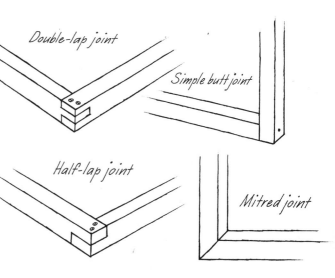

Screen frame with angle irons to reinforce corner joints.

Male and female parts of pushpin hinge and removable pin to hold them together.

Back view of screen frame hinged to baseboard.

Back view of screen frame with hinges attached to strip of wood the same height as the frame.

consists of two interlocking metal plates (a male plate with three loops and a female plate with two loops) held together by a removable rodlike pin.

To hinge the frame, first remove the pin to separate the two plates. On the frame edge fasten the male plate toward one end of the wide dimension and the female plate toward the other end, placing each about 2″ or so away from the ends of the frame. Then place the hinged frame on the baseboard, visually centering it. Now separate the plates of a second set of hinges and attach each plate to the baseboard to interlock with its counterpart on the frame.

The frame hinged to the baseboard can be raised or lowered freely. To be sure there isn't the slightest tendency of a side-to-side shift, check to see that the hinges are screwed on tightly and that the hinge pins fit snugly. Any side-to-side shift during the printing will cause trouble in register control, especially in multi-color work.

At this point it's a good idea to give frame and baseboard a good all-around sanding to remove any rough edges, then follow up with a protective coat of lacquer. This seals the wood and helps keep it from warping; it also makes the frame easier to clean after printing.

The Screen Fabric

Natural silk (produced by silkworms), originally the only fabric used in screen printing, is still considered by many to be the best all-around screen fabric. Nylon, dacron, wire cloth, and other manmade fabrics have been widely adopted in industrial and commercial screen printing. The least expensive screen fabric is cotton organdy, but it's questionable whether the savings in cost balances its inherent drawbacks. Among other things, cotton organdy is difficult to stretch without tearing, and once stretched, it doesn't retain its tautness since it's subject to changes in humidity. In addition, the weave isn't as uniform and graded as silk and some of the other screen fabrics.

For the artist and printmaker, silk is the most compatible of fabrics. It can be used with any type of screen ink formulation, is not adversely affected by strong solvents, and, stretched properly, always retains its original degree of tautness. Silk possesses remarkable tensile strength and a natural resiliency which makes it the easiest screen fabric to stretch on the frame. Silk comes in different mesh sizes, the normal range going from 6XX to 20XX, with 12XX considered the medium and most popular. (The higher the number, the finer the mesh.) Anything above

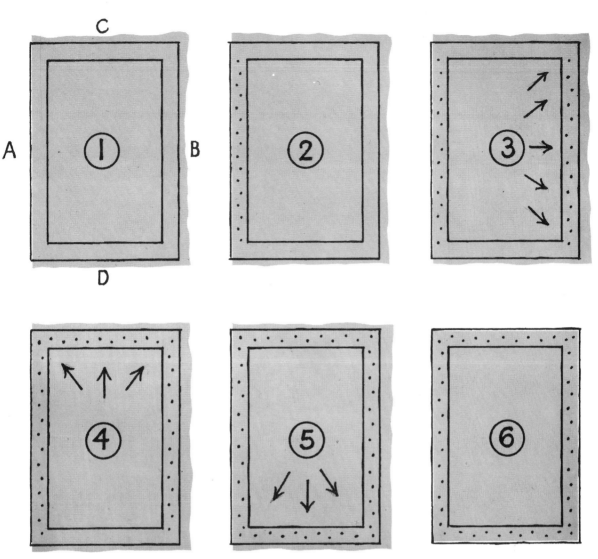

Suggested sequence for stretching and attaching screen fabric to the frame.

12XX is generally reserved for unusually fine detail and for photographic halftone reproduction. The XX signifies "double extra"—the fiber weight recommended for most screen-printing purposes.

Silk, as well as some of the other screen fabrics, is sold in standard widths from 40" to 60", and beyond. Select the width most economical for your frame dimensions. Lengths are cut to any size specified, although dealers prefer to sell by the yard.

Attaching the Fabric to the Frame

The fabric when stretched and tacked to the frame becomes the *screen*. It's important to end up with a screen that's as taut as a drum. Here's one way of going about it:

1. Line up the fabric so that the mesh runs parallel to the frame. Don't worry about which side of the fabric is to face up; there's no right or wrong side. To give you an ample edge to grip for stretching, cut the fabric about 2" larger than the outer dimensions of the frame.

Place one edge of the fabric (preferably the selvage edge) flush with side A (see the illustration above). Bear in mind that the fabric is to be tacked to the *face* of the frame, not around the edges, as is the custom in stretching artist's canvas.

2. Using heavy staples (or #4 carpet tacks), fasten the fabric to side A, spacing them about 1" apart. It works best if you start at the center, alternately stapling on each side of center until the entire side is stretched and stapled.

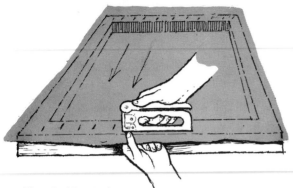

Many find the staple gun easier to use than hammer and tacks since it allows one hand to be free to stretch and hold the fabric as it is being fastened to the frame.

Pull pliers, the kind used for stretching artists' canvas, come in handy for gripping the screen fabric when fastening it to the frame.

Gummed-paper binding over the tacked areas provides an additional safeguard against leakage and also covers the tacks for a smoother surface.

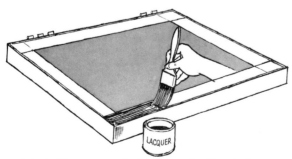

A coat of lacquer over the binding makes it easier to wash the screen and reinforces the bond between binding and fabric.

No special effort is required to stretch the first side. Just be sure to leave no wrinkles between staples. If you're using tacks, be sure to drive them all the way into the wood. It's the *head* of the tack, not so much the stem or shaft, that keeps the fabric anchored to the frame.

3. Firmly gripping the fabric and pulling it forcefully toward you diagonally, staple the opposite side (side B). Again begin at the center, alternating from side to side of center. You may find it easier to get a better grip on the fabric with a canvas stretcher (a tool resembling a pair of wide-lipped pliers that artists sometimes employ for stretching canvas.) Be careful, however, not to pull so hard that you tear the silk, especially from under the staples already in place.

4. Next do side C or D; it doesn't matter which. This calls for a somewhat less forceful pull, but nonetheless make an effort to leave no slack or wrinkles.

5. Now stretch the last side, again pulling the fabric as tightly as you can from the center out, and staple it down.

6. With a single-edge razor blade, trim the excess fabric that overhangs the edges of the frame. Then brush a coat of lacquer over the stapled areas, going ½" or so into the open mesh. The coating acts as an adhesive and helps reinforce the bond between fabric and wood.

Taping the Screen

To safeguard against the possibility of printing ink oozing through the edges where fabric and wood meet, it's essential to seal both the inside and the back of the screen. For this, a 1½" wide gummed paper tape—the kind used for sealing packages—is recommended. The procedure is as follows:

1. Place the screen, fabric side up (the side bearing the staples), on a worktable and cut four strips of tape measured to the outer dimensions of the frame.

2. Water-moisten the gummed strips and place them over the surface of the frame, covering the staples and extending about ¼" into the open screen area. Rub down well. Be sure to press out trapped air bubbles.

3. Turn the screen over (fabric side down) to tape the inside along the edges where fabric and wood meet. Now cut four strips of tape to fit the inside dimensions of the frame. Fold each strip in half and paste it down so that one half lies flat on the fabric and the other half fits snugly

against the inside edge of the frame. Then reinforce the four corners with small strips of gummed paper tape as an additional safeguard against leakage.

4. Brush all taped areas—both inside and on the back of the screen—with lacquer. This coating prevents the possibility of ink going through the tape during the course of printing. It also facilitates washing the screen.

The Squeegee

The squeegee consists of a strip of thick rubber belting partly encased in a wooden holder. It is dragged across the screen, causing the printing ink to squeeze through (hence the word squeegee) the open parts of the stencil image onto the surface to be printed.

There are two distinct types: the *one-hand* squeegee and the *two-hand* squeegee. The one-hand squeegee (which has a center-grip handle) is *pushed* across the screen with one hand while the two-hand squeegee is gripped with both hands and is *pulled* across the screen. It doesn't make much difference which type of squeegee you select; it's mostly a matter of what you get used to.

You can construct your own squeegee by purchasing the rubber belting separately and sandwiching it between a casing of two slats of wood, with the rubber extending about 1¼″ beyond the casing. Rubber belting, generally 2″ wide and ⅜″ thick, is sold by the inch. If you wish to purchase the casing only, that too is available. It's advisable, however, at least at first, to buy the squeegee completely assembled and ready for printing. Dealers carry a line of squeegees which they cut to the length you want, so you're not restricted to standard sizes.

For our 13″ x 24″ screen (inside dimensions), the squeegee should measure about 11″ or 12″. This allows for some leeway up and down. If the squeegee is made any larger, it may not fit the screen. If too small, it may require two crossings to cover the full width of the design image. Overlapping crossings can often prove to be objectionable because of a noticeable pile-up of ink where the strokes overlap. It would also take considerably more time to do the printing.

The rubber belting is the working part of the squeegee. It's available not only in natural rubber, but in neoprene and polyplastic as well. In any form, it's made in different degrees of pliability—soft, medium, and hard. You'll find a natural rubber squeegee with medium pliability adequate for almost all your printing projects—it's also the least expensive. The neoprene and plas-

Gummed-paper binding pasted on the inside of the screen helps keep the ink from oozing through between the fabric and the frame.

Two-hand squeegee.

One-hand squeegee with grip handle in center.

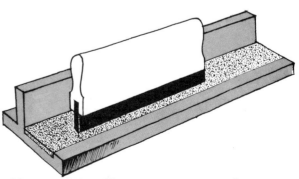

A few even strokes of the squeegee across a sandpaper block restore the rubber blade to its original sharpness.

tic squeegees are mostly reserved for commercial work. It takes thousands of impressions for the blade to show signs of wear. When it begins to dull, a dozen or so strokes over a sandpaper board or garnet cloth will restore the edge. Properly taken care of, the squeegee can last almost indefinitely.

Screen-Lifting Devices

There are a number of ways to keep the screen in a raised position (about 35° angle) when inserting and removing the stock before and after a print is made. The simplest device is a little, loose-hanging wood stick attached to one side of the frame. When the screen is raised, the stick drops down by its own weight; when lowered, it lies flat with the surface of the baseboard. Shown below and on the next page are some semiautomatic lifting devices that you can set up if your printing projects run into large editions. For limited editions, the dropstick is adequate.

Drying Devices

Normally, screen inks dry within 20 to 30 minutes, some even faster—but none dry instantly. You must therefore provide adequate means for keeping the wet prints separated during drying. At the beginning of this chapter we saw that the Millers solved the drying problem by stringing up a cord with clothespins attached. They also rigged up a strip of lumber with protruding nails for stacking on the floor prints too heavy to hang. You can likewise improvise these and other drying facilities to meet specific conditions.

With the screen unit and auxiliary equipment assembled and set up, you're ready for the next phase. This encompasses the various methods of stencil preparation best suited to faithfully reproduce your original artwork in any quantity you wish.

Screen-Holding Devices

Various devices you can improvise to keep the screen propped up when placing the card in register and after the print is made.

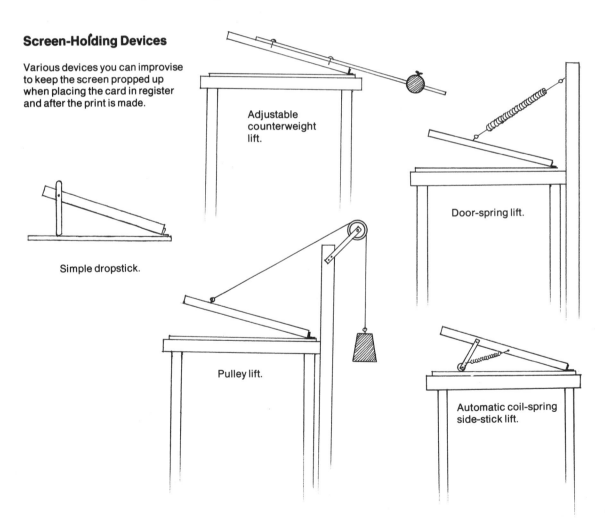

Adjustable counterweight lift.

Door-spring lift.

Simple dropstick.

Pulley lift.

Automatic coil-spring side-stick lift.

Print-Drying Devices

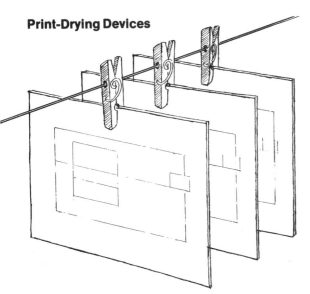

Hanging the prints with clothespins strung on taut wire or string.

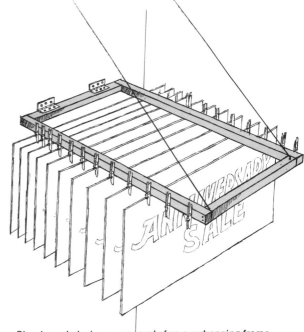

Simple rack device composed of an overhanging frame which may be raised out of the way when not in use. Clothespins nailed to the sides of the frame hold prints during drying.

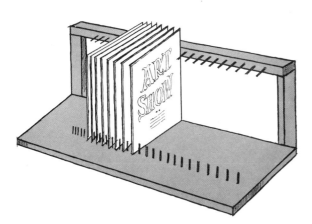

A rack stand that can be placed on a table for stacking rigid cards for drying.

Coil spring fastened to a board for stacking rigid cards.

A long strip of wood with nails or pegs keeps rigid cards stacked upright on the floor for drying.

A festoon-type parallel-bar arrangement works well for drying long paper banners, piece goods, and other flexible stock.

Professional fold-over drying rack available in various dimensions in wood or metal. The rack's self-balancing tension-spring construction permits trays to be raised or lowered for easy placement and removal of prints.

3 Hand-cut film stencils

The working principle of the hand-cut film method is based on the use of an emulsion-type film tissue which when cut and adhered·to the screen forms the stencil image—the emulsion acting as a blockout medium for the printing ink. This method is reserved for work where sharp lines and precise detail are essential to the quality of the printed results. With the handcut film method you can reproduce the design and lettering with literally knife-edge sharpness. A well-made film stencil can give you as many prints as you can possibly use—thousands if required—without loss of quality.

For general poster reproduction, the film method of preparing stencils has other practical features. Your artwork doesn't need to be meticulously finished or even completely colored in. All that's really necessary is a clean outline drawing in pen or pencil. Then too, with the proper selection of stencil film, it's feasible to print with a complete range of screen inks, including oil-based or water-based inks, enamels, fluorescents, etc.

Materials and Equipment

The tools used in making the stencil are unsophisticated and inexpensive, comprising mainly a small stencil knife, a circle cutter, and a few incidentals.

Stencil Knife. Unlike the usual array of cutting tools of various sizes and shapes used in woodblock and similar printmaking crafts, no wide assortment of stencil knives is required for preparing film stencils. The same stencil knife can be used for cutting broad areas as well as fine detail. There are several types, but functionally they are identical. Some have fixed blades, some have removable blades, and some have rotating swivel blades. The choice is a matter of personal preference.

Circle Cutter. A compass, the kind used for drawing circles, is also serviceable for cutting circles in film by inserting a small blade in the part that usually holds the lead point. Blades to

fit the compass are readily available. Special film-stencil circle cutters can be had for unusually small circles or extra large ones.

Honing Stone. Normally, the stencil knife keeps its cutting edge for a long time. When it does require a bit of honing or sharpening, a small sharpening stone such as the fine-grained Arkansas stone is excellent for the purpose.

Acetate Triangle. This serves as a straightedge for guiding the stencil knife when cutting mechanically straight lines.

Work Lamp. A gooseneck lamp or other adjustable source of light such as a "floating-arm" type artist's lamp is helpful when cutting fine detail. It's superior to overhead illumination because the light can be directed to the exact work area you want.

Stencil Film. The basic blockout medium for the hand-cut film stencil method is a transparent film consisting of an emulsion-layer temporarily laminated to a plastic or glassine backing sheet. The emulsion layer is cut and subsequently becomes the stencil tissue; the backing sheet merely acts as a temporary support. Stencil film with the plastic backing sheet is in many ways superior. It has exceptional transparency, lies flat regardless of changes in temperature and humidity, cuts smoothly, and adheres to the screen very easily.

There are two basic types of hand-cut stencil film: a *lacquer* film which is adhered with a lacquer thinner, and a *water-soluble* film adhered with water. For limited production needs and home use, water-soluble film has the advantage in that no volatile or flammable solvents are used in the process of adhering and dissolving the stencil tissue. With water-soluble film, all screen-printing inks can be used with the exception of those that are of water-based formulation. Lacquer film, on the other hand, is exceptionally durable—it practically never wears out. With lacquer films it's possible to print with water-based inks as well as other ink formulations which don't contain a lacquer solvent.

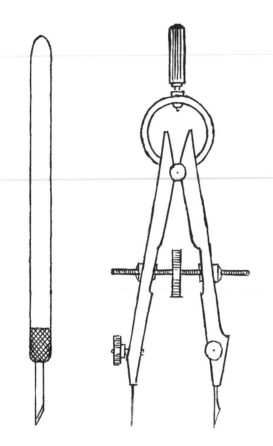

(Left) Simple, inexpensive stencil knife with replaceable blade. (Right) Bow compass with small stencil-blade attachment cuts mechanically perfect circles. The radius is regulated by turning the center wheel.

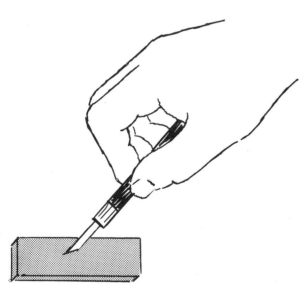

A pocket-size Arkansas honing stone is useful for keeping the stencil blade sharp.

Adhering and Removing Fluids. For lacquer film, the adhering fluid is a species of lacquer thinner formulated specifically for the particular film used. It's best to purchase it from the same source as the film to assure compatibility. The removing fluid for lacquer film (a more potent lacquer thinner) is needed to dissolve the film image so that the screen can be reclaimed and used for a new project. When working with any type of lacquer thinner or other volatile solvent, adequate provision must be made for proper ventilation, with care taken to keep such material covered when not in use and away from open flame and excessive heat.

Water-soluble film requires no special adhering or removing fluids. Ordinary tap water serves both purposes.

Blockout Fluid. The open area on the screen surrounding the adhered film must be blocked out by some means to keep the ink from going through beyond the perimeter of the film. Several commercial blockout fluids are available for the purpose, however, a thin solution of LePage's water-soluble glue or a lacquer mixed to a thin consistency is all that's required. For short editions, a sheet of paper cut to fit the open area and taped to the underside of the screen will do as well.

Making a Film Stencil

In this and other stencil-making techniques described in the chapters to follow, the design to be reproduced will (for the sake of instructional clarity) be confined to a single color. The technical aspects of multicolor work—how to reproduce a design in two or more colors and get them to register properly—are described in Chapter 7.

1. Cut the film to size. Measure off the film size you need, cutting it several inches larger all around than the dimensions of the art to be reproduced.

2. Tape the film over the art. Center the film (emulsion side up) over the art and fasten it securely in position with small strips of masking tape.

3. Trace-cut the design image. Hold the stencil knife almost perpendicular to the surface, and with the tip of the blade follow the outlines of the art as you see them through the film. You'll see the cuts made by the knife more distinctly if your light source is adjusted to catch the glint of the incisions. Trace-cut the *upper* (emulsion) layer only without penetrating the backing sheet. This may seem a bit tricky at first, but by exerting a minimum of pressure on the stencil

knife, it's easily achievable. If the blade is sharp—as it should be—it will glide along the lines smoothly and easily. Although you may wish to cut everything freehand, you may make use of the circle cutter or compass with blade attachment for cutting mechanically perfect circles and a celluloid triangle as a guide for straight lines.

To assure that the film will strip easily within the cut areas, slightly extend your cuts wherever two lines intersect. Overcuts, though visible on the film, seal up automatically in the process of adhering; none show up in the print.

4. Strip the film. Place the tip of the stencil blade at any intersecting cut on the film, hold a finger against the flat of the blade, and lift upward to get a start. Then with the film held between two fingers, or with a pair of tweezers if you like, lift the cut areas away from the backing sheet. Remember, *the areas you strip away are the areas that print.* With a soft-haired brush, or a piece of masking tape wound around your finger with the adhesive side out, remove any stray pieces of film, specks of dirt, or other foreign matter within the stripped areas. After the film has been adhered, it's bothersome—at times almost impossible—to dislodge these without impairing the stencil.

5. Set the register guides. Place the art (with film still attached) on the baseboard, visually centering it under the screen. Then tape it down in position. Set the register guides by cutting three small pieces of cardboard (approximately ½" x 1") about the same thickness as the stock you'll be printing on. Staple, tack, or otherwise affix one of these flush against the lower left (or right) side of the art and the other two along the bottom, spaced a good distance from each other. The cardboard tabs when affixed to the baseboard serve as register guides.

The three-point guide system assures that the stock to be printed can always be set in the same fixed position on the baseboard. This makes it simple to quickly and accurately align all subsequent colors in multicolor reproduction.

6. Prepare the screen fabric. Check to be sure that the screen fabric is free of sizing, grease, or dust. A scrupulously clean screen is a prerequisite to good adhering. The usual routine is to sponge down the screen with warm water and Ajax, or similar scouring powder, rinse, and allow to dry thoroughly.

7. Adhere the film. Remove most of the tape that holds the film to the art, leaving only two small pieces to keep it from shifting out of position.

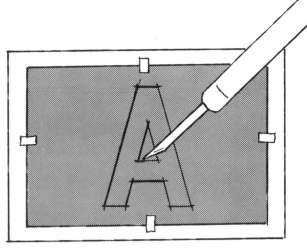

Trace-cutting the outline of the design with the stencil knife.

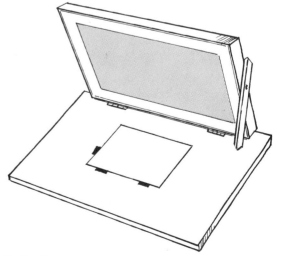

Stripping the film within the trace-cut areas. The stripped areas will print.

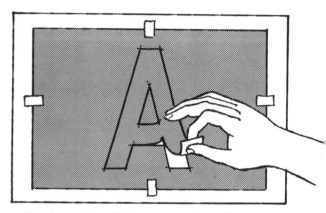

Setting the three register guides on the baseboard.

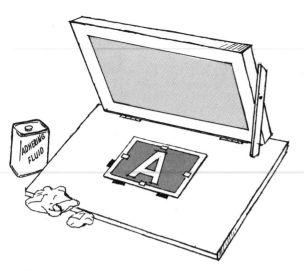

Placing the art with film attached in the guides.

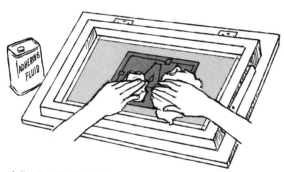

Adhering the film to the screen.

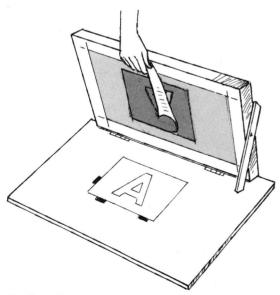

Peeling off the backing sheet to open the stencil.

Lower the screen, making sure that fabric and film are in perfect contact.

To adhere lacquer film, get two lintfree rags ready, preferably soft flannel or cotton. Saturate one rag with lacquer-thinner adhering fluid. Wring it out well so that it's damp, not dripping wet. Holding the damp rag in one hand and the dry one in the other, apply the damp rag to the surface of the screen directly over the film area, and wipe off immediately with the dry rag.

Do this in a systematic way. Start at the upper left-hand corner, covering about a 6″ square area at a time, alternating the wetting and drying routine as you proceed in one direction. Or else, start at the center and go outwards. From time to time, turn the dry rag over to get a fresh surface or change rags as necessary. *Don't rub or press down with either wet or dry rag.* The mere moistening and drying action is sufficient to make the film adhere to the screen.

Properly applied, the adhering fluid should soften the lacquer film just enough for it to cling to the screen fabric. Too much fluid will dissolve the film completely, or cause the edges to be blurry or "burned."

The faster the adhering fluid is applied and removed, the better the adhesion, and the sharper the edges of the stencil image.

To adhere water-soluble film, moisten both sides of the screen with water while the screen is in a raised position. The wetness is necessary to make the fabric receptive to the film. While the screen is wet, lower it to come in contact with the film underneath. Then move a water-wet sponge lightly across the surface of the entire screen area in a few overlapping strokes. Remove excess moisture by blotting gently with clean (preferably white) newsprint, changing the paper until most of the moisture is absorbed. Allow to dry naturally or use a fan to hasten drying time.

8. Remove the backing sheet. When the film is thoroughly dry, raise the screen. You'll note that the film has detached itself from the art and now clings firmly to the underside of the screen.

To remove the backing sheet, start at one corner and pull it gently away. Having served its purpose as a temporary carrier, it can now be discarded.

The removal of the backing sheet opens the stencil image.

9. Mask out the open screen area surrounding the stencil film. Raise the screen slightly by propping it up with a strip of wood or other object so that the fabric doesn't come in contact with the baseboard. Then with a sharp-edged piece of stiff cardboard used in the manner of a

squeegee, scrape an even layer of blockout fluid on the open area surrounding the film, overlapping the film edge ½″ or so. Coating the screen with a scrape card is faster than with a brush and yields better results. Allow the blockout fluid to dry normally or use a fan if you're in a hurry. Then apply a second coat in the same manner to assure complete coverage.

If you wish, you may disengage the screen from the baseboard and block out the open screen area, doing this on a worktable. (In this case, the blockout medium can be applied either to the top or the underside of the screen.) When dry, reengage the screen. Another way, especially when printing short editions, is to block out the open screen with a paper mask. Almost any kind of thin paper will do, but newsprint or bond paper seems to work best. To prepare a paper mask, cut an opening slightly smaller than the perimeter of the stencil image. Then fasten it to the underside of the screen with a few pieces of tape. In the process of printing, the natural viscosity of the ink acts as an adherent and makes the paper stick to the screen.

10. Examine the screen. If there are any pinholes or leaks in any part of the screen, touch them up with the blockout fluid, using a brush of appropriate size. After the screen is checked over, the stencil is ready for printing.

Reclaiming the Screen for Reuse

To remove lacquer film from the screen, wet the underside with removing fluid. Place several sheets of newspaper on the baseboard and lower the screen. Pour a liberal amount of removing fluid into the screen and swish it around with a soft rag. After a few minutes, when the lacquer film image begins to blur and disintegrate, raise the screen and remove the saturated newspapers. You'll note that most of the film in its dissolved state comes away with it.

Any bit of film remaining on the screen is easily dislodged by rubbing both sides simultaneously with a small suede brush or rag saturated with removing fluid. After an additional wash, dry the screen thoroughly with a soft, absorbent rag.

To remove water-soluble film from the screen, sponge warm water on both sides and rub down vigorously until all evidence of film disappears. For faster results, you can place the screen in a sink or drain tub and hose it down with a strong spray of warm water. Follow this with a cold-water rinse and allow to dry.

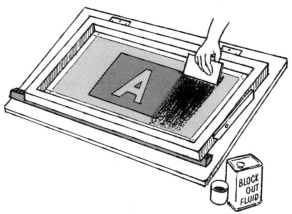

Masking out the open area of the screen surrounding the film.

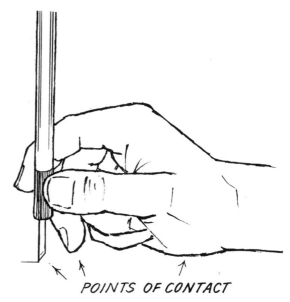

POINTS OF CONTACT

When cutting film, grip the stencil knife with just enough pressure to cut through the film without penetrating the backing sheet.

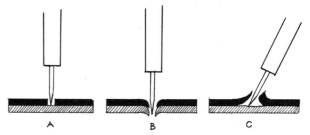

Schematic view showing how the quality of a film cut is affected by the position and pressure of the stencil blade. (A) *Good*—blade is perpendicular and the pressure applied is just enough to cut the film without penetrating the backing sheet. (B) *Poor*—blade is perpendicular but too much pressure cuts both the film and the backing sheet. (C) *Poor*—pressure is right but blade cuts the film at an angle causing the film surface to lift.

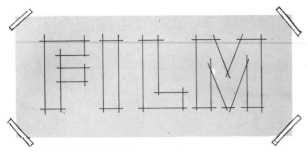

To facilitate stripping the trace-cut areas, be sure to overcut slightly at all intersecting lines. Overcuts seal up in the adhering and don't show up in the print.

The quality of the film stencil depends largely on care in adhering it to the screen. Use clean, soft cloths both for wetting and drying the film.

An expedient way to block out the open screen area surrounding the film is to attach a sheet of paper with a "window cutout," taping it to the underside of the screen.

Additional Notes on Hand-Cut Film Stencil Preparation

To check the cutting edge of the stencil blade, cut a series of closely spaced crosshatch lines on a piece of film. If the blade is sharp, the areas between the intersecting cuts (no matter how small) stay in place; if the blade is dull or has developed a burr, the intersecting areas pop up. The crosshatch test is also a check on the freshness of the film. Fresh film will steadfastly hold intersecting areas.

Feather-touch pressure is all that's necessary to cut through the thin layer of emulsion without depressing or going through the backing sheet. Look at the underside of the backing sheet. If you see an indentation caused by the pressure of the knife, you are cutting too deep. This not only slows up the cutting but impedes ease of adhesion.

If an isolated segment of film (for example, the inside triangle of the letter A) has shifted, dropped out, or has been stripped by mistake, it can be reset without difficulty. Just put it back in place and press it down. There's usually enough residual adhesive to make it stick; if not, dab a bit of diluted rubber cement on the back.

A sheet of paper or acetate placed under the hand while cutting will help protect the surface of the film from smudges and grease marks. Film that's kept clean adheres the easiest.

To establish better contact between film and screen fabric, it's sometimes helpful to place a "pack-up" of several sheets of cardboard underneath the art bearing the film. This pack-up, to be effective, must be made smaller than the inside dimensions of the screen.

Keep an electric fan blowing on the screen while adhering the film. A flow of cool air helps evaporate the adhering fluid before it has a chance to settle in the mesh and thus "burn" the edges of the stencil.

It's important to allow the film to dry thoroughly before stripping the backing sheet. Premature stripping may lift up the film edges or pull along some of the elements of the design, seriously impairing the quality of the stencil.

After adhering is complete and the backing sheet removed, it's a good idea to wipe the underside of the screen with a cloth dampened with mineral spirits. This removes any trace of adhesive used in the manufacture of the film to hold the emulsion to the backing sheet.

Hand-cut film stencils were employed for this 19" x 25", two-color poster, designed and reproduced by the screen printing class of the High School of Art and Design, New York.

4 Paper stencils

In theory, cutting paper stencils is as simple as cutting out paper dolls. This method of stencil preparation is by far the fastest of all stencil-making methods employed in screen printing. Minutes after the stencil is cut it's ready for ink and squeegee. There's no involved adhering process to go through. Since paper, which forms the stencil sheet, is made full size to cover the entire screen area, there's no masking out. It's also the least expensive of the stencil methods. The cost of paper is negligible—almost any paper will do—and there are no adhering or removing solvents to purchase.

Counterbalancing these apparent advantages are certain technical limitations which must be considered. Paper stencils are comparatively fragile, thus making them unsuited for printing extended editions. Unlike some of the other stencil methods discussed in this book, the paper stencil method is limited mostly to large design areas.

Materials Needed

Just a few items are all that's required in the preparation of hand-cut paper stencils.

Cutting Tools. There are no standard cutting tools strictly reserved for cutting paper stencils. It's mostly a matter of personal preference. A frisket knife, which is basically a stencil knife with a somewhat larger blade, is fine, but a single-edge razor blade is equally functional. In fact, in some ways it may be even more desirable because you don't have to bother sharpening it. Discard it when it dulls, and get a fresh one.

As a rule, paper stencils are cut freehand. However, if you want mechanical precision, a compass cutter can be used for circles and a celluloid or metal straightedge employed as a guide for straight lines.

Honing Stone. If you prefer working with a frisket knife instead of an expendable razor blade, a honing stone will be needed to keep the knife blade sharp. A drop of machine oil will lubricate the stone's surface, making sharpening easier.

Stencil Paper. Practically any fairly absorbent transparent or semitransparent paper makes a good stencil sheet. This includes tracing paper, bond paper, sign-painters' poster paper, even a good grade of white newsprint. Whatever paper you select, it's important that in addition to a degree of transparency, it be fairly thin, flat, and free of creases and ripples.

Making a Paper Stencil

Fundamentally, making a paper stencil involves laying down a sheet of paper on the baseboard, trace-cutting the design, lowering the screen to pull an ink impression, and then stripping the cut areas to open the stencil.

1. Set the register guides. Place the art in a predetermined position on the baseboard and set the register guides in the manner described in the previous chapter.

2. Cut the paper to size. Cut a sheet of stencil paper a little larger than the inside dimensions of the screen. Place it over the art and with several small strips of masking tape fasten it to the baseboard to keep it from shifting.

3. Trace-cut the stencil sheet. After checking the sharpness of the cutting tool, carefully trace-cut along the outlines of the art, as you see them through the paper. With a little practice you'll instinctively know how much pressure to apply to the tool to cut through the paper without cutting into the art below. From time to time lift the cut segments to see if they've been cut through properly, and place them back in position.

4. Code the cut segments. With a pencil or felt-tip marker, place an X (or other symbol) over each cut segment. This will help identify the part to be stripped later on.

5. Release the stencil sheet from the baseboard. Carefully remove all tape that holds the stencil sheet to the baseboard. Avoid any motion which might cause the stencil sheet or any of the segments to move out of position. Then very slowly lower the screen.

6. Adhere the stencil sheet. Pour a liberal quantity of screen ink into one side of the screen, and with a firm and even pressure, squeegee it across to the opposite end. Then pass the squeegee over once or twice more to be sure that the ink fills the mesh of the screen and penetrates to the stencil sheet below.

You shouldn't be concerned about ink coming through and spoiling the art still positioned on the baseboard. At this stage, the stencil sheet, though cut, has not as yet been stripped.

7. Strip the stencil sheet. Slowly and carefully raise the screen. You'll note that the entire stencil sheet now clings firmly to the underside. The natural viscosity of the screen ink is sufficient to keep the stencil sheet and all its parts independently adhered to the screen. To open the stencil, merely strip or peel off the coded segments. Then fasten several pieces of masking tape along the edges of the stencil sheet as to keep it from shifting during printing.

Upon removing the art from the baseboard, proceed with printing the edition.

Reclaiming the Screen for Reuse

No special solvents are needed to remove a paper stencil from the screen. When the printing is done and the screen cleared of ink and washed, the stencil drops off of its own accord. Any segments that may still cling to the screen are easy to lift off. A paper stencil cannot be rerun.

Additional Notes on Paper Stencil Preparation

If the paper selected for the stencil isn't quite clear enough to see through, a little kerosene, turpentine, or oil applied to the surface will appreciably improve its transparency.

Avoid using paper which has been tightly wound around a core. It tends to curl, making it troublesome to cut and adhere. It's preferable to buy the paper in sheet rather than roll form.

The sharper the cutting edge of the blade, the less pressure will be required to cut through the stencil paper and the easier the cutting will be.

A sheet of heavy-gauge acetate positioned between the art and the stencil paper will protect the art during the cutting and at the same time provide a smooth undersurface to work on.

Although overcuts at intersecting lines normally don't show up in the print, it's good practice to keep overcuts to a minimum and make them as short as possible.

If the screen ink is of the proper viscosity, the island segments of the stencil image (for example, the inside of the letter O) usually remain in their fixed position in relation to the rest of the stencil, the ink acting as an adhesive. As an added measure, to keep the segments from shifting during the course of printing, the following procedure is suggested.

When the screen is in a lowered position over the stencil sheet just prior to pouring in the ink for adhering, place a spot of quick-drying, water-soluble glue (or lacquer) on the screen mesh directly over the island segments and press down momentarily with your finger. As the glue seeps through the screen and dries, it securely anchors the segments.

With paper stencils, the consistency of the screen ink is of paramount importance if it's to serve as an adhering agent. If the ink is too fluid, it won't hold the stencil sheet on the screen; if the ink is inordinately heavy, difficulty will be encountered in pushing it through the screen. Ink with a fluid but buttery consistency works best.

Bear in mind that once the paper stencil is adhered to the screen and the printing started, the entire edition must be completed without undue delay. A paper stencil cannot be preserved for a rerun. It's strictly a quick "one-shot" medium.

If an impasto or slightly embossed printing effect is desired, the paper selected for the stencil must be of somewhat heavier weight. The thickness of the paper largely determines the thickness of the ink deposit.

To a limited degree, interesting textured edges are achievable with paper stencils if the paper (instead of being cut in routine fashion) is torn or singed around the edges.

Although an ordinary single-edge razor blade works well as a cutting tool for paper stencils, better control is achievable with a frisket knife such as the one shown here.

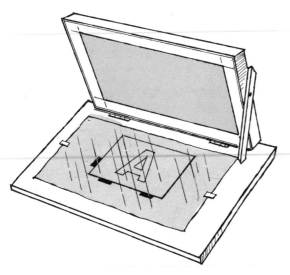

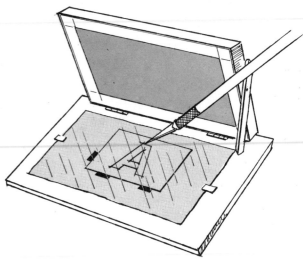

Positioning the stencil paper over the artwork set in the register guides.

Trace-cutting outlines of the design as seen through the paper.

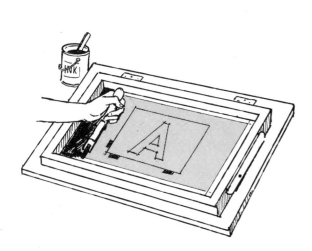

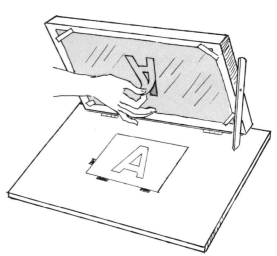

Adhering the stencil by squeegeeing ink across the screen.

Stripping the areas for ink to go through.

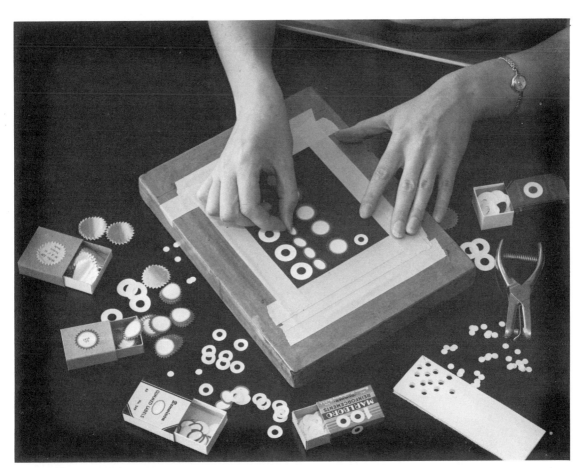

Interesting negative image effects can be achieved by pasting precut paper shapes to the underside of the open screen areas.

ABCDEFGHI
JKLMNOPQ
RSTUVXYZ

An ideal freehand alphabet for use with paper stencils. There are no delicate parts to worry about, and no "islands" or centers within letters to shift or drop away.

An 18-color commercial poster produced by the photostencil method with hand-painted positives rendered in drybrush technique. Lettering on top was printed from a handcut-film stencil. Print by the author.

5 Photographic stencils

So far we've outlined the procedures for preparing stencils by the hand-cut film and paper methods. Though each of these possesses distinct advantages for general poster reproduction, both are normally restricted to flat-color techniques with a minimum of textural treatments and subtle tonal qualities. These technical limitations can be largely overcome by the adroit use of the photostencil methods described in this chapter.

With photographic stencils, practically any art technique done with brush, pen, or crayon can be reproduced with maximum fidelity. More than that, you'll be able to reproduce work too small or fine in detail to be attempted by hand, as for example, lettering the size of the type on this page, fine-line engravings and photographs that appear in newspapers and magazines as well as those made by yourself—and print them in any quantity. A well-made photostencil has unexcelled durability.

Materials and Equipment

You don't have to own a camera or elaborate darkroom equipment to achieve creditable results with photographic stencils. There are no involved formulas or recipes to compound. The few simple chemicals needed are easily obtainable—often in convenient, premeasured form supplied by the manufacturer. The equipment needed costs comparatively little to acquire. The chances are that you already have most of them on hand.

Trays. You'll be using two trays: one for developing, one for washing out. The tray size will depend upon the dimensions of your design. Professional photographers favor trays made of stainless steel, but these are expensive. Glass, plastic, or porcelain trays are fully adequate for the purpose. Pyrex baking pans of the right size will do, also.

Rubber Gloves. Chemicals for photostencil preparation generally present no serious problem in handling. Nonetheless, it's always advisable to wear rubber gloves as a precautionary measure against any possible dermatological reactions while working with sensitizing and developing solutions.

Spray Hose. A shower hose or any flexible hose with spray attachment is serviceable if it can be connected to a hot-and-cold-water faucet. The hose is used in the washing-out process as well as when reclaiming the screen.

Water Thermometer. This is a standard item obtainable in all hardware stores. You'll need it to test the temperature of the water when developing the photo image.

Measuring Cup. A common household article, a measuring cup comes in handy in making up sensitizing and developing solutions.

Timer. In photostencil preparation, no split-second timing is called for. Exposure time is measured in minutes, not seconds. Consequently, an ordinary kitchen timer is okay. A more sophisticated timing device, if desired, can be purchased at any photo-supply house.

Exposure Lights. There is considerable latitude in the kind and intensity of light that can be used in the exposure phase of preparing the stencil. Professionals prefer carbon-arc lamps. For home and studio use, however, photoflood bulbs, GE sunlamp-type bulbs with reflector, or fluorescent-light units are quite adequate, though the time of exposure will be relatively longer.

Electric Fan. A portable electric fan will be useful for cooling and drying the emulsion during several phases of the photographic procedure.

The above constitute most of the essential equipment needed for preparing photostencils. With the exception of the exposure lights, none wears out in use. You may, of course, later add to your stock of equipment or subtitute more professional gadgetry—as your enthusiasm for the process grows and as circumstances warrant.

Miscellaneous equipment includes a *sheet of clear plate glass* to act as a contact weight during exposure; a *felt or foam-rubber pad* to assure

good contact between the positive and the sensitized surface; a *safelight* or *bug bulb* for subdued illumination. Expendable material includes *photostencil film*, *direct photostencil emulsion*, *sensitizing chemicals*, *blockout fluid*, and *opaquing compound*. These can be purchased as required.

The Photographic Principle Applied to Stencil Preparation

The underlying principle which makes it possible to produce stencils photographically can be demonstrated in the following way.

Let's say you coat a silkscreen with a water-soluble gelatin emulsion that's been made photographically sensitive to light and allow it to dry. You then cut a simple silhouette of a bird out of black opaque paper, place it in contact with the sensitized coating and expose the setup under a strong light. Here's what happens: The actinic action of the light brings about a chemical change in the coating so that the areas exposed to light are no longer soluble in water. The areas shielded from the light aren't affected and remain water soluble. When the screen is washed with water, the unexposed or light-shielded parts dissolve and wash away; the exposed parts do not. The result is a photogram-type of stencil image on the screen conforming to the size and shape of the paper cutout of the bird.

In this simple demonstration, the opaque cutout has served as a vehicle for creating a positive to block out the light. Instead of using cut paper, we can create a simple silhouette—or for that matter any design or lettering—by applying opaque paint to a sheet of clear film, tracing paper, or other transparent material.

Whether you make your own transparent positive or have it done by a professional photoengraving or copy service, the results are the same: what is represented in opaque form on the positive will upon exposure yield an open or printing image on the screen.

About Transparent Positives

The term *positive* requires a brief explanation to counterdistinguish it from *negative*—a photographic term with which you may be more familiar. The difference between the two is as follows: In a negative, the black and white values of the original subject are reversed. What is white (transparent) on the subject is black (opaque) on the film; conversely, what is black on the subject is white on the film. In a positive, black and white values on the film are the same as those on the subject.

Positives (which are employed more frequently in photostencil preparation) may be made by hand or by camera.

Handmade Positives. The design image on the transparent surface can be rendered with black paint, India ink, crayon, china marker, or special opaquing compound made for the purpose. The artistic technique and the tools you use are optional as long as the resulting image is distinctly in black and white or what is technically referred to as "line work." Categorically, line work includes not only lines of any thickness, shape, and size but also solids, stippling, crosshatching, drybrush, spatter, etc. Since photographic stencils are usually made as contact prints with the poster placed directly on the sensitized surface, the transparent positive must be the same size as the intended print.

Camera-Made Positives. You can have your transparent positive made by camera by sending the art (whether it be type matter, lettering, or design) to a commercial photoengraving or photocopy house. The art will be photographically transferred to a transparent film to serve as a positive suitable for photostencil preparation. In addition to line work, the camera can, with special equipment, convert continuous tones into half-tone dots, thus making it feasible to reproduce photographs and illustrations of all kinds. The image on a camera-made positive can be made same size, reduced, or enlarged, as required.

Making a Photostencil

Basically, there are two main approaches to photostencil preparation, the *direct* method and the *transfer* method. The direct method involves coating the screen fabric directly with an emulsion that has been chemically made light-sensitive; the transfer (or indirect) method involves the use of a sensitized film that's transferred and adhered to the screen.

The Direct Method. The emulsion used in the direct method can be obtained either in presensitized form ready for exposure or in a nonsensitized form which must be sensitized by the user. The advantage in the latter is that you can sensitize the emulsion just before you make the exposure, thus assuring maximum sensitivity to light. The procedure for working with both forms of emulsion is essentially the same, except that when using the presensitized form, step 2 (sensitizing the emulsion) is omitted.

1. Check the screen fabric. For photographic work especially, it's of utmost importance that

the screen be scrupulously clean. With a cloth or sponge wash down both sides of the screen fabric with warm water and an automatic dishwasher powder. Rinse thoroughly and then give the screen a final brisk wash with cold water. Allow it to dry.

2. Sensitize the emulsion. Make up a bichromate sensitizing solution, combining it with the emulsion following the manufacturer's data sheet. For example, the directions may require you to dissolve 1 ounce of ammonium bichromate in 8 ounces of lukewarm water. The sensitizing solution is then added to the emulsion in the ratio of 1:5, that is, 1 part sensitizing solution to 5 parts emulsion.

3. Apply the sensitized emulsion to the screen. Using a rigid, sharp-edged piece of cardboard in the manner of a squeegee, apply an even coat of sensitized emulsion to both sides of the screen, waiting for one side to dry before doing the other. With a fan going, drying should take no more than 15 to 20 minutes for the first side and less time for the other side. Care must be taken to work in a clean, dustproof area to avoid dust settling on the coated screen.

In its wet state, the sensitized emulsion is not highly sensitive to light; it becomes light-sensitive only upon drying. The general practice is to work under subdued illumination.

4. Set up for the exposure. For proper exposure conditions, perfect contact must be established between the positive and the sensitized screen. This can easily be done by improvising a contact arrangement consisting of a pack-up and a sheet of clear glass. The pack-up may be a foam-rubber pad mounted on a cardboard or wood platform built up to be slightly higher than the screen frame and small enough to fit within the inside dimensions.

Position the sensitized screen, fabric side up, so it rests flat over the pack-up. Center the positive on the screen with the image on the positive *facing down*, so that lettering (if any) reads backward. Place the sheet of glass on top of the positive (weighted down on each side if necessary) to be sure that the positive and the sensitized surface of the screen are in close contact. This can be done under subdued lighting.

Suspend the exposure light unit directly over the center of the area to be exposed so that the light rays strike the surface evenly.

The distance of the exposure light unit from the surface to be exposed depends upon the type of light used, its intensity, and the dimensions of the design image on the positive. For example, if you're using a GE-sunlamp bulb to expose a 12"

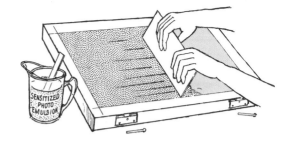

Coating the screen with sensitized emulsion.

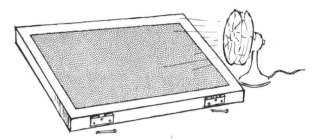

Setting the screen to dry. A fan hastens drying considerably.

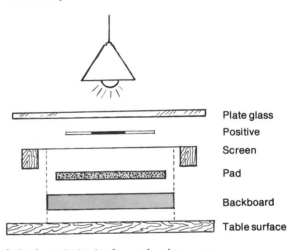

Plate glass
Positive
Screen
Pad
Backboard
Table surface

A simple contact setup for overhead exposure.

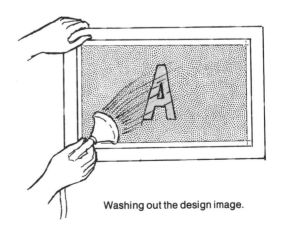

Washing out the design image.

The Transfer Method

Cutting the photofilm to size.

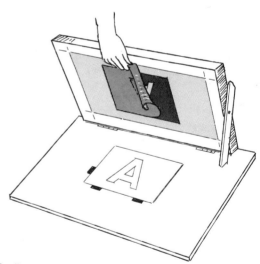

Schematic view of simple contact setup for photofilm exposure using overhead light source.

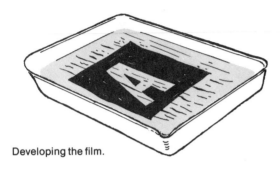

Developing the film.

Washing out the film with spray of water directed over the design-image area.

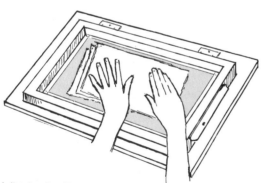

Adhering the film to the screen.

Peeling away the backing sheet to open the stencil.

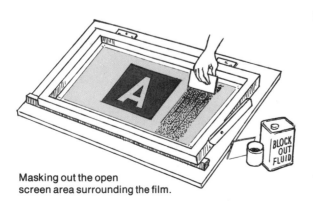

Masking out the open screen area surrounding the film.

x 18″ area, the light source would normally be about 20″ above the contact setup. (The distance would have to be increased if the same light were used to expose a larger area.)

5. Make the exposure. For the 12″ x 18″ area with the light source about 20″ above the contact setup, the exposure time might be about 4 or 5 minutes. Exposure time varies widely from just a few minutes to as much as 15 or 20 minutes, depending upon many conditions—not only the nature and the intensity of the light and the distance of the light from the contact setup, but also to a great extent on the nature of the design image on the positive, the temperature and humidity of the air, the freshness of the sensitized solution, etc. For best results, make preliminary tests to establish the right exposure time for a given set of conditions. Guidelines relative to exposure schedules and preliminary testing are given in manufacturers' data sheets.

6. Wash out the design image. Dismantle the contact setup. Then, with the screen held upright in a sink or drain tub, direct a moderately strong spray of lukewarm water to both sides. The areas on the screen shielded from light during the exposure interval begin to wash away. When that happens, you'll see the design image appear and take shape. Continue washing until the image is clear and sharply defined. Follow up with a spray of cold water. The washing should take no more than a few minutes and may be handled under normal lighting conditions.

7. Dry the screen. Place the screen between several sheets of white newsprint or paper towels and blot gently to absorb excess water. Continue this blotting procedure, changing papers as needed. Then allow the screen to dry either naturally or with a fan.

8. Inspect the stencil. Carefully examine the stencil for any evidence of pinholes, leaks, or other irregularities. Touch up with lacquer or other blockout fluid where necessary. Then engage the screen on the baseboard.

The Transfer Method. In the direct method just described, the photo emulsion is in *fluid* form and is applied directly to the screen. Upon drying, it's exposed and washed out to create a stencil image. In the transfer method, the photo emulsion is in *film* form which after an exposure, developing, and wash-out sequence is transferred to the screen to become the stencil.

The photostencil film for the transfer method consists of a sheet of gelatinous emulsion supported on a clear plastic backing. It's available in two forms: *presensitized* and *nonsensitized*.

There are a number of different types of presensitized films on the market but, with minor technical variations, the procedure for their use is basically the same. Nonsensitized film calls for an additional step involving coating the film with a sensitizing solution prior to exposure. The film most recommended for home, school, and studio use is the presensitized type and is employed in the procedure described here.

1. Check the screen fabric. Follow the usual cleansing procedure to assure that the screen fabric is free from dust, grease, or sizing.

2. Cut the film to size. Cut the film several inches larger than the design image on the positive, placing the rest back in its original container. Although this type of film (unlike conventional camera-speed film) is not actinically highly sensitive to ordinary room illumination, it's good general practice to work under subdued lighting conditions, away from direct sunlight or bright fluorescent lights.

3. Set up for the exposure. Position the film (*emulsion side down*) on a padding made of foam rubber or thick black felt. Center the positive (*image side down*) on the film, so that the design appears in reverse as if seen in a mirror. (If lettering is part of the design image, it should face backward, that is, right to left.) Then place a sheet of clear glass over the positive, weighting it down at each end (if required) to assure good contact between the positive and film. As in the direct method, suspend the overhead exposure light directly over the center of the area to be exposed so that the light rays strike the surface evenly.

4. Expose the film. The same conditions which effect exposure time in the direct method—namely, type and intensity of exposure lights, distance away from the sensitized surface, nature of the positive, etc., apply to photostencil film exposures as well. Approximate exposure schedules mentioned in the manufacturer's photofilm data sheets can serve as a guide. Determining optimum exposure time under a given set of conditions, however, is mostly a matter of testing and acquired judgment based on your own experience.

5. Develop the film. For this you'll need a developing solution. Manufacturers of photofilm supply the two basic chemicals which when combined make up the developing solution. These come conveniently measured out in two separate packets with specific directions for mixing. The procedure is simple and can be carried out in subdued light.

To develop the film, here's what you do. After the exposure phase, place the film, emulsion side up, in a tray and pour the developer uniformly over the surface of the film. Use a sufficient amount of developer to completely cover it. Rock the tray occasionally to stimulate the action of the solution. After a minute or so, remove the film and place it, *emulsion side up*, on a sheet of glass (or other rigid nonabsorbent surface). At this stage the film is ready for the next step, which is washing out.

6. Wash out the film. Direct a gentle spray of warm water (about 95°F., 35°C.) over the entire film surface. You'll see the design image begin to emerge and get clearer and clearer as that part of the emulsion shielded by the opaque design image on the positive during the exposure dissolves and washes away. Follow up with a spray of cold water to chill and set the film.

7. Adhere the film. The film (still supported on the sheet of glass) is now ready to be adhered to the screen. Place it in a predetermined position on the baseboard, lower the screen, and press firmly to establish good contact between fabric and film.

To remove excess moisture as it seeps through the screen fabric, place several sheets of paper towels on the surface of the screen, and blot gently with the palm of the hand or with a soft cloth. Continue blotting until very little or no moisture comes through. Change the paper toweling when necessary. Allow the film to dry naturally or use a fan if you wish.

8. Remove the plastic backing sheet. When the film is thoroughly dry, raise the screen. You'll note that the entire film tissue (with plastic backing still attached) has fully adhered to the underside of the screen. The backing sheet can now be removed to open the stencil. To do this, lift one corner of the sheet and gently pull it away from the film.

9. Mask out the screen area surrounding the stencil tissue. Since the film tissue is usually smaller than the inside dimensions of the screen, the open mesh surrounding it must be blocked out. This can be done with any blockout fluid available. For short runs, a paper mask taped to the underside of the screen should prove to be sufficient.

10. Inspect the stencil. Check the stencil for possible pinholes and leaks. Touch up where necessary with the blockout fluid.

Reclaiming the Screen for Reuse

When no longer needed, there are ways of dissolving the stencil image, enabling the screen to be used again.

A photostencil made with the transfer film method is generally somewhat easier to reclaim than one made with the direct emulsion method. In the former, the stencil tissue merely *clings to the surface* of the screen fabric; in the latter the stencil tissue is virtually *embedded within the mesh* of the screen fabric.

To reclaim a transfer photofilm stencil, sponge both sides of the screen with hot water until the film tissue swells and shows signs of softening. Follow up with a brisk rubdown with a small handbrush, concentrating mostly on the side where the film is. Finally, hose down with a forceful spray of hot water.

To reclaim a direct photo emulsion stencil, follow the same washing procedure. It may take a bit more time and effort to soften and completely dislodge the emulsion within the screen mesh. A commercial enzyme formulated specifically for removing photostencil emulsion (obtainable from silkscreen suppliers) will readily dissolve stubborn areas which fail to respond to the hot-water treatment. When using an enzyme, it's necessary to stop its further chemical action by neutralizing it with a vinegar-water solution, then to follow up with a forceful spray of cold water.

Special Effects with Photostencils

There are a number of ways to achieve special effects photographically. Here are some that you may want to try.

Photograms. A photogram is a print resulting from the use of an opaque object as a "positive." Paper or thin cardboard when cut to form a silhouette of the design provides a simple means for creating a photogram. Photograms can also be created with such things as pressed flowers, leaves, paper clips, coins, hairnets, rubber bands, and a host of other fairly flat, opaque objects. Some very interesting textural effects can be achieved with rice, salt, grass, sand, and anything else, large or small, that has sufficient opacity to block out light. In the preparation of a silkscreened photogram, the objects are placed on a sheet of glass, clear acetate, or other transparent material, or directly on the sensitized surface, and exposed in the usual manner. A photogram may be used as a design motif by itself or in combination with other design elements.

Photogram silhouette images achieved by positioning opaque objects to block out the light on sensitized surface during the exposure interval.

A fine-line engraving faithfully reproduced
with the photostencil method.

A screen print in five colors reproduced from
a snapshot with stencils using camera-
separation positives.

Simulated Drypoint. A positive made in the manner of a drypoint etching offers possibilities for experimentation. Briefly, here's the procedure. Place a sheet of heavy-gauge celluloid or similar hard-surfaced plastic over a prepared line drawing. With an engraver's needle or other sharp-pointed tool, trace-scratch the lines of the drawing on the celluloid surface. Rub an opaque ink (black preferred) into the engraved lines. Remove whatever ink is left on the surface with a cloth dampened with the compatible solvent, then wipe dry. The opaque line image on the celluloid comprises the positive. From there on, the procedure for making the photostencil follows the usual course.

Texture Sheets. These sheets can mechanically produce dotted, linear, or other textural effects with a uniformity that is difficult, if not impossible, to achieve by hand. Most art-supply stores stock a variety of them.

Texture sheets come in dozens of different patterns, preprinted in opaque inks on transparent tissue. When applied to a positive, the selected pattern becomes an integral part of the design image. Similar preprinted sheets are available in hundreds of typefaces and lettering styles, all of which can be transferred or otherwise applied to the positive and incorporated into the design. Also available are pressure-sensitive shading sheets which make a wide range of tonal effects achievable with one printing.

Additional Notes on Photostencil Preparation

To effectively block out the light on the positive, the design image must be opaque. To check opacity, hold the positive up against a light. Touch up or repaint where necessary.

Instead of painting in the design on a sheet of clear acetate to create a handmade positive, the design can be trace-cut with a stencil knife using a special film such as the Ulano Rubylith. This film, though optically transparent, has the property of blocking out light during the exposure phase.

For hand-painted positives, you can use any clear or transparent surface, including glass, acetate, or tracing paper. Even white bond paper, if mineral spirits are applied to increase its transparency, will serve the purpose. The greater the degree of transparency, the less exposure time will be needed to create the stencil.

Whether the positive is handmade or camera-produced, be sure to keep it free of dirt, grease, and fingerprints. They show up as pinholes or leaks in the stencil.

Under a given set of circumstances, over-exposure results in loss of detail; underexposure results in a weak stencil which is susceptible to pinholes. The more intense the light and the shorter the exposure, the sharper the stencil image will be.

Always use a fan while exposing. Heat emitted by the light source tends to harden the sensitized surface, making it brittle.

A superior stencil image results when the developing is done without loss of time, directly after exposure. If that can't be arranged, cover the sensitized surface, keeping it dustfree and lightproof until it can be developed. Best results are achieved when the developing solution is freshly mixed. However, any solution left over can be stored for a short time in a brown bottle to protect it from reaction to light. Because developing solutions tend to generate an expandable gas, they shouldn't be kept tightly stopped.

When stripping the backing sheet from the film after it has been transferred to the screen, make sure that the film tissue is thoroughly dry. If you're too hasty in removing the backing sheet, you may spoil the stencil.

If you don't expect to use a photostencil for a repeat edition, it's better to wash the image off soon after printing. The longer a photostencil is stored away, the more difficult it becomes to remove the stencil image.

6 Blockout and resist stencils

Prints made with the blockout and resist methods described in this chapter are characterized by somewhat soft edges and frequently by minute pinholes which develop either in the preparation of the stencil or during the printing operation. While these are generally conceded to be serious technical limitations for routine poster reproduction, they aren't considered as such in the freer and more experimental procedures entailed in fine art and decorative printmaking. Most artists and printmakers find in the blockout and resist methods a responsive medium for experimentation and improvisation, and employ these methods singly or in combination with knife-cut and photostencil methods to achieve the full range of effects they are striving for.

Blockout Method

Broadly speaking, any means by which parts of the open screen are blocked out to create a stencil image can be categorically classified as a "blockout" method. This is true irrespective of what the blockout medium may be—glue, paper, film tissue, photographic emulsion. In the more restricted terminology of the craft, however, the blockout method refers specifically to that procedure whereby a film-forming fluid such as glue, lacquer, or shellac is used to create a stencil image on the screen by blocking out some parts and leaving others open. The open parts become the positive (printing) image; the blocked-out parts become the negative (nonprinting) image.

In the simple blockout method, the artist traces a carefully worked-out design onto the screen and then brushes on the blockout fluid, which when dry closes the screen mesh. There are venturesome souls, however, who work from a mere idea sketch and through improvisations create the design image directly on the screen while applying the blockout medium. In this case, the approach, is that of a creative art medium rather than a mechanical reproduction technique. No matter how the original design is conceived or how it's carried out, once the block-

out fluid is applied to the screen and forms an impregnable barrier for the printing ink, the stencil is ready for printing.

Tusche-Glue Resist Method

To make a tusche-glue stencil, the artist paints or draws his design on the surface of the screen with lithographic tusche—a black, slightly greasy compound which comes in liquid, crayon, and pencil form. The tusched-in design on the screen is, in a sense, a preview of the finished print except that on the screen the image is black (the natural color of the tusche), whereas in the print it can be any color, depending upon the ink used.

After the tusche is applied, the entire surface of the screen (tusched-in design and all) is coated over with a quick-drying, water-soluble glue. When the glue dries to a hard film, the tusche is ready to be dissolved. This is done by applying mineral spirits (a solvent for the tusche) to the underside of the screen directly below the tusched-in areas. As the tusche dissolves, the glue particles on top (now having nothing to hold onto) scale off, opening the stencil image.

The blockout and tusche-glue stencil methods permit wide latitude in textural improvisation as well as linear treatment. Both methods can serve as a means of duplicating an existing design in as many colors as are required for a faithful reproduction. However, their main feature lies in the fact that a decorative or abstract design can be evolved extemporaneously during the process of stencil preparation and the application of color. The blockout fluid, as well as the tusche, can be applied to the screen not only by using brushes, pens, and other conventional art tools but also by sponges, burlap, crushed paper, and carpet swatches, used additively or subtractively. With these and other means, many effects (some of them quite accidental) are obtainable which endow the print with a unique character of its own, quite distinguishable from prints produced by knife-cut and photographic stencil methods.

Glue Blockout Method

1. The artwork to be reproduced.

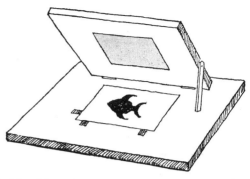

2. Artwork is positioned in the register guides on the baseboard.

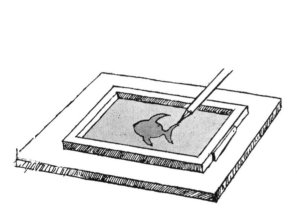

3. The outlines of the art are traced with pencil or pen.

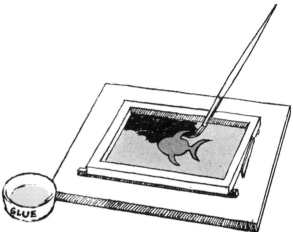

4. With the screen slightly propped up to keep the fabric out of contact, the area *surrounding* the outline tracing is blocked out with water-soluble glue or commercial blockout fluid, to create a positive image. To create a negative (nonprinting image) the area *within* the traced lines is blocked out.

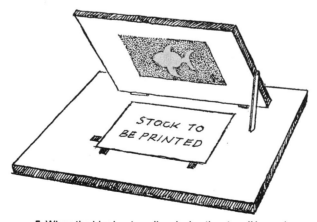

5. When the blockout medium is dry, the stencil is ready for ink and squeegee.

Tusche-Glue Resist Method

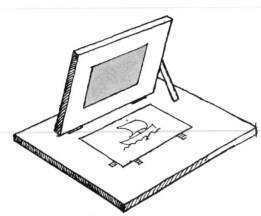

1. The artwork is positioned in the register guides on the baseboard.

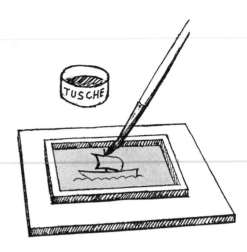

2. The design is duplicated on the surface of the screen with lithographic tusche.

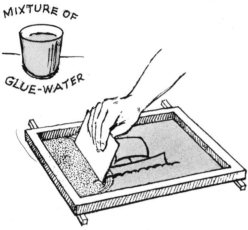

3. A thin coating of water-soluble glue is spread over the entire surface of the screen, including the tusched-in design image.

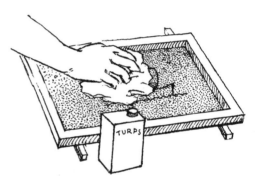

4. With the screen propped up on strips of wood (or raised on its hinges), the tusched-in design image is washed on both sides with turpentine or similar mineral spirits. This dissolves and washes away the tusched areas but does not effect the glue.

5. The screen is dried with soft cloth to absorb any evidence of residual mineral spirits.

(Left) Simple one-color print produced with the tusche-glue resist method.

(Above) Interesting textural effects possible with liquid tusche painted over the screen fabric or rubbed with tusche in crayon form over grained surfaces such as linen, sandpaper, leather, etc.

(Left) A one-color print produced with the glue blockout method. The white areas shown as a negative image were those blocked out on the screen with glue.

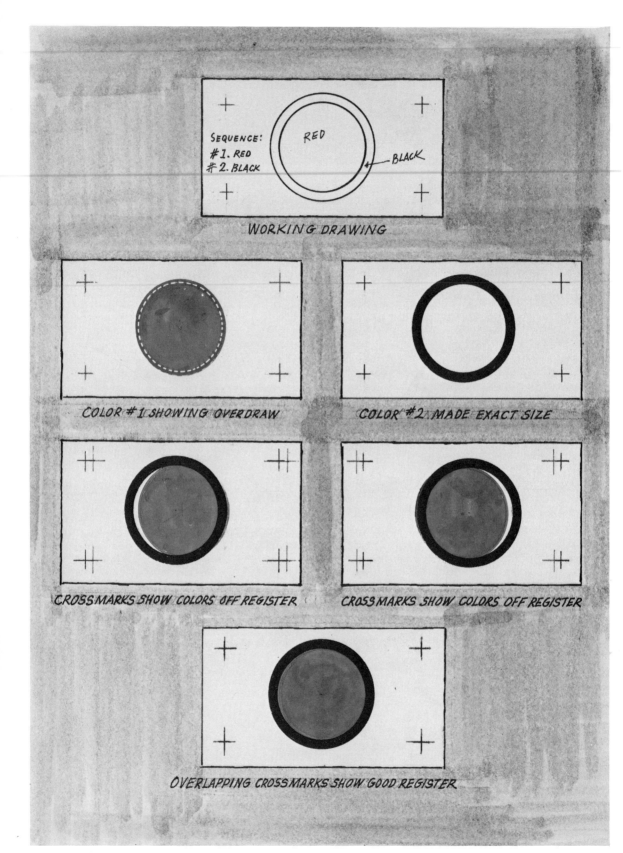

Crossmark register system in the preparation of stencils for reproducing designs in more than one color.

7 Reproducing multicolored posters

Up to now the methods of stencil preparation have involved designs in one color. You're now ready to see how stencils are prepared and set up for multicolor work.

In most cases, a separate stencil and a separate printing are needed for each color. Thus, for example, a poster reproduced in five colors normally requires five stencils and five printings. It's possible to get a multiplicity of colors with a limited number of stencils and printings through the use of transparent inks. This, however, is a bit more involved and will be discussed later in the chapter. Since the general run of poster printing is done mostly with opaque inks, we'll first outline the procedure for doing multicolor reproduction with that in mind.

Stencil Preparation for Printing with Opaque Inks

For the sake of simplicity, let's say you want to reproduce a two-color design calling for two separate stencils, one for each color. How to prepare each of these stencils and get them to register will be the present task. In order that we may deal with a specific situation, let's assume that the design to be reproduced is centered on a white cardboard, the same size as the stock to be used in printing the edition. The basic design consists of just two elements—a 5″ solid red circle surrounded by a 1″ black outline. The printing is to be done with opaque inks using hand-cut film stencils.

A number of preliminary steps are necessary before preparing the stencils:

1. Draw register marks by making four small crosses (like the fine hairlines on a gun sight) in pencil or ink, one at each of the four corners of the art. These need not be more than ½″ in length. The crossmark system is what all printers go by to check on register control in multicolor work.

2. Plan the order in which the colors are to be printed. There are no hard and fast rules for determining the sequence of colors when printing

with opaque inks, but here are some helpful guidelines: It frequently works best to print the background area or main element first, the smaller elements later. Thus if a poster consists of dark blue lettering on a yellow background, you would print yellow (the background) first; dark blue (the lettering) second. Wherever feasible, it's better (though not always necessary) to print light colors prior to the dark ones. In using lettering or another design element where an outline surrounds a solid area (as in the case of our hypothetical circle design), it's technically desirable to print the solid area first.

3. When you've decided on the sequence in which the colors are to be printed, jot it down somewhere in the margin of the art, as a production note. In the present instance, this would read:

COLOR SEQUENCE

Color #1, red
Color #2, black
(to be printed with opaque ink using hand-cut film stencils)

This production note may not seem too important in a simple two-color job such as this. In a more ambitious project, however, involving many colors and many stencils, it will help you keep track of the order in which the stencils are to be made and printed.

Preparing the Stencil for the First Color

1. Cut the stencil film. As usual, tape the film over the art. Make sure that the sheet of film is large enough to include the four crossmarks.

Cut the red area with a circle cutter, making it about 1/16″ larger all around than it is on the art. This extension beyond the actual area, or "overdraw" as it's called, provides a margin of safety to compensate for any slight discrepancies in register during the printing.

With the aid of a straightedge, cut the lines of the crossmarks; for the time being they are to be considered as part of the design. Remember,

each line—no matter how thin—has to be cut on four sides, otherwise the film won't strip.

2. Strip the stencil film. Strip the film within the cut areas. This includes the solid circle as well as the crossmarks.

3. Set the register guides. Place the film (still taped over the art) on the baseboard and fasten the register guides in the usual position—two on the bottom edge of the art, one at the side.

4. Adhere and set up the stencil for printing. Remove most of the tape that holds the film to the art, leaving just enough to keep the film from shifting. Lower the screen and adhere the stencil following the usual procedure. Then raise the screen and peel away the backing sheet to open the stencil. Remove the art from the baseboard and block out the open screen area surrounding the film.

5. Proceed with the printing operation. Pull several "artist's proofs" to check that everything is right. That done, close up the open crossmarks on the screen with small strips of masking tape applied to the underside; then continue printing the entire edition with color #1.

Note. Save the proof sheets. You'll need them to check the register for color #2.

Preparing the Stencil for the Second Color

The procedure for making the stencil for color #2 (black) follows along the same line as for the first color, but with this important difference: this time, do *not* overdraw. Cut the black outline (in this case, the second and final color to be printed), making it the *same* size as on the art. Include the crossmarks. Strip the film, adhere it to the screen, peel away the backing sheet, etc. The stencil is all set for ink and squeegee.

Check color registration by running off the artist's proof sheets you had set aside when printing the first color. Assuming that everything was done correctly, i.e., the stencils cut and adhered accurately, the printing stock placed snugly against the register guides, there was no side-to-side movement of the screen, etc., then the black crossmarks should coincide exactly with the red ones. The alignment of the four crossmarks determines whether the colors are in accurate register. Block out the crossmarks and continue to print the entire edition. Because the ink is opaque, the red overdraw won't show up in the finished print.

When printing with opaque inks the procedure for cutting the stencils to register in three, five, or any number of colors is the same as the simple two-color design just described. Wher-

ever one color is adjacent to or overlaps another, overdraws are necessary for proper alignment and register control of colors. This holds true no matter what stencil-making technique is used.

Stencil Preparation for Printing with Transparent Inks

The stencil-making procedure for printing with transparent inks is fundamentally the same as for printing with opaque inks, except here the overdraws are used for trapping one color underneath another to get additional color effects, rather than as a means of controlling register. For example, in our hypothetical design, if we were to print transparent black to partly overlap the red, we would get an additional color—brown. The finished print would show a solid red circle surrounded by a two-color outline—brown (where the transparent black overlaps the red) and black where the color prints on the white surface.

When printing with transparent inks, to get more vibrant and pronounced color effects resulting from trapping one color underneath another, it's best, wherever feasible, to print the deeper or darker color first, the lighter (overlapping) color next. Also, it's good to bear in mind that the final color effect depends to a large extent on the degree of transparency of the overlapping colors.

Printing with transparent inks can be a practical as well as an artistic advantage. It means that with a limited number of stencils and printings, a wide range of color effects can be achieved. Through proper superimposition of colors, it's feasible to end up with three or four times as many distinct colors and shades as are actually printed. The expanded color range made possible by the adroit use of transparent inks has a special appeal for artists who look upon screen printing as a creative art medium rather than as a formalized duplicating process.

In view of the apparent advantages of transparent inks, why then not work with them exclusively? Why print with opaque inks, which for the most part require a separate stencil and separate printing for each color? The prime and most important reason is that with transparent inks it's difficult to predict with certainty how closely the trapped colors in the print will match the original colors on the art. For example, transparent cerise red printed over an area of turquoise blue will result in a purple where the colors overlap, but not necessarily the exact shade of purple as on the art. With opaque inks, on the other hand, it's possible to duplicate accurately all colors on the print to match those on

the art. Another reason why transparent inks aren't more widely used in poster reproduction is that inks to be transparent must be diluted with a plasticizer in the form of transparent base. Such ink formulations are generally not as permanent or fadeproof as fully pigmented opaque inks. Also, if you don't plan to get additional colors through superimposition, stencils must be made with great precision without overdraws. Adjacent color areas have to butt up against each other exactly for perfect register. Also, unlike printing with standard opaque inks, transparent inks are meant for white or other light-colored stock only.

How to Print Two or More Colors with the Same Stencil

At times it may be possible to work with a single stencil to reproduce more than one color; this can save on time and expense if handled properly.

The "Split-Fountain" Method. If two (or more) color areas are widely separated from each other on the art, they can be printed with the same stencil and at the same time in this manner: Partition off the screen temporarily by means of a heavy cardboard strip, made leakproof so that the ink of one compartment can't run into the other. Pour each of the inks into its corresponding compartment. Then with individual squeegees, scrape the inks across the screen in the usual way.

Partial Blockout Method. If the color areas are separated but too near each other to allow for partitioning the screen, the several colors can be printed from the stencil individually though not at the same time. Temporarily block out all areas except the one being printed by taping a paper mask to the underside of the screen. When finished with this color, use the same blockout procedure for the other colors, until all are printed.

Color Blend Method. Though silkscreen is primarily a flat or solid-tone printing medium, some attempts at color blending in the printing can work successfully if the blend runs on a parallel line in the direction of the squeegee stroke. An example of that would be a background area such as a large expanse of sky where the color changes in a gradual blend from a deep blue on top to a pale blue on the horizon. To achieve a blend effect of this kind, prepare inks in three distinct shades of blue—deep blue, medium blue, and pale blue—all of fairly heavy consistency, each mixed in its own container. Pour a quantity of each shade of blue in the proper or-

Partitioning the screen with cardboard to create two or more compartments makes it possible to print several colors simultaneously.

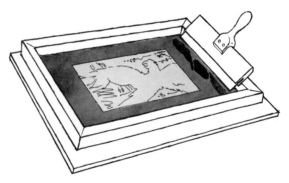

Though silkscreen is basically a solid-color reproduction medium, some blending is achievable by placing two or more colors in the screen which gradually intermix and blend as the printing proceeds.

der into the screen and squeegee across. The first few prints will undoubtedly show three distinct bands of blue, but as the inks gradually run into each other in the screen during the course of printing, the blending will become more and more subtle. No two prints will be exactly alike. After a while, the colors in the screen will neutralize each other and have to be replenished in the same order to reestablish the desired blend effect.

Somewhat akin to the blending described above is the *free-mixture* blend. Here subtlety of tone or color gradation is not the objective. Quite the contrary. This time the objective is to get as variegated a color pattern as inventiveness, or "happy accident," can bring about. To achieve a free-mixture blend, pour different color inks into the screen in any order that suggests itself to you and then squeegee across in any direction whatever. The resulting prints will be characterized by a marbleized conglomerate color pattern. Every print will be different; each one an "original."

How to Combine Screen Printing with Hand Coloring

For limited-edition multicolor posters or decorative prints, it's sometimes feasible to design your work in such a way that the basic elements of the composition are held together by a bold outline in black or other dark color. This outline functions visually like the leading in a stained-glass window. Screen print the outline; fill in the color areas by hand. You'll get interesting, luminous effects by using either transparent watercolors or felt-tip markers as a coloring medium. Each copy thus produced becomes virtually a hand-colored "original," combining the character of a print with the personal touch of a painting.

Decorative poster in five flat colors with a subtle color-blend effect in the background.

8 What you should know about inks

The ink used in screen printing in some ways looks like ordinary house paint but it is very different in chemical makeup. Because of its similarity to house paint, it shouldn't be assumed that just any paint purchased in the local paint or hardware store will do. Screen inks are formulated to go through the fine mesh of the screen fabric without clogging or drying in, and yet dry fast on the printed surface.

Basic Classifications of Inks

The word *ink* as it's used here, following the custom of the trade, designates the entire range of screen-printing media and in this sense is synonymous with "paint," "color," and "process paints." These terms are often used interchangeably in dealer brochures and other commercial literature relating to screen printing.

Oil-Based Inks. Most poster printing is done with inks of the oil-based type. Such inks have a number of inherent advantages. They are 100% waterproof; that's important when the poster, sign, or whatever it is you're printing is meant for outdoor display. They don't wrinkle, pucker, or shrink the surface to which they are applied— even if the printing is done on tissue-thin paper stock. What's more, they can be formulated to be completely opaque so that a light color can be printed over a dark color as easily as the other way around. Oil-based inks can be made to dry with any degree of finish desired—from a dull-flat to a gloss. And equally important, when using oil-based inks you can print with any type of stencil—paper, glue-resist, hand-cut film, photographic, etc.

Water-Based Inks. To a limited extent, water-based inks can be used with moderate success in screen printing. Their chief drawbacks (which explains why they aren't more widely used in the field) are: the colors (though brilliant) lack opacity, making it difficult to print a light color to cover a dark one; they are not waterproof and therefore aren't suitable for printing on stock intended for outdoor display; and they lack the adhesive quality necessary to hold up well on nonabsorbent surfaces. Water-based inks can't be used with glue blockout or other water-soluble stencil methods.

Counterbalancing these technical limitations is the fact that water-based inks are comparatively odorless and don't require a flammable solvent for thinning the ink or for washups: water is both thinning and washup agent. Generally, water-based inks are a more popular printing medium for students and hobbyists than for serious poster- and printmakers.

Lacquer-Type Inks. These are primarily used for printing on vinyl and other plastic material but work equally well on all paper and cardboard stock, leather, cork, wood, ceramics, metal, glass, etc. Commercially, they are the choice printing medium for decals, washable wallpaper, toys and novelties of all kinds. Lacquer-type inks are flexible, have good opacity, and dry within 30 to 40 minutes with a "wet-look" gloss finish. They are not troublefree, however, for the average noncommercial user. They have a strong toxic odor requiring special attention to proper ventilation and have a higher degree of flammability than other screen-printing inks. Lacquer-type inks are not suitable for hand-cut lacquer film stencils or other stencils where a lacquer base serves as a blockout material.

Inks and Solvents to Start Out With

Following are some pointers on purchasing your initial inventory of inks and solvents. As you take on specific assignments, the quantities of supplies and range of colors will increase depending on each poster run.

Oil-Based Poster Inks. You'll do best starting off with oil-based inks, which are the most versatile and the easiest to work with for poster printing. Your silkscreen-supply dealer has dozens of different colors to select from. All that's needed is a limited number of basic colors which through proper intermixing will yield practically any color, tone, or shade you want. Screen inks are packaged in jars and cans, from ½ pint up to gallon lots.

As a starting inventory, ½ pint of each of the following should be quite sufficient.

Red	Turquoise blue
Lemon yellow	White
Bulletin blue	Black

Replenish the colors as circumstances require. You'll find you'll be using white and black in larger quantities because they are not only printing colors in themselves, but are used for tinting and shading as well.

Reducers and Solvents. A *reducer* in screen-printing terminology is a thinning agent which, when intermixed with ink in moderate quantity, doesn't change the color, alter the drying time, or in any way unbalance the chemical composition of the ink formulation. A reducer (a form of varnish) merely reduces the viscosity of the ink, giving it greater fluidity. To be sure that reducer and ink are compatible, it's best to get the type recommended by the manufacturer of the particular ink you're using. Suggested quantity—one pint.

A *solvent* may also serve as a thinning agent at times, but it functions primarily as a washup medium for screen and squeegee. The solvent for oil-based inks is of the mineral-spirits type in the form of kerosene, Varnolene, Varsol, turpentine, etc. Suggested quantity—one quart.

Auxiliary Ink Supplies

The following are supplies you may need to alter ink composition or create special effects.

Transparent Base and Extender. Normally, oil-based screen inks are opaque as they come in the container. Indeed, that's one of their outstanding advantages. There are occasions, however, for whatever reason, you may wish to make the ink less opaque. This can easily be done by adding transparent base to the ink mixture; the more base added, the more transparent the color. Transparent base serves another purpose as well. If inadvertently ink has been thinned down too much, causing it to "creep" in the print, the situation may be remedied by adding a little base to it. This not only restores the original viscosity of the ink but makes it "short" and buttery, thereby greatly improving the printing quality. Extender, in a way, serves the same purpose, except that it isn't quite as smooth in texture. It's used mostly as a measure of economy to extend the volume of the ink. Both transparent base and extender are less expensive than the regular line of screen printing inks.

Toners. These are highly concentrated, finely ground pigment colors in heavy paste form meant to be used in conjunction with transparent base to produce clear, transparent tones. Toners may also be mixed with standard opaque white to give a full spectrum of pastel tints. In their natural state, toners are much too thick to be added to base or other ink mixtures without first being thinned down with varnish, oil, or other reducing agent.

Fluorescent Inks. These inks possess an almost radiant luminosity and are said to be four times as bright as standard colors. They come in a select number of colors and are screened in much the same way as standard inks except that best results are achieved with a mesh no finer than #12XX. Since all fluorescent colors are by nature transparent, they must be printed on a pure, white surface to show up at their brightest.

Metallic Inks. Available in gold, silver, and copper, as well as in a variety of other metallic finishes, metallic inks come in two forms—ready-mixed and as a powder to be intermixed with a vehicle such as varnish. The most lustrous results are achieved when powder and vehicle are mixed just prior to printing. As in printing with fluorescents, a screen mesh no finer than 12XX will yield the best results. Metallic inks lend themselves exceptionally well to a high-relief effect simulating to some degree a raised embossed surface.

Computing Ink Coverage

Screen inks go a long way in surface coverage; the squeegee lays on a much thinner and more evenly distributed deposit of ink than is possible to do by hand. In estimating how much ink to mix, the rule of thumb is 250 square feet of coverage per quart. On that basis, if you were to print an edition of 50 11″ x 14″ posters, the total ink consumption would be less than ½ pint, assuming that the major part of the surface is covered. This estimate is only approximate. Paint consumption varies not only with the size of the printing area but also with the pressure exerted on the squeegee, and above all, with the nature of the stock on which the printing is done. A nonabsorbent stock such as glass or metal will use less ink than cloth, cork, or similar absorbent material. Knowing just how much ink to mix will come with experience.

Mixing and Matching Colors: Some Basic Guidelines

1. Any color mixture produced by two or more colors, or by the addition of base, varnish, or other ingredient must be stirred thoroughly to

avoid streaks coming up during the printing.

2. When intermixing two colors to produce a third, it's best to start with the lighter of the two as a foundation, and add the deeper color to it; not the other way around. For example, in intermixing white and black to produce gray, start with white and add black, as needed. Deeper colors have greater tinting power.

3. Ink should be strained if it shows any semblance of skinning, impurities, or other foreign matter. Straining can be done either with a double layer of cheesecloth tied around a container or by passing the ink through a fine-meshed sieve.

4. For difficult-to-match colors it's a good idea to prepare a bit more ink than your computed estimate. It's troublesome to try to rematch colors during the printing operation.

5. Screen colors when dry don't always look the same as they do in the wet state. In most cases, they tend to dry a little lighter and somewhat duller. Where close color match is important, allow the color swatch to dry, and remix and rematch the color if necessary, before proceeding with the printing. Use the same stock for the color swatch as for the edition. The nature of the stock has a bearing on how the color dries.

6. In general, follow the same procedure for matching screen inks as you do for matching artist's poster colors. Work under good light (preferably daylight) and make use of the "color-match window" shown on page 70 when comparing the mixed color to the corresponding color on the art.

7. To minimize fire hazards, oil-based inks, lacquers, and all volatile solvents should be kept covered when not in use, with care taken to store them away from open flame or excessive heat.

8. Although theoretically inks procured from different manufacturers are intermixable, this doesn't always work in actual practice. The finely balanced ingredients of one manufacturer's line of ink may not be entirely compatible with that of another, and the results of such intermixtures are not always predictable. It's best to stay with one manufacturer's line of ink that you have found to be satisfactory for your needs.

9. Get to know ink manufacturers' color lines. Although normally standard oil-based ink can be used for printing on practically any stock, ink manufacturers formulate special inks for difficult-to-print-on surfaces such as vinyl, glass, canvas, etc. Sample color booklets are generally free and are available on request.

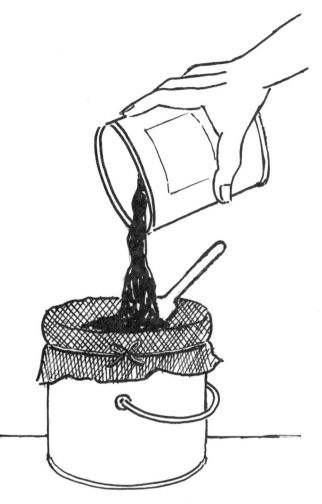

Cheesecloth tied around the rim of a container makes a good ink strainer. A wooden paddle or plastic spoon expedites the straining operation.

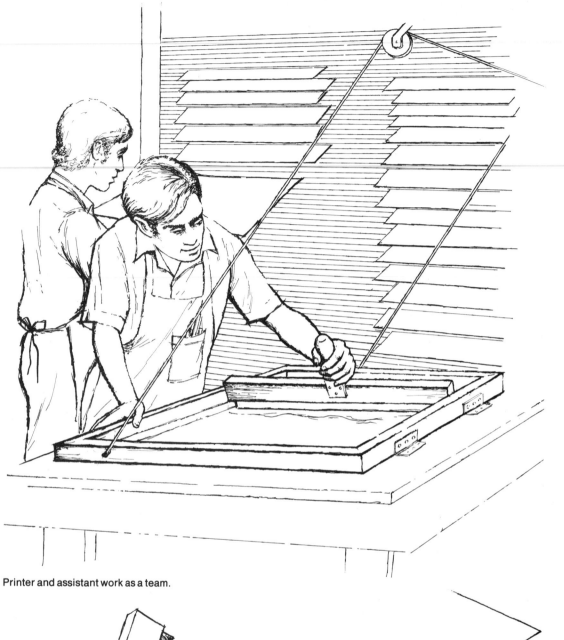

Printer and assistant work as a team.

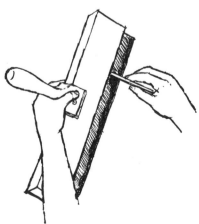

Cleaning the squeegee is as important as cleaning the screen. Both must be done thoroughly right after the printing operation is finished.

Plastic or metal clip-on register guides help to prevent thin paper or board from slipping out of register during printing.

9 The printing procedure

Printing is the fun part of screen process technology. You who have designed the original artwork have the satisfaction of seeing the final results of your talents and efforts in black and white, or better still, in full color. And the entire operation is under your control!

Silkscreen printing originated as a manually operated process, and to a large extent it still is. Even in commercial establishments which have at their disposal automatic screen-printing presses geared to do thousands of impressions an hour, a good part of the work is relegated to hand production. In the fine arts, limited-edition screen prints are all hand produced, either by the artists themselves or, if done commercially, under their close personal supervision.

In simple terms, the printing procedure involves moving the squeegee from one end of the screen to the other and by this action a quantity of ink is made to penetrate the stencil. Each crossing of the squeegee produces a print. If you watch a screen printer at work, the entire procedure looks so simple. It is—but it takes practice to do it smoothly and efficiently.

We have seen, some chapters back, how Bob and Diane Miller went about printing their small edition of posters with home-crafted equipment and improvised drying facilities. Let's at this time observe at close range a printer and his helper at work screen printing an edition of 500 large-size cardboard posters. The job on hand calls for a three-color poster to be printed with oil-based inks using the hand-cut film stencil method. One master baseboard is to be used throughout the entire run, with each of the three screens fitting the same master hinges. The planned sequence of printing is (1) yellow, (2) red, (3) black.

The Printing Setup

We'll assume the stencils are already cut and adhered, inks matched and pretested, register guides set, and the proper squeegee selected. The stack of 500 cards to be printed is neatly piled on a table at one side of the screen unit,

and the professional drying rack is stationed on the other side—an arrangement which permits an orderly flow of work from one side of the setup to the other. Everything is ready to go.

To start with, the printer securely fixes the baseboard to a solid worktable of convenient height, hooks up screen #1 (yellow), and attaches a counterbalancing device for automatically raising the screen. He then places a card in the register guides, lowers the screen, and pours a portion of ink into the far end. He takes a position in front of the screen unit, feet apart to assure good balance.

Pulling Proofs

Employing a one-hand center-grip squeegee, he pushes the ink across the screen from one side to the other. In crossing, he maintains evenly distributed pressure on the squeegee, tilting it slightly in the direction of the stroke, then rests it against the edge of the screen frame at the end of the stroke. He carefully checks the first few impressions he pulls and sets them aside as proof sheets. He blocks out the four crossmarks with small strips of tape placed on the underside of the screen, and proceeds with the printing.

Printing the Edition

The routine is as follows: The printer sets a card in the register guides, lowers the screen, and pushes the squeegee across with one hand while resting the other on the screen frame. After the impression is made, the screen is lifted. At this time, an assistant (he's known in the trade as the "take-off man") places the wet print on a shelf in the drying rack. The printer then sets the next card into the register guides and lowers the screen once more. The printing continues in this fashion: right to left, left to right, each passage of the squeegee producing another print. The take-off man is as busy as he can be—removing each card from the baseboard as soon as it's printed and placing it on the drying rack—his action timed to keep pace with the printer. From time to time, as the ink diminishes in the screen, the

Journal covers for clubs, school and church groups are reproducible by screen printing at low cost on any type of material or paper.

With a bit of ingenuity, a setup can be improvised to print on toys, books, and other three-dimensional items. The screen is hinged to a strip of wood the same height as the object to be printed.

printer stops to replenish it. One filling of the screen may last 20 or 30 impressions. It all depends upon the printing area and the nature of the stock. Occasionally, the printer wipes the underside of the screen with a soft dry rag to clean up any evidence of smudging as the printing proceeds. Working unhurriedly and systematically, the entire run of 500 cards is printed with the first color in a little over two hours. The screen is now ready to be cleaned and the second screen for color #2 set up for printing.

Cleaning the Screen

The take-off man disengages the screen from the master hinges on the baseboard and transfers it to a worktable. First, he spreads several layers of newspapers under the screen, then, with the aid of a sharp-edged piece of cardboard, he scrapes the remaining ink to one side of the screen, scoops it up, and puts it back in the can. In a similar way, he removes whatever ink clings to the squeegee. With a plentiful supply of absorbent rags on hand, he proceeds to wash the screen with Varnolene—an effective and low-cost ink solvent of the mineral-spirits type. He swishes a solvent-saturated rag not only over the image area but over the entire screen surface, making sure to reach the corners as well. Next he turns the screen around to wash and clean the underside. He uses a dry rag to mop up all traces of ink and solvent from both sides. The squeegee and screen frame are cleaned with equal thoroughness. Washing and cleaning take no more than 15 minutes from start to finish.

Cleaning up, the last step in the printing cycle, is an important aspect of maintenance. Unless this is done properly, the screen and squeegee may be ruined or seriously impaired. As in the printing itself, it takes dexterity plus experience to do the job neatly and with dispatch.

Setting Up and Printing Subsequent Colors

While the screen is being cleaned, the printer proceeds with the "make-ready" (a printer's term synonymous with setting up) for the second color in the sequence of printings. He hooks up the second screen on the baseboard, carefully checks hinges and screen to be sure there's no side-to-side shift, gets the ink ready, and sees that everything is in order for the second printing. He runs off the proof sheets and checks the crossmarks for accuracy of register, making whatever adjustments are necessary. To be in perfect register, the crossmarks of one color must coincide exactly with those of the previous color.

After blocking out the crossmarks on the

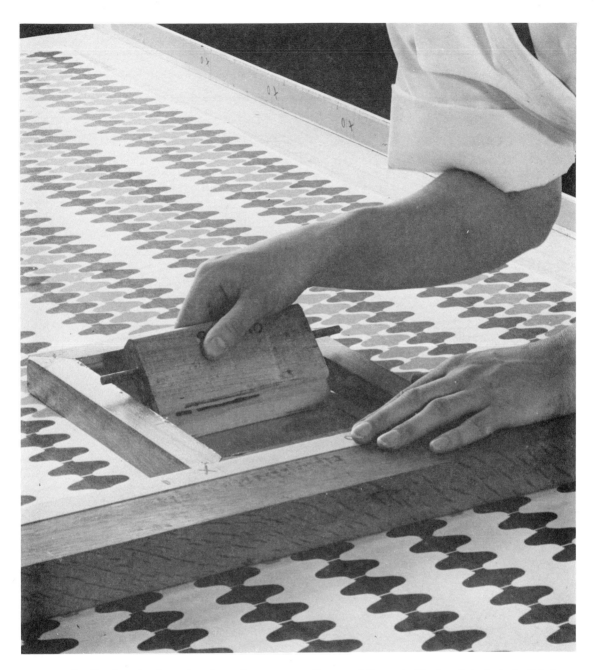

screen and collecting the dry prints from the rack, color #2 (red) is run off. The printing procedure for this color is the same as the first. When color #2 is finished, the last color (black) is printed.

The entire job of printing the lot of 500 posters in three colors (that's a total run of 1500 impressions) plus "overs" for proofs and spoilage, is completed well within one normal workday.

It's good to know that the manually operated screen printing unit employed by commercial printers is substantially the same as the one you have at your disposal. With the spirited assist-

Screen printing on textiles is an industry by itself, but on a small scale it's possible to set up simple equipment whereby limited textile printing can be done at home, in the studio or classroom. For material in yardage lengths, it works best to keep the cloth stationary and to move the screen and squeegee to predetermined positions for accurate alignment of continuous patterns.

ance of a member of your family, a friend, or an associate, you too can, in a more limited capacity, undertake to do production jobs right at home or workshop, with you yourself acting in the capacity of designer and master printer.

Table of Conversion Factors

TABLE OF CONVERSION FACTORS

To Convert:		From	To	Multiply by
	Multiply by	To	From	
LENGTH	0.03937	Inches	Millimeters	25.4
	0.3937	Inches	Centimeters	2.54
	39.37	Inches	Meters	0.0254
	3.2808	Feet	Meters	0.3048
	1.0936	Yards	Meters	0.9144
	0.62137	Statute Miles	Kilometers	1.6093
AREA	0.155	Square Inches	Square Centimeters	6.4516
	10.764	Square Feet	Square Meters	0.0929
	1.196	Square Yards	Square Meters	0.83613
	0.0015625	Square Miles	Acres	640.
	2.471	Acres	Hectares	0.40469

Illustration credits

Annotated bibliography

Biegeleisen, J. I., *The ABC of Lettering.* Rev. ed., New York: Harper & Row 1976.

A fundamental treatise on the development of skill in brush lettering.

———*Art Director's Book of Type Faces.* 2nd ed., New York: Arco Publishing Co., 1970.

A compendium of large-size type faces, upper case, lower case, and numbers with an explanation of how the type is rendered and applied to various commercial uses.

———*Screen Printing*, New York: Watson-Guptill Publications, 1971, and London: Evans Brothers, Ltd., 1974.

A basic manual covering all the methods of screen printing, with special emphasis on art reproduction.

Cavanagh, J. Albert. *Lettering and Alphabets*, New York: Dover Publishing Co., 1946.

Hand-lettered alphabets designed by one of the foremost lettering artists of his day, for brush and ruling pen.

Clements, Ben, and Rosenfeld. David. *Photographic Composition.* Englewood Cliffs, New Jersey: Prentice-Hall Inc., 1974.

While this book is directed mainly to photographers, the elements of composition so adequately analyzed, apply equally well to illustrations for poster design.

Craig, James. *Designing With Type.* New York: Watson-Guptill Publications, 1971.

An excellent presentation on the art of lettering and type for reproduction and typographic layout.

Douglass, Ralph, ed. *Calligraphic Lettering.* 3rd ed., rev. ed., and enl. ed. New York: Watson-Guptill Publications, 1970.

Designed for those who like to do calligraphy professionally or as an avocation. One of the best books on the subject.

Gates, David. *Lettering for Reproduction.* New York: Watson-Guptill Publications, 1969.

A helpful guide to esthetics and procedures of producing lettering suitable for reproduction.

Heller, Jules. *Printmaking Today.* 2nd ed. New York: Holt, Rinehart and Winston, 1972.

A good orientation to the graphic arts, with special emphasis on fine art reproduction.

Hillier, Bevis. *Posters.* New York: Stein and Day, and London: Weidenfeld and Nicolson, Ltd., 1969.

An excellent treatise on the history of poster design with many examples of outstanding posters of the past in black and white and color.

Horn, George F. *Posters*: Designing, Making, Reproducing. Worcester, Mass.: Davis Pub., Inc., 1964.

An elementary book on the art of poster design and reproduction.

Hornung, Clarence P. *Handbook of Early Advertising Art.* 2 vols. 3rd rev. ed. New York: Dover Publications, 1956.

An encyclopedic source of old-type drawings arranged by subject and presented from original steel engravings.

Kosloff, Albert. *Photographic Screen Printing.* Cincinnati, Ohio: Signs of the Times Publishing Co., 1972.

A technical treatise on the procedure for making photographic screens for commercial printing purposes.

Kuwayama, Yasaburo. *Trademarks and Symbols.* 2 vols. New York: Van Nostrand Reinhold, 1973.

A veritable encyclopedia of outstanding trademarks and logotype designs the world over.

Macdonald, Byron, N. *Calligraphy.* New York: Pentalic Corporation.

Treats especially the art of lettering with the broad pen.

Maurello, S. Ralph. *How to Do Paste-ups and Mechanicals.* New York: Tudor Pub. Co., 1960.

A practical treatise on the studio skills and procedures for preparing art for camera reproduction. Well illustrated.

Metzl, Ervine. *The Poster.* New York: Watson-Guptill Publications, 1963.

A scholarly work on poster design with many illustrations in full color.

Rickards, Maurice. *The Rise and Fall of the Poster.* New York: McGraw-Hill, 1971.

A good anthology of posters, old and new, treated historically.

Auxiliary Reference Sources

Barber, Bruce T. *Designer's Dictionary.* Lockport, New York: Upson Co.

A practical workbook of ideas for retail display and promotion. A good source book on two- or three-dimensional design.

Fredericks, Kay L., and Johnson, William R. *Holiday Characters, Adapt-A-Board Book.* Minneapolis, Minn.: Trend Publications.

Easy-to-do cartoon figures suitable for the holiday seasons, especially designed for use as reference material for school bulletin boards.

Metro Associated Services, Inc., New York.

Suppliers of ready-to-use pen-and-ink spots for advertising purposes. A nationwide service.

Pictorial Archives, Dover Publishing Co., New York.

A series of illustrative books on a variety of subjects containing copyright-free artwork that can be reproduced in any medium without special permission from the publishers.

Reynolds, Lloyd J. *Italic Calligraphy and Handwriting.* New York: Pentalic Corporation.

A little workbook on the art of calligraphy with inspiring examples and exercises to go by.

Stoner, Charles, and Frankenfeld, Henry. *Speedball Textbook*, Philadelphia, Pa.: Hunt Mfg. Co.

An inexpensive paperback replete with information and examples of freehand lettering with the pen.

Sutphen, Dick. *The Cartoon Clip Book.* Scottsdale, Ariz.: The Dick Sutphen Studio, Inc.

One of a series of copyright-free clip books printed on good paper stock for use in advertising paste-ups.

Harry Volk Art Studio, Rockford, Ill.

Suppliers of ready-to-use pen-and-ink spots for advertising purposes. A nationwide service.

Yogg & Co., Inc., Millburn, N.J.

Leading designers and producers of stock posters available to restaurants and the food trade.

Professional Journals of Special Interest

American Artist/magazine, One Astor Plaza, New York, N.Y. 10036

Art Direction/magazine, 19 West 44 St., New York, N.Y. 10036

Graphis, The Graphis Press, Zurich, Switzerland

*Screen Printing/*magazine, 407 Gilbert Ave., Cincinnati, Ohio 45202

*Signs of the Times/*magazine, 407 Gilbert Ave., Cincinnati, Ohio 45202

Glossary/index

Script (a classification of alphabets based on handwriting, usually with connecting links). *See* Alphabet styles

Secondary colors (these are orange, violet, and green—each is midway between the primaries from which it can be mixed), 66

Selling point, 11, 13

Sensitizer (a dichromate solution, such as potassium or ammonium dichromate, which when added to a photographic colloid such as gelatin renders it actinically sensitive to the action of light), 136–137

Serif (the finishing-off stroke or spur at the end of the main stroke of certain alphabet styles)

Serigraphy (a term used for screen printing as a creative art medium to differentiate it from its application as a commercial reproduction process), 113

Shade (a color made darker by the addition of black)

Shading sheets (transparent sheets with imprinted lines, dots, and a variety of patterns, used for obtaining tonal and special texture effects in photographic reproduction processes)

Sharpening: pencils, 14, 15; stencil knives, 130

Showcard, 11; board, 28; brushes, 16; colors 21, 68

Sign-painter's oil colors, 69

Silkscreen, 111, 120; construction, 114–120; drying, 120; lifting devices, 120; silk, 116–117; stretching, *117*

Simplicity, 11, 13, 81

Single-thick: board, 19; strokes, 24, 28

Sketchbook, 51

Solvents, 71, 124, 140, 153, 154, 157–158

Spacing, 28, 29

Spatter, 91, 134

Speedball pen, 16, 28

Spencerian penmanship, 28

Split fountain (a technique in which two or more nonadjacent colors are printed simultaneously by partitioning the screen into compartments), 151

Sponging, 91

Spray colors, 69, 85, 86

Squeegee (a rubber-bladed implement used in forcing the ink through the openings of a stencil), *112*, 113–114, 119, 127, 151, 152, 157; cleaning, *156*

S/S (abbreviation for *same size*; a notation relating to size of artwork to be reproduced), 98

Stage-set display, 105

Staple gun, *118*

Stars, how to draw, 99

Stat. *See* Photostat

Steel brush (a lettering tool similar to a traditional brush; it comes with flexible steel strips instead of hair bristles), 16

Steinlen, Théophile, 91

Stencil(s), 113, 125; adhering, 124, 130; blockout, 144, *145*; blockout fluid, 124–127; circles, 123; films, 123–130; lacquer, 123–126, 127; paper, 130–131; photographic, 134–143; removing, 124–130; resist, 144–147; tusche-glue, 144, 146; water-soluble, 123, 127

Stippling, 91, 136

Stock (a broad term referring to paper, cardboard, plastic, metal or whatever material is to be used for artwork or printing). *See* Board *and* Paper

Stool, artist's work, 14–15, 21, *22*

Straightedge, 17

Striping, 98–99

Stripping, 125, 128, 131, *132*, 143, 150

Strokes: brush, 16; diagonal, 24; horizontal, 24–25, 28; pen, 16; round, 25, 28; single-thick, 24, *27*, 28; thick-and-thin, 24, *27*, 28; vertical, 24, 28

Surface, board; coarse, 19; cold-pressed, 19; hot-pressed, 19

Surprise, element of, 12–13

Symmetrical balance, 12

Table, drafting, 14

Take-off (the act of removing the wet print from the baseboard and placing it on a rack or other drying device), 157

Take-one display, 105

Tape measure, 17

Template (a mold or pattern used as a guide to mark out a shape with mechanical precision), *86*, 105

Texture sheets, 143

Thematic symbol, 52

Thinner (a shortened term for lacquer thinner. It generally encompasses wash thinner, adhering thinner, and various other diluents and solvents for lacquer and other nitrocellulose compounds). See Lacquer: thinner

Three-wing display (a cardboard scored vertically at two places so that it can be folded like a screen, thus forming three surfaces—a center and two side sections), 103

Thumbnail sketch (experimental layout sketch in miniature preliminary to the more finished comprehensive), 81

Thumbtacks, 14, 19

Tinsel, 105

Tint (a color made lighter with the addition of white)

Toner (a highly concentrated pigment color mostly used in conjunction with transparent base to produce transparent tints), 154

Tooth, 69

Toulouse-Lautrec, Henri de, 91

Trace-cut, 124, 130, 132

Tracing media, 94–95

Tracing paper, 19, 20, 130, 143

Transfer lettering (pressure-sensitive lettering or type matter printed on a backing sheet whereby it can be transferred to a drawing surface), 86–91

Transfer method, of photostencil preparation, 136, 139–140

Transparent base (a clean, Vaseline-like substance which when added to an ink mixture reduces its opacity, thickens its flow, and at the same time extends its volume), 154

Transparent ink, 150–151

Transparent positive, 136

Trapping (printing one color over another in order to obtain compound colors or tones by using transparent inks)

Trays, for developing photostencils, 134

Triangle, 14, *15*, 17, 123

Triple-thick board, 19

T-square (a straightedge made of wood, metal, or plastic with a long blade and short crossbar, shaped like the letter T; it's the major tool used to square up artwork on the drawing board), 14, *15*, 16–17, *25*, 100

Turpentine, 71, 154

Tusche (a black, slightly greasy compound in liquid or crayon form used as one of the principle resist media in stencil preparation). *See* Stencil, tusche-glue

Ulano Rubylith film, 143

Uppercase (the **capital** letters of the alphabet, abbreviated uc), 25, 29, 43

Value (the degree of lightness or darkness of a color), 66, 67

Edited by Sarah Bodine
Designed by James Craig
Set in 10 point Times Roman by Publishers Graphic, Inc.
Printed and bound by Interstate Book Manufacturers, Inc.
Color printed by Toppan Printing Company (U.S.A.) Ltd.